THE FREELANCE MANIFESTO

D1293340

THE FREELANCE MANIFESTO

A FIELD GUIDE FOR THE MODERN
MOTION DESIGNER

JOEY KORENMAN

LIONCREST
PUBLISHING

COPYRIGHT © 2017 JOEY KORENMAN
All rights reserved.

Illustrations by Amy Unger.

THE FREELANCE MANIFESTO
A Field Guide for the Modern Motion Designer

ISBN 978-1-61961-671-4 *Paperback*
 978-1-61961-672-1 *Ebook*

To my gorgeous, patient, amazing wife, Amy, and my beautiful, crazy, wonderful kiddos, Layla, Emeline, and Elliot. Thank you for being a constant source of happiness and life to me, especially when I embark on endeavors (like writing a book) that remove me from society for weeks on end. I love you. You're my why.

CONTENTS

FOREWORD

BY JAKE BENJAMIN

You're about to read, in book form, a series of lessons that I learned in person over beers. When you read what Joey has to say about freelancing, you'll probably feel as skeptical, terrified, and exhilarated as I did almost a decade ago when I first heard his ideas. Here's how my story started. See if any of it feels familiar to you.

In 2008, I was an assistant editor at an awesome studio in Boston. Being an assistant was great at first. It was the only time in my career when I could easily pick the brains of more seasoned editors and learn not just the "hows" but also the "whys" when it came to being an editor. I happen to be very technically inclined, which was a major strength but, as I soon found out, also a huge weight holding me back. After a few years, I was still just

an assistant editor/tech person and was ready to start moving up the food chain.

At my company, there was no shortage of budding assistants eager to make their mark on the world. I had seniority, but I was also the only one with the technical skills to fix problems for more senior artists as they popped up. I started watching edit after edit go to the other assistant editors. When I asked my boss about it, he told me the painful truth that there are plenty of editors but not enough good techs. You'll hear more about this problem in the book, by the way. It's a common issue that can come with being on staff.

It was painful to go in every day to work on all of these amazing projects and not be in a position to make a creative contribution to them. And when I did get edits, I felt like they were scraps thrown at me just to keep me happy enough to keep doing the tech work.

Then the recession hit, everyone in the industry was hurting, and the company I was at was no exception. Being the only assistant who was also a tech at the company protected me from getting laid off. Unfortunately, it was also keeping me from reaching my creative goals. To add insult to injury, my company instituted across-the-board pay cuts. I was still an assistant editor and not making

very much. I was cash-poor, and even a small pay cut was going to make it very hard for me to pay my debts. This was my breaking point. I remember the feelings of frustration and helplessness. And do you know what people around me said when I'd talk about it? "You're lucky to have a job." Right, thanks.

Cue Joey Korenman, this crazy-talented freelance editor/animator friend of mine who did a lot of work for my company. He was a really successful freelancer who was constantly working at the best shops in town. The day of the pay cuts, I was venting my frustrations to him, and he told me we needed to get beers after work.

That night Joey sat me down at a bar and told me it was time to quit my job and go freelance. He said that sometimes you hit a point where you just can't grow anymore at your company. Dissatisfaction can build and build, and at a certain point, it's time to get out, before it turns into resentment, and you burn a bridge. That is *exactly* how I felt.

What he was saying made a lot of sense, but all I had at that point were some meager savings, a small portfolio of work, and a million questions. Not to mention that there was a recession going on. So, we did the math. For me to earn enough by freelancing to match my current

salary at the time, I needed to get seven days of work per month.

Wait, that can't be right. Seven days a month? Shit. I can do that.

The math was right. Joey and I sat there for hours while I fired question after question at him about freelancing, each one basically an excuse I had as to why I didn't think I'd be able to do it. Joey assured me that if I did the leg work and followed a plan, there was no doubt I would be able to attract clients. The most important thing he told me was that no matter what's going on in the industry, hiring managers are having just as much trouble finding talent as talent is having to find work. And, most importantly, Joey paid for our beers and told me the best part about freelancing: our beers were a tax write-off.

Joey laid down a foundation for what was about to become the best and scariest decision of my life. While everyone, it seemed, was clinging onto their jobs for dear life, I walked into my boss's office the next day and handed in my notice. Then I took Joey's advice and started hustling. It took me about two months to start getting fairly steady work, and already, I was making more money than I did when I had a staff job. At the end of my first year, I doubled my salary, and by year three, I was making six figures!

Then I decided I wanted to move to New York, a place where I didn't have any connections in the industry, the cost of living was higher, and I'd be competing for work with super talented editors. I was basically starting from scratch as a new freelancer. All the same insecurities and feelings came back as I was about to enter a new market, only this time, I was armed with a more robust portfolio, years of experience as an actual editor under my belt, and a ton of practice using the freelancing knowledge I first learned from Joey. The transition was far easier than I'd thought it would be. I started working almost immediately and continued to earn six figures, even in my first year in a brand-new market.

I guess the moral of the story is, grab a beer with Joey, but if you can't do that, at least listen to what he has to say about freelancing. Read this book and do what it says. You'll be glad you did.

—JAKE BENJAMIN
jaketotheb.com

INTRODUCTION

You probably bought this book hoping it would help you learn a few business tips to get your freelance career off the ground, and it will, but my hope is that it'll do a hell of a lot more than that. This book is a Trojan horse. It's a whack upside your head to get you to take control of your career and life. Yeah, I know that's a lofty goal. And I'm already starting to sound like a self-help guru, which makes both of us uncomfortable.

The truth is, you're going to hear a lot of things from me in this book that will make you uncomfortable, especially if you consider yourself an Artist. That's good because this book is for Artists. It's for Motion Designers who care about being Artists and don't want to go broke—or lose sight of why they got into Motion Design in the first place.

As you read, try to keep this in mind: Comfort is the enemy of growth. You're going to get uncomfortable, and you're going to grow.

So, ready to feel uncomfortable?

WHY FREELANCE?

The freelance life is one of the best-kept secrets I know. It's a secret I uncovered by accident and with one word— *yes.* That's all it took, and suddenly, I was a freelancer. It's a secret that made me feel GUILTY when I started doing it. *What do you mean I can triple my salary and work fewer days? And still do work I'm proud to put on my reel?* It seemed INSANE. *Aren't Artists supposed to be "starving"?* I felt soooo guilty...until my first client paid my first invoice. Then all I could think was, *Wow, this actually works. IT WORKS. Why isn't everyone doing this?*

As crazy as it sounds, and I know it may sound *reeeeealllly* crazy, you can actually make more money and have more freedom and do cooler work all at the same time. It's bonkers, I know. I'm going to show you exactly how I did it because that's the only way you'll believe me.

You can be skeptical for now. I was skeptical, too. But hang on, I'm getting ahead of myself. Let me tell you how my freelance career started.

I discovered the freelance secret by accident. Fresh out of college with a degree in film and television from Boston University, I started doing postproduction work for a local studio. I was fortunate to get that job. Many graduates in the industry finish college and end up working in other fields. I felt lucky, but I dreamed of working for a top studio, creating cutting-edge MoGraph stuff. Instead, I was doing mostly unsexy work for low pay. I was an editor, cutting commercials and industrial videos and the occasional long-form piece. It was mostly soul-sucking advertising. I had no clue that doing better work this early in my career and making a lot of money at it were even possible. I thought that long term I might eventually earn a salary high enough to be comfortable. My dad was a surgeon, so I grew up in an upper-middle-class situation that I hoped I'd one day be able to create on my own. But working as an editor, I wasn't even thinking about the money yet. I just wanted to do more creative work—the "amazingly cool shit" I'd seen on some top studio websites like MK12 (mk12.com) and Eyeball (eyeballnyc.com).

Whenever cooler MoGraph work came in—the creative, challenging work that people on staff (like me) wanted to do—the studio hired a guy named Mike to do it. Mike was the first freelancer I'd ever met and a very talented animator and designer. He would come in and do the fun stuff. Mike got paid (a lot) more than we did, and he

wasn't tied to the studio. When he finished a job, he left. He'd freelance at another company for a while or take a vacation. Another cool job would come in, and Mike was hired again to do the work. I won't lie; I was jealous of Mike. I wanted to know how he did it—*how did he become a freelancer?*

I grilled Mike about his freelance career. *How did he get jobs? How much did he charge? Did he think I could be a freelancer, too?* Then I bribed him with beers—a great move for getting info out of people. He spilled his guts. What he told me seemed too easy, but there he was, getting good work and getting paid a lot of money to do it.

One day, Mike asked if I was interested in doing freelance work for Converse shoes. He was already booked and couldn't do the job. I was terrified and ecstatic all at the same time. I'd have to quit my full-time job to take the gig, but here was my foot-in-the-door moment for freelancing. I couldn't pass it up. "Yes," I said, not knowing at the time how that answer would change my life forever.

Mike referred the client to me, and the Converse producer called to talk about the work and find out my rate. Mike had told me what I should charge, so I was prepared for the question. Still, my "rate"—the standard daily rate for a freelance Motion Designer—sounded like an imaginary

number in my head, like more money than I had a right to expect. Mike had confidence in me, though, and convinced me I was worth the fee. I swallowed and then forced the words out of my mouth. "Five hundred dollars a day," I squeaked.

"Great!" the producer said. "We'll see you Monday."

That moment, I went from making $700 a week as an employee to $500 a *day* as a freelancer. FIVE HUNDRED DOLLARS A DAY. I was doing better work, the work I wanted to do, and by the way, somebody was going to pay me $500 a day to do it! My head exploded. I am not making this up...except for the head-exploding part. You get the point. I was flabbergasted. (Great word, right?)

The gig at Converse lasted two weeks and paid more money than I was used to making in a month. The gig could have been a one-shot deal, but I was determined to learn how to become a successful freelance Motion Designer. I had quit my studio job, and over the next few years, my career took off. It wasn't pretty, though. I made an absolute crapload of mistakes. I stumbled, tripped, fell, and got back up and eventually figured out how to consistently find work and make my clients happy. More importantly, I realized that freelancing allowed me to reach not just my professional but also PERSONAL goals.

It allowed me the control over my life that I was craving and that I knew I'd never give up again.

This book lays out in plain English the exact methods I used to build a very rewarding freelance career that put me in the six-figure-salary zone, a place I never dreamed I'd be. This secret is too good to keep to myself, and I've shared it with a lot of my friends who have gone on to freelance. Now I want to share that secret with the MoGraph community—and with you.

That's why you're holding this book. I had to write this down so other people can know that it's possible and exactly how to do it. A couple of years after I went freelance—after I'd figured all this out—I talked to some friends, other people on staff at studios that I knew from freelancing. They would ask me, "Hey, freelancing seems great. Do you think I could do it?" I would pep-talk them into it, and they'd quit their jobs and ask me, "What do I do next?" I'd tell them. They would do what I told them, then come back and ask me again, "What do I do next?" I often felt like I talked them into jumping off a cliff because they were as skeptical and afraid as I was at first, but when they got it—oh boy, they got it—their lives changed. But first, they had to let go of that comfortable job, and that's key to a lot of what I'm going to tell you. Remember, comfort is the enemy of growth, and if you want to succeed at this,

you have to seek discomfort. You have to get up—GET UP—and reach. That's how you get there.

You are probably thinking, *If freelancing is so great, why isn't everybody doing it?* There are two good reasons. The first is that most people simply don't know how to quit their jobs and take a different path. I wrote this book to help them make that transition, with step-by-step instructions. The second reason is fear. Most of us are afraid of trying something new and failing. That's OK because when you are afraid, I will be here for you every step of the way. We'll take the freelance journey together in baby steps.

LIFE ON STAFF

While I was on staff at the studio, I was sharing an apartment in East Cambridge, Massachusetts, with two college buddies and just scraping by on my salary. When I took my girlfriend, Amy—who's now my wife—out to dinner, we'd skip the wine (too expensive at restaurants) and instead buy a jug of cheap Carlo Rossi wine (the "Jug of Fun!") at the liquor store to drink afterward.

With only two weeks of paid time off every year, our vacations weren't very exciting. We would try to stretch those ten days off every year (TEN days off every YEAR) and do what everyone else does: take off Friday to Monday

to take advantage of the weekend days off. We didn't fly much because it was too expensive, so we'd drive to New Hampshire to go camping. Of course, everyone else in the city had the same idea and schedule, so we'd be driving in heavy traffic and camping at packed campgrounds.

On top of that, my job editing commercials at the studio started to feel like it wasn't fitting anymore. Motion Design was a very new field in 2003, and I quickly fell in love with it. Back then, it was called Motion Graphics, or MoGraph, and it was the domain of a small group of wizards who figured out how to produce killer work well before Google and YouTube (and School of Motion) made it easy for anyone to learn how to make cool stuff. Instead of being limited by the footage that was given to me as an editor, I could create literally anything I could imagine and pull off in After Effects. My studio job offered me very few opportunities to hop into After Effects and make cool stuff, and when a MoGraph job did come in, a freelancer was usually called to do the work because I was too busy editing. That experience taught me an important lesson: *When you work for someone else, you have no control over the work you do.*

I'll say that again because I want it to sink in: *When you work for someone else, you have no control over the work you do. None.*

Once I started freelancing, everything changed. Within six months, I had knocked out all my credit card debt and wasn't living paycheck to paycheck anymore. The bigger deal was that I could support Amy while she finished grad school. I was so proud to be able to do that. We went on fun trips, too, because I could afford them and didn't have to worry about squeezing my vacation in around weekends and the ten days a year I used to be allowed to travel. We went to France, the Netherlands, Israel... DISNEY WORLD! I didn't think I'd be in that position until I was a grizzled veteran in my forties, but there I was at twenty-four years old, making six figures and having a real life.

During my first year as a freelancer, I said yes to every job to build a large client base. I was booked almost every day, but the work I was doing wasn't as cool as the stuff I was seeing from the best studios. And those studios sure as hell weren't calling me. I didn't have the portfolio that would impress them yet and sorely needed to improve my reel. My financial situation had improved immensely, but my reel needed a tune-up. Ironically, the lesson here is that being just "good enough" can get you plenty of gigs if you make your clients happy and work in a town where there isn't a huge pool of awesome freelancers. I also learned, eventually, that being better than "good enough" won't necessarily allow you to charge more for your work. You

have to gain the control to charge more. I'll tell you all about that in a little while.

In my second freelance year, I focused on sharpening my skill set. I took classes to learn new tools and techniques and finally got a foot in the door at a studio that did Motion Graphics work for HBO, Showtime, and the Discovery Channel. Surrounded by amazing talent, I felt like an imposter. I was a "two" surrounded by "nines." They weren't just a little better than me; they were light-years ahead of me. That studio gave me work that was beyond my current ability, allowing me a chance to fail, but I worked like a mule, staying all night to prove myself and turn out awesome product. I improved tremendously as a Motion Designer, my reel improved, and by the end of that second year, I began turning down work frequently.

I eventually boosted my day rate to $600 and made more than $125,000 in a year. Raising my rate that first time was one of the scariest things I've ever done. It's terrifying for a freelancer to ask for more money because it's so easy for the client to say no, and then it's awkward. Worse, they can just stop hiring you. It took me two weeks to work up the guts to do it, and I actually called my old boss from the studio—never burn a bridge—to ask for his advice, which he graciously gave me. I almost fainted asking for a raise in my rate, but I did it, and it worked. I will tell you

what your rate should be in chapter 6, "I Trust You," how I raised my rate in chapter 7, "I Need You," and how to raise your rate in chapter 8, "Your Freelance Life."

I should point out, by the way, that I'm not Superman. I was scared to death doing this, figuring it all out. Some days, I still can't believe I did it, and I never, ever expected to be making that kind of money back then. The first time I did my taxes and saw that I had actually paid more in taxes that year than I had made as salary in my old on-staff life, I felt like I was dreaming. It was weird, surreal, and awesome.

The money and cool projects were great, but over time, I wanted more control over what I worked on. I wanted to lead jobs, have more creative control, and have the latitude to experiment more. I wanted to be able to bill like I had been billing, without needing to put my butt in a specific chair and animating ten hours a day. This required a change in strategy. Up to that point, I worked for "middlemen," such as ad agencies, post houses, and marketing companies. These are places that get projects from clients and then hire freelancers to do the work, taking a cut of the budget. What if I bypassed the middleman and went after clients directly?

By the way, working for middlemen is not necessarily a

bad thing. You can often work with amazing people and learn a ton, and it's a good experience when you start freelancing. What I eventually realized is that there is a trade-off because what you gain in that experience, you give up in time—time to experiment and learn on your own—and income potential. Sometimes it makes sense to do that. We'll talk about this more in a little while.

My first direct-to-client gig was creating videos for Stonyfield Farm, a New Hampshire yogurt company. I knew I would have to book a studio and hire a producer, voice-over artists, and an illustrator to help with the work, so I sketched out a budget of $10,000. That price was a great deal for Stonyfield Farm, less than a quarter of what they would pay a traditional studio, but it was also a sweet deal for me as a freelancer.

With direct-to-client work, the client's expectations also changed. When you freelance for a studio, you're sitting in a chair in their office for eight hours a day from Monday through Friday, doing the work. Stonyfield Farm wasn't a studio with a roomful of iMacs, and I wasn't working on a studio schedule. Sure, I had a deadline, but now I was in charge of the studio—my spare bedroom—and my own schedule. The experience was challenging, but it taught me how to manage a team and a client and juggle multiple projects.

I continued approaching clients directly and managing multiple projects frequently, hiring my buddies to help produce jobs that I couldn't physically do by myself. Because I was taking on so much work, the final year I freelanced before starting a studio was the most grueling and stressful year I'd had up until that point. Amy and I were saving to pay for our wedding, and we wanted to do it FAST. I'd double- and triple-booked myself for months and was pulling all-nighters to get stuff out. But I was in charge of all of those jobs, working on my terms, and that year, I made $200,000 and paid for our wedding and honeymoon.

Two. Hundred. Grand. Think about that. That year was grueling, but it taught me another valuable lesson about freelancing: *You can choose a year of hell in exchange for a big bag of gold.* You can work long hours and put yourself through tons of stress if there's a good reason, like getting married, starting a studio, or saving for a house. I don't recommend doing all that in one year, but it's a choice you have when you're a freelancer and not on staff answering to a boss.

The skills I learned doing direct-to-client work proved extremely valuable when two partners and I launched Toil, a Motion Design studio in Boston. We acquired bigger ad agency and network clients and worked on brands

like Speed Channel, McDonald's, Progressive Insurance, Volvo, Saucony, and Ocean Spray. We hired staff and other freelance Motion Designers to work for us. We were bringing in a lot of clients and a lot of cash. And, boy, did we need to bring in a bunch of cash to cover the enormous monthly bill it cost to run the studio, pay everybody, and still make a nice profit. This was my first lesson in appreciating the value of the low overhead that freelancers enjoy. We busted our asses in those first several months, and it paid off when Toil made about half a million dollars in revenue the first year. So, between freelancing earlier in the year, doing some voice-over work on the side—work I had picked up through networking as a freelancer—and running Toil, I made $230,000 that year.

Toil gave me a steady paycheck. I wanted to buy a house and have children, so I liked the financial stability the company offered. But freelancing, I came to understand, is about making choices. Before I started the company, I could freelance for a year and make $200,000, or I could freelance for just six months and make $100,000. With six months off, I could do other things in my life, like take my family to London, or learn Spanish, or train for a marathon. I could also work on my website and reel and become a better Motion Designer.

That choice wouldn't fly at Toil. I had regular clients and

people working for me. My downtown Boston office came with massive monthly expenses, and I had to work hard to keep the lights on. I slowly began to resent not having much of a choice about my work schedule or how much time I could take off to do other important things. I realized that I'd given up freedom in exchange for stability. Initially, I thought that's what I really wanted, but after four years, I realized that stability is an illusion. If I stopped hustling or we slowed down the pace of work at Toil, the business would tank, and my paychecks would stop.

I was becoming seriously burned out. The stress of running a company and juggling work, family, and life—plus trying to get better at my craft and scratch that creative itch—totally fizzled me. As much as I loved Toil, I decided that I didn't want to run a business for twelve months a year anymore, so I gave my notice. Leaving Toil was one of the hardest things I've ever done, but I wanted to try a different path.

Instead of going right back to freelancing, I took a job—and a huge pay cut—to teach at the Ringling College of Art & Design in Sarasota, Florida. I had a wife, two kids, and a mortgage at the time, so it was terrifying, but I knew in the back of my mind that I could always freelance if the job didn't work out. The college had recently started a Motion Design department, and they hired me to teach

my specialty, animation. The job was a way out of the responsibility of running a business twelve months a year. At Toil, I was used to the stability of a steady paycheck, and I had that again with Ringling but without the responsibility of managing an entire company. I sold my house in Massachusetts and moved my family to Florida.

Teaching was an amazing experience that eventually led me to discover my *why*—why I was driven to want certain things in life. But I missed freelancing, and I even missed running my own business. What if I could combine all those things I loved about teaching, freelancing, and running a business into one career?

That question led me to start my current business, School of Motion. It takes some money and a lot of time to get a business off the ground, and the only way to raise the funds was to become a full-time freelancer again. So, while I taught, I began soliciting freelance jobs again, but this time I knew *why* I was doing them. I developed a career strategy and created a tactical approach to achieve my goals, satisfy my *why*, and design my ideal life.

My *why* had two goals—teaching and spending time with my family. I found that I had more than one *why*, and you will, too. In part one of this book, *The Freelance Manifesto*, you'll see why identifying your own *why* is important.

Your *why* determines your freelance choices, which gives you the power and motivation to create the life you want.

The *how*—how I achieved my goals as a freelancer, and how you can achieve yours—is described in *Part II: The Freelancer's Field Guide*. Part two teaches you the methods I developed for a successful freelance career. These methods allow you to design the life you want and earn the money and freedom to live it. OK, fine, that sounds lofty and weird and new agey, I know, but I warned you that I was going to say some things that would make you uncomfortable, even skeptical.

Think of it this way: If you're like most people, you got on a train the minute you started school, and you've been running on that same track ever since. After high school and college, you took a job that happened to be out there, one you could do that was offered by an employer who would hire you. That's backward. That track leads to only one place, and you may not like it, but now you're stuck. You're stuck in a city, a job, and a life that you picked from a few choices, without ever imagining that there are many more choices out there.

Instead of blindly following that track, you can literally write down how you want your life to look and then take steps to make it look that way. This exercise has been

called "The Perfect Day Exercise," and legends like Debbie Millman recommend doing it (see freelance.how/debbie). The nuts and bolts are this: Figure out what you want a typical day ten years from now to look like. Where do you want to live? What kind of work do you want to do? Do you want to go into an office every day and work with the same people, or do you want to work with different people? Maybe you want to work remotely. Do you want to live in an expensive place, or do you want to live somewhere cheap? In the city or in the country? By the sea or in the mountains? Now ask yourself, if your actions stay the same as they are now, will that perfect day be your reality in ten years? Probably not.

Figure out what you want because you can have it, but only if you change your mindset. Give yourself permission to decide what your life is going to look like, or else it will just be a random collection of haphazard choices that met some short-term goals.

When I decided to leave Toil, it was because of this exercise. It was the first time I consciously went through the exercise of "choosing," and it was liberating to imagine what my life could be like if I actually took control and designed it. Amy and I sat down and literally wrote down our ideal life, what we wanted—and did not want—our lives to look like. We both wanted to live in a warm, sunny

place. I didn't want to commute to work ever again, so I wrote, "I don't want to commute. I want to ride my bike to work every day." When we moved to Florida, we chose an apartment that was close enough to Ringling that I could ride my bike to work, and we sold one of our two cars so I would *have* to ride that bike. Making that decision and taking those steps saved me from commuting, but the funny thing is, that daily bike ride came with a lot of other benefits I hadn't considered. It was automatic exercise and became great daily therapy for me, but it never would have happened if I hadn't sat down with Amy and thought about what I wanted my life to look like.

If you're in a staff job, you may think your options are limited. You probably think the Motion Design field is so small that you have to settle for whatever job you can get. That's not true, and by the end of this book, you'll know what I know. Then you can sit down and design your own life.

WHO CAN BENEFIT FROM THIS BOOK

This book is written *for* Motion Designers, but it is not a guide to *learning* Motion Design. Anyone who is interested in a freelance career can benefit from the methods in this book, but it is primarily intended for people who have some skill and experience in Motion Design. This includes

Motion Designers currently on staff, Motion Designers who are already freelancing, and Motion Design students considering a freelance career.

STAFF MOTION DESIGNERS

If you're working on staff and not doing the work you want to do, this book is for you. If you think your boss or your client is going to suddenly start asking you to do the super sexy work you're craving, instead of the work they need done, you will be waiting forever.

There's a core concept of being a freelancer, and you're going to hear me repeat it throughout this book: *You will never get paid to do something that you haven't already done before.*

You will never get paid to do something that you haven't already done before.

You Will Never Get Paid To Do Something That You Haven't Already Done Before.

YOU WILL NEVER GET PAID TO DO SOMETHING THAT YOU HAVEN'T ALREADY DONE BEFORE.

Sorry for yelling, but you need to really get that to have a

freelancing career. *You will never get paid to do something that you haven't already done before.* So, you need to do the work you want to get paid for before you can get paid to do it. The only way to do that is to take time off from paid work to do projects that push you to the next level. That core concept applies to businesses, too. Companies have to make a profit, or they go out of business. So, they focus on doing the kind of work they've already done— work they can get paid to do. To progress as a company, you have to occasionally do work for free or super cheap, so you can have creative control, do your best work, and have something amazing to show your paying clients. If there's money involved, you often won't be able to do your best work.

The best studios in the world operate like this. Companies like Buck, Royale, Shilo, and MK12 invest MASSIVE resources to do unpaid work, so they can do better work and eventually get paid to do it. In 2012, Buck created a piece called *Good Books "Metamorphosis."* That piece was most likely a money-loser on a humongous scale, but the publicity, accolades, and talent development that the project earned were priceless. It elevated the company to the pinnacle of Motion Design studios. Buck used that piece to develop its internal talent and ended up with better Motion Designers. *Metamorphosis* launched careers and made Buck a household name in the Motion Design

industry. However, unless a company's margins are high enough to do that kind of work at low or no profit, its employees are often going to be doing only paid, middle-of-the-road work.

If your company isn't occasionally doing work for free, you'll never have the opportunity to do your best work. So many staff Motion Designers wait around, hoping an opportunity will pop up. That will never, ever happen. You have to make your own opportunities. If you're on staff and not doing the work you want to be doing, think about freelancing. Think hard.

FREELANCE MOTION DESIGNERS

If you're already a freelancer and want to make more money, this book is for you. If you're making $70,000 a year as a freelancer, you could probably be making $100,000 and have more control over the work you do. This book teaches you the business of freelancing, so you can eventually pick and choose the work you do and even choose how much money you make doing it.

But wait, *Motion Designers are creative. We're Artists. We aren't good at business.* Don't believe it. We may be Artists, but we can be good at business, too. You have to be creative *and* good at business to maximize your potential

as a freelancer, and the business part is what I lay out for you in this book. And don't think business means hard sells, spreadsheets, and contracts. That's a HUGE misconception. Business is the art of providing value to your clients. You're not tricking anyone; in the end, you're just making their lives easier. But they won't give you the chance to make their lives easier unless you can market yourself properly and establish relationships.

For example, a section of this book deals with cold e-mailing potential clients. A company isn't going to hire you if they don't know you exist. This book will teach you how to write an e-mail to a prospect. You have to prove to clients that you're reliable and get them to trust you, and I'll show you how to do that. If you're already doing those things, I'll show you how to do them better.

Knowing how much to charge is another business decision necessary to maximize your success. Freelancers don't know what to charge because no one talks about their fees, and hiring managers often admit there is no correlation between what most freelancers charge and the quality of work. There are Motion Designers right out of college with no industry experience asking for $700 a day and rock stars charging $250 a day. This book will show you how to set your rate.

You could be a talented Motion Designer, but do you consistently attract new and better clients? Are there mistakes on your website that are turning clients away? How long is your reel, and what's in it? Are your rates too low or too high? I'm going to take you step by step through all the little details and everything you need to do on the business side, so that by the end of this book, you'll be way more comfortable with it than you are now.

You'll learn the nuts and bolts of being a successful freelancer, but you won't sacrifice the reason you became a Motion Designer. You'll still be a creative Artist who makes amazing video. Your goal, as a creative person who wants to do badass work—which takes time and money—is to learn how to separate the money-making projects from the creative ones. Freelancing lets you do that.

STUDENT MOTION DESIGNERS

If you're finishing up a four-year Motion Design degree, this book is for you.

I taught a class of seniors at Ringling College of Art & Design, and our conversations often turned to career plans. The students heard about wunderkind freelance Motion Designers who did work for big companies like Buck or Google and went to LA for months to work on

movie projects. My students hoped they could work for a studio for a few years and then "go freelance" and do cool work and have a freelancer lifestyle, but they had no idea how to get there.

To work at the highest levels, you need the portfolio to support that goal. Even if you come out of Ringling, or any other great Motion Design college, your first job might be as an in-house Motion Designer for an ad agency doing bottom-of-the-barrel work. You'll be doing work that needs to get done, and it's not sexy. It's not what you need in your portfolio to get hired by better clients.

Sure, you can get a job at a studio to make money and then do creative work on your own time before and after work. But even if you have the discipline to do that, you're going to burn out fast. Freelancing is more sustainable.

But here's a caveat: If you're coming right out of school and haven't worked in the business anywhere AT ALL, get a staff job first. When you're starting out, a staff job can be an amazing place to learn skills. You won't be a successful freelancer if you have no skills. So, get a job, but start thinking about freelancing. If you've been out of school for a while, have been working, and have the skills, think about making the leap.

It's never too early to start thinking about freelancing. I'll teach you what it is, how it works, and why you should aspire to do it.

WHAT'S IN THIS BOOK AND WHY YOU SHOULD READ IT

There are two parts to the book. *Part I: The Freelance Manifesto* explains why you should REALLY consider freelancing. If you're already a freelancer, you may be tempted to skip over it. I don't recommend skipping part one because it's important to understand the *why* before you understand the *how* in order to fully apply the principles. You have to learn it, accept it, and believe it—not just intellectually but deep in your bones. OK, that sounds goofy, but it's the truth. Once you grasp the possibilities freelancing offers, you will be more committed to embrace the stressful changes required to go freelance. It's scary, but it's worth it.

Understand *The Freelance Manifesto* and you will make better decisions in your freelance career. Part one explains the freelancer's dilemma: how your personal and career goals change over time, and why my approach to freelancing can help you overcome that dilemma. I'll also explain the catch-22 that keeps you from doing better work, and how you can overcome that obstacle. I'll show you the

opportunities open to you as a freelancer and dispel all the myths, so you can move forward confidently in your career. You really do need to fully understand why you are becoming a freelancer in order to reap all the rewards, and I want you to really get that before you move on to part two.

Part II: The Freelancer's Field Guide shows you how to do it. This is the step-by-step process with specific tools, templates, and examples. Freelancing can be a messy process, so I break it down into five phases to give you a framework that makes it easier to learn. I'll step you through every phase, and you'll learn how to introduce yourself to clients and get them to like you, trust you, come to depend on you, and hire you—over and over again.

I have to stress that none of this will work if you don't have solid Motion Design skills. That's the price of entry into freelancing. Make sure you have that side down. (I'm completely unbiased, but check out schoolofmotion.com if you need help with those skills.) You don't have to be a rock star—you'll get there over time—and once you have a solid base of Motion Design skills, you can focus on the business side.

I mentioned that this book is a bit of a Trojan horse. Well, here it is, the real reason I wrote it: This book is a call

to arms, my rallying cry to you to take control of your life—design it, own it, make it what you want it to be. I'll show you how to do it and remind you that with that knowledge and power comes the responsibility of using it properly. You will have to choose what is important to you. If your lifestyle, your family, getting out of debt, and buying a house are important to you, you can choose to do jobs that will move you closer to those goals. If your goal is to work six months a year and travel or work with nonprofits and do fun, creative work, you can choose to do that. Your goals can change from year to year. But you will always have that choice.

Freelancing is a big topic and can be daunting. When I teach daunting stuff, my philosophy is to use a funnel approach. I start at the wide end of the funnel, where the knowledge flows freely and it's easy to make progress. As you move down the funnel, progress gets harder, but I'll be right there with you, and you'll continue to move forward. You'll get some wins immediately. As the work gets tougher, I'll be by your side, and by the end of phase five, this whole freelancing thing won't be so scary. You might even find yourself sitting at your day job soon, fantasizing about the day you seize control and start steering your own ship.

Now, let's do this.

PART I

THE FREELANCE MANIFESTO

Please don't skip this part of the book. I know you're eager to get to *Part II: The Freelancer's Field Guide*, but if you skip this part, you'll miss the whole reason for freelancing. Hint: It's not about the money.

CHAPTER 1

THE FREELANCER'S DILEMMA

Working on staff can be limiting for many reasons, but freelancing done wrong is just as limiting. You need to understand this now—before you waste one more minute of your time doing it the wrong way—so you can move forward, consciously making choices about how your life should be, instead of settling for the opportunities that are presented to you.

THE GOAL

When you're a full-time Motion Designer working for a studio, there's only one direction to move as far as your career goes: up. You climb and climb and climb to the next level. You get there, and then you climb some

more. In contrast, freelancing is an infinite playground, crisscrossed with dozens of roads, and you choose the road you wish to take. You can go down one road for a while and then jump to a different road. You can even go *backward* for a while. The road you take is determined by your goal, and the first step in *The Freelance Manifesto* is to think about your goal. Your goal may be different depending on your age, and it can change at any time. If you're working on staff, you're locked into one goal—the one set by your employer—and it's nearly impossible to reach your own changing goals. You can overcome that dilemma with freelancing.

Say you're twenty-three, single, and right out of school. You want to work for a top studio in New York City or Los Angeles, doing the coolest stuff out there. Working at a major studio is a full-time job that demands working long hours on a salary. The top studios are in big cities with high costs of living, and you won't be making a ton of money initially. Let's say they start you at $55,000 a year. Sounds great, right? Well, fifty-five grand is not a lot of money in New York City. You won't have much disposable income, and God forbid you have student loans. (UGH. *F*** student loans.*) Knowing that, if working for a top studio is still your goal, how do you get there? Better yet, how can you do work for a major studio and make good money at it, work only when you want to work, and

live wherever you want to live? As a freelancer, you can have that goal.

Or say you're thirty-four, and you have a family and a mortgage. That's the position I found myself in. I still wanted to do creative work, but I wanted to get paid more. I wanted to be done at five o'clock so I could cook dinner on the grill for my family, do baths and bedtime with the kids, then hang out with my wife—and not think about work. That was my goal.

Maybe you're forty-six, the kids have moved out, and now you just want to pay off your mortgage. How do you go from making $70,000 in one year to making $200,000? If you work for a studio, you can't. You can't have that goal.

If you're on staff at a studio, you can't choose the work you do, control how much you work, or have any sway at all over how much money you make. You've relinquished control of those things and, ultimately, your personal lifestyle goals to the studio. And the boss probably wants your butt in a seat in the studio every day from nine to five. He's paying for your butt to be there. You could be doing cooler work, or hanging out with your family, or making more money, but you're on staff getting paid to sit in that seat until five o'clock. You have no work choices, time choices, or money choices. With all that said, there

are times when you really just want a staff job. You're young with no experience and you REALLY need a steady paycheck, or you need to be around and learn from more experienced people. It's a trade-off that sometimes makes sense. But it's a trade-off.

Freelancing gives you the authority to make those choices. Whatever your goal, you need flexibility to achieve it. Being on staff, you give up that flexibility in exchange for the illusion of security. That is the dilemma: not having the authority to make the choices you need to make to achieve your goals.

THE CATCH

Fun fact: Many Motion Design gigs aren't very exciting. An example might be animating a logo for a pharmaceutical company that's introducing a new drug to reinvigorate your man parts. Nobody sets out on a career in Motion Design to animate that logo. But it pays well, and someone has to do it.

In the Motion Design universe, big companies with large budgets also tend to want more creative control over the product. Smaller brands tend to be less controlling and open to more interesting work, and nonprofits often get the best Motion Design work because they have no money

at all. They can't afford to tell the Motion Designers what to do, so they throw themselves on the studio's mercy. The studio will do the work with the caveat that the non-profit has to relinquish creative control to the designers. That's where some of the best work comes from. When clients have a lot of money to spend, they want to put their thumbprints on the work, but they are not designers. The studio loses creative control, and the final product is not very good.

If you work on staff for a midlevel marketing agency, you will seldom get an opportunity to do your best work. That's one reason it's hard to improve and progress as a designer working on staff—unless you happen to work at a top studio, in which case, CONGRATULATIONS! You have an amazing opportunity to learn that most Motion Designers never get. As a freelancer, you can do better work, but when you're starting out, companies are not going to pay you to do that kind of work until you've proven yourself. That's the catch-22.

The best MoGraph companies in the world do expensive work for big clients that pay a lot of money, and they also do work for free for smaller clients that have no money. This allows them to remain profitable, while also doing work where they have a lot of creative control. They see this as an investment because their people are able to

improve their skills while creating an impressive portfolio to show clients. If you're on staff at a place like this, you might get to do some cool work AND be paid for it. Unfortunately, there are not enough companies doing this, and the majority of Motion Designers will never work for those companies.

Why doesn't every company do this? When you're running a business, it's hard to say no to paying clients. Businesses can't always afford to turn down paid work, take a month off to do better work, and build their portfolio in order to attract better clients.

Studios need to make tens of thousands of dollars every month to pay the bills. If you're a staff employee, your boss will not turn down paid work for a month so you can do something creative. He has bills to pay. That catch-22 was one of the biggest challenges we faced back at Toil.

Freelancing frees you from those financial bonds to some extent. As a freelancer, taking time off to work on your reel might cost you a few thousand bucks, and with no big office, no staff, and much lower expenses, that might be no big deal.

THE MORE CREATIVELY BANKRUPT A PROJECT IS, THE MORE MONEY THERE IS IN PLAY.
—DAVID LEWANDOWSKI, FROM *WONDERLAND*, DIRECTED BY TERRY RAYMENT AT ESKIMO FREELANCE.HOW/WONDERLAND

A BRILLIANT Artist named David Lewandowski taught me an important concept, and you need to understand it because it explains the *why* behind freelancing. He hints at this concept in the fantastic short documentary *Wonderland*.

"For me, the commercial space is very much about letting go of all of your vision, I guess, and giving people what they want. And not really, like, being precious about it.

"Because it's not cool. Like, whatever you're doing, it's not cool. No matter how cool it is, it's still a commercial, right?"

Over dinner one night while I was at Ringling, David elaborated on this point a bit and put it in terms that made so much sense to me, and I knew that I'd never approach work the same way. If you ever find yourself in a position to have dinner with David Lewandowski, move heaven and earth to do it.

I adopted his concept, turned it into a graph, and called it Pain and Rainbows. It depicts the correlation between the amount of money a job pays and the amount of creative control the client maintains.

In the simplest terms, the more money a client pays you, the more control they want, and the less creative the job's going to be. That is the "Pain" end of the graph. The less money a client has, the cooler the job. The project's budget can even be negative, where there is no client, no money, and you may be spending your own cash. That is where you can be the most creative, and that's often where your best work comes from. That's the "Rainbows" end of the graph. Some of the best work in Motion Design in the last decade has been these "passion projects" that individuals or studios have done, unpaid work where they had the freedom to create whatever they wanted: the Rainbows.

Now let's talk about the middle. The middle of the graph are jobs where there's some money and some creative control but not a lot of either. It's not the Pain where you're making a lot of money, and it's not the Rainbows where you're doing your best work. It's No Man's Land, and you have no good reason to be there.

Lots of freelance Motion Designers get trapped in No Man's Land. The money is just enough to sustain you, and the creative aspect is just cool enough that you don't hate yourself for doing it, but it isn't moving you forward creatively or financially. You're treading water.

When you're in Pain, you get a big paycheck. The paycheck is nice, but it's secondary to the real reason you want to do that kind of work. The paycheck affords you *time*. As a freelancer, that big payday gives you the freedom to start saying no to other paid work and using your time to create something on the other end of the graph, the Rainbows.

There in the Rainbows, you have total control. You can do exactly what you want, create your vision, and make something really cool that you would not have the opportunity to create otherwise. Those Rainbow jobs will get you noticed and move your career forward. Pain makes the Rainbows possible. Kind of sounds like a catchphrase from a 1980s cartoon, doesn't it?

Most of the work you do on staff is in No Man's Land. Companies are drawn to bread and butter. They want consistent work, and that comes from midlevel clients. There's a lot of competition for big-money jobs. Companies want those big-money jobs because it takes the stress off and pays the bills for a few months, but those jobs are tough to get. So, they pay the bills with middle-of-the-road, No Man's Land jobs.

Companies take No Man's Land jobs for the same reason people stay in staff jobs: fear. For a business owner, the fear is, if they don't take a middle-of-the-road paid job, the client will find someone else to do the job and never call them again. Word will spread around town that they're not accepting work, no one else will hire them, and they will go into a death spiral. They'll have to lay off all their employees and shut the doors. This isn't actually the case most of the time, but it's a persistent fear that any business owner can relate to. If you own a studio or are working on staff, and you don't do those No Man's Land jobs, you will have to remortgage your home, your wife will leave you and take the house and the kids, and you'll end up living in a van. That's the fear that keeps companies and their employees in No Man's Land.

Even companies doing millions of dollars in revenue every year have that fear to a degree. They fear the current job

is the last one they'll ever do. To split the graph and get to those two extremes, the Pain and Rainbows, they have to say no occasionally to work in the middle.

Motion Designers stay on staff, fearing that if they leave, their last studio paycheck is the last dollar they'll ever make. Freelancers have that fear, too. Your rational brain gets overtaken by your lizard brain, with primitive thoughts of fear and aggression and worst-case scenarios that take you all the way to homelessness. But freelancers have the luxury of low overhead, whereas companies don't. A big part of going freelance is coming to grips with the fact that, most likely, nothing bad is going to happen to you. If you're a half-decent Motion Designer and do what you're supposed to do, you are going to get booked, and nothing bad will happen at all. And if it does, it will never be as bad as your lizard brain would have you imagine.

Eventually, you may have to get out of your staff job to leave No Man's Land. If you don't, you will never be motivated enough to take your freelance career seriously. As long as you have that automatic paycheck going into your bank account twice a month, you will continue to make excuses that keep you from doing what you need to do. Leaving your job will give you that solid kick in the ass you need to move your freelance career forward. You have to leave your staff job to stay motivated to do great

work as well. When you're a freelancer, your reputation is always on the line. You have skin in the game, and the stakes are high. You're fired up about every job because if you don't do a good job, the client doesn't have to hire you again. There's a direct relationship between the work you do and your future with the client. On the other hand, if you're on staff, you get paid whether the work is great or not. You know that when you finish a job, there's probably another one right behind it. If there isn't, you'll still get paid for sitting in that chair doing nothing until the next job comes in.

As a freelancer, knowing your good work will provide you with repeat business is motivating. More importantly, you can exceed your client's expectations and improve your reputation in the marketplace. If you do a good job for a client, not only will they hire you again, but their employees, when they move to other companies, will also recommend you to their new studios. Staking your reputation on the work you're doing every day is enormously motivating. Your reputation is everything when you're a freelancer.

When I was at Toil, we did a boatload of advertising work, and one of our biggest clients was the ad agency for a well-known sandwich shop chain. The work was not sexy. Like a lot of advertising, it wasn't clever, edgy, or funny. It was

intended to make sure people knew the name and price of the sandwich that was cheaper that month. I wasn't excited about the work, but it was paid, regular work.

Initially, there was a feeling of relief every month when the work came in. It allowed me to pay the bills. But the budgets weren't life-changing, and the work was painful. The ad agency would ask for a bunch of crazy changes, and the head of the sub company always wanted to put his thumbprint on it. It wasn't creatively challenging, and I couldn't put it on our reel. It didn't pay enough to allow us to take time off for "spec"—free—projects either.

Eventually, I began to dread that work. Our company was treading water, not moving forward or backward, just stuck in the middle of No Man's Land. When you're stuck in the middle for too long, you start to get jaded about the work that got you excited about Motion Design in the first place.

The sandwich commercials were national TV spots that ran during *Monday Night Football*. One ran during the Super Bowl. Early in my career, I would have called my mom to let her know my commercial was coming on so she could see my work on TV. It was a big deal to me. Now my work was airing on national TV to millions of people. But after a while, it wasn't a big deal anymore because it

wasn't the work I wanted to be doing. Our profession is very cool, but sooner or later, the shine will wear off, and it'll just be your job. If it's not moving in the direction you want, it can be demoralizing.

I found myself getting a lot more excited over work that paid nothing but offered me complete creative control. That was when my company did its best work. On the other end of the spectrum, we did some extremely lucrative work for financial companies with huge budgets. Those jobs paid so much that it took the pressure off and made it easier to take on low- and no-budget jobs.

It was incredibly hard to maintain that balance as a company—doing work that spanned the entire spectrum—but it planted the seed for me, the realization that I had to stop doing sandwich ads and get out of No Man's Land. Suddenly, things started clicking and I had sort of an *epiphany*, as if that idea did something to my brain that got me thinking in a totally different way. It rewired me, really. This was big. The blinders were off. After leaving Toil, I took that philosophy with me as a freelancer.

The big paycheck jobs on the Pain end of the scale aren't particularly creative or artistic. Animating a pie chart with dancing numbers synced up to a voice-over about how to balance your portfolio is not what Motion Designers want

to do. That work won't end up on you reel, but it pays so much that it affords you the time to do other work that you *can* put on your reel.

Motion Designers struggle with accepting the fact that we're doing commercial art. If you're working on an animation for a gigantic bank, the bank doesn't care that you're an Artist. They care that the logo is big enough and that it's the right color. They care if they can squeeze four pages of legalese at the end of your video. It can feel gross, and you might think the Motion Design business would be great if it weren't for the clients. Don't adopt that attitude. If you're getting paid to do work for a client, assume it's not cool. Accept that you're doing work for money, own it, and move on.

The long-term goal is to get out of No Man's Land and split your time between Pain and Rainbows. Why are you animating a pie chart? You're doing it to get a lot of money for a month of work so you can take the next month off to do the work you want to do. Accepting that concept is liberating because it gives you a *why*.

Freelancing is a way to get unstuck, own your time, and split it between Pain and Rainbows. You need to consciously choose Pain work and accept it, so you have time to do the Rainbow work. Time is far more valuable to you

than money. You can always make more money, but you can't make more time. To invest in yourself, the currency you need is not money but time.

Time is the freelancer's currency, and spending time in the middle of the graph making sort-of-cool work for sort-of-nice money is not going to afford you any time or move your career forward.

Let me reiterate: making money is not the primary goal. If you make a lot of money and keep getting the same projects you hate doing, your career won't go anywhere. Money is a tool that buys you time to improve your skills and do the kind of work that will get you noticed and bring you the work you crave.

Now, you might think that if you keep doing middle-of-road work, eventually your clients will wise up and bring you cooler stuff to do. The fact is, even if they have cooler stuff, they won't give it to you. They'll probably give it to someone who's already doing that kind of work—not you, their middle-of-the-road Motion Designer. Again, it's the catch-22. You need time to learn new tricks and build a better portfolio, and no one's going to pay you to get there. Once you have the time, and you get better, you will have a better reel and get better jobs. Once you get better jobs, you will have an even better reel and

get even better jobs. It's like a flywheel that keeps you moving forward.

At that point in your freelance career, you'll start getting hired to do more interesting work. Don't lose sight of both ends of the spectrum, though. You still need those Pain jobs, those moneymakers, but with your new-and-improved portfolio, you'll land better big-budget jobs. You'll also get better Rainbow jobs because your skills have improved. As your reputation grows, you'll get better clients at both ends of the spectrum.

When you get to that point, you're winning. Freelancing becomes an adjustable tool. For the times in your life when money is important, you adjust that tool and your time toward big-budget jobs. If you want to improve your skills as a Motion Designer, you can choose to do fewer paid jobs and concentrate on your reel. That Rainbow time does not all have to be used for work, though, and as you get bigger and better paying Pain jobs, you will have more Rainbow time to use however you want. You may want to work less and devote more time to your family, friends, or to yourself.

How you use your time is determined by your goals and your bigger *why*—basically, what you want to do with your life. For example, I have a friend—let's call him

Fred—whose goal was to pay off his house, so he chose to spend an entire year on the Pain side. He didn't care that the work wasn't particularly creative because he had made up his mind that his goal was to not have a mortgage. I did the same thing to pay for my wedding. You can't do that in a staff job, but you can do it as a freelancer.

> **I CAN SAY FOR PROBABLY ABOUT FOUR OR FIVE YEARS, I JUST TOOK THE MONEY JOBS. I WASN'T GROWING, BUT I WAS MAKING TONS AND TONS AND TONS OF CASH. WE HAD SOME PERSONAL STUFF THAT WAS GOING ON THAT WE NEEDED THE MONEY FOR, SO IT HELPED. IT HELPED OUT TREMENDOUSLY THAT I WAS ABLE TO DO THAT. I WOULDN'T HAVE BEEN ABLE TO MAKE NEARLY THAT MUCH MONEY HAD I BEEN AT A FULL-TIME JOB BECAUSE IT ALLOWED ME TO JUST SAY YES TO MORE THINGS.**
>
> **—ADAM PLOUFF, FREELANCER, BATTLEAXE.CO**

I have another animator friend named Kyle who's at the other extreme. He loves travel and snowboarding—that's his *why*—and he doesn't need hundreds of thousands of dollars to do what he wants in life. But he has reached that point in his freelance career where he can take on a few big-paycheck jobs at the Pain side of the scale, so he can spend lots of his time traveling, snowboarding, and doing work he wants to do at the Rainbow end. I'll

tell you more about Fred, Kyle, and some other people, their *whys*, and how they satisfied them with freelancing later in this book.

Initially, you won't start out with the magical ability to pick and choose the work that lets you meet your financial and lifestyle goals like my friends did, but you can get there and it's not as hard as you think. That's the end game.

CHAPTER 2

THE FREELANCE OPPORTUNITY

What's in it for me? That's what you want to know, right? You've gotten this far in the book, and you're still wondering what you have to gain from all this hoopla. Well, let me tell you.

MAKE MORE MONEY

The obvious and most immediate benefit of freelancing is that you'll make more money, and while money is not the goal, it will buy you more time and more freedom.

As part of my research for this book, the team at School of Motion conducted a survey of Motion Design producers, studio owners, hiring managers, and ad agencies and a

second survey of freelance Motion Designers. According to our survey of Motion Designers, the average freelancer made $91,000 a year, and 48 percent of them made six figures. That's more than the average salary of a seasoned staff Motion Designer and much more than the salary of a Motion Designer in the first five years of their career.

When I left my first job, I was making $38,000 a year, or $152 a day. When you freelance, one of your first clients is often your old employer. They still need Motion Designers and they like you, so they will often hire you freelance. They no longer have to pay for your health insurance and other benefits, and they're hiring you for the short term, so they're going to pay you a lot more. Overnight, you're doing exactly the same work, in the same room, in the same chair, on the same computer, for the same company but getting paid a lot more money. My day rate went from $146 to $500 a day. I more than tripled my salary as a freelancer working for my old company.

To be a successful freelancer, you need to get booked consistently, and this book teaches you how to do that. It should go without saying that you also have to do good work. If you do, you can effectively double or triple your salary when you go from a staff job to freelancing.

DO COOLER WORK

Working on staff, you're completely dependent on your employer to bring in interesting, creative work. Most companies rarely get that kind of work. They'd like to, but financially, it doesn't work. And it's not about greed: it's about reality. Businesses take on clients that become repeat customers, bread-and-butter clients that pay the bills, and you have to service them. It's not your place to tell them what you want to do for them. You do what they are willing to pay you to do, what they need to have done.

Unless your employer devotes significant time and resources to creating work for free, the odds of your getting challenging, creative work are slim. As a freelancer, you eliminate those barriers. You do not have the high overhead to worry about, so you can accept work that doesn't pay much or doesn't pay at all—assuming you've spent some time doing Pain projects.

As a freelancer doing jobs for smaller clients, you may be concerned that you don't have any big names in your portfolio. The fact is, it's not that important. Clients we surveyed said that while seeing a big name on a freelancer's reel may show them the freelancer is used to working at a demanding pace, it doesn't show them how good the Motion Designer's work is. Clients are more concerned with seeing good work, and everyone in this industry

knows the most interesting work is often not created for big-name clients; it's created for small clients, or for no client at all.

CHOOSE HOW MUCH YOU WORK

One fear of going freelance is the worry that you won't be booked enough. According to our survey, 41 percent of freelancers said they were booked all the time. Sure enough, within six months of going freelance, I was booked all the time, and eventually, I was turning down work. Freelancers regularly turn down work because they can't take on more, or they just don't want to.

As a freelancer, you get to choose how much you work. There's a caveat, which we'll talk about in chapter 3, "Free-lancing Myths," but you can—eventually—set your own schedule and work as much or as little as you like. The obvious benefit is work-life balance.

Don't expect this benefit to come right away. You should expect to put in more time initially as a freelancer. The learning curve for Motion Design is hard enough, and getting really good at what you do takes time. Learning how to manage projects and clients also takes time.

Imagine you're building a rocket ship for a client who

knows nothing about rocket ships. You show them the rocket ship, and they decide they want another window in the rocket, a really small change in their eyes. Of course, now you're going to have to remove the entire shell and move the engine somewhere else, and all the custom-made wiring doesn't fit anymore. To the client, it's a simple change because they don't know anything about rocket ships. Many clients don't know anything about Motion Design either, and they will ask you to make changes that can cost you a lot of time and grief, simply because they don't understand the implications of what they're asking. You can learn how to manage that process with the client, but it will take some time initially. You may have to put in more hours to get started. But as an employee on staff, you have to put in overtime, too. That's the reality of being employed. As a freelancer, the extra time you put in on the front end of your career diminishes over time, as you learn more and gain more control.

There's no such thing as two weeks' paid vacation for a freelancer. There's no paid vacation at all, but you can take a whole month off if you want to. When you think about it, it's crazy that most of us in the United States accept two weeks off a year as normal. There are fifty-two weeks in every year, two of them are yours, and fifty of them belong to your employer. When you go freelance, it's like the blinders come off, and you realize how insane that is.

We live in this awesome world surrounded by wonderful people we care about and get only two weeks a year—plus weekends, whoop-de-do—to enjoy them.

IT HIT ME ONE DAY THAT I'M SPENDING MORE TIME MAKING MONEY THAN I AM WITH MY FAMILY. IF THE WAY YOU USE YOUR TIME IS A SNAPSHOT OF WHAT YOUR PRIORITIES ARE, THEN MONEY WAS MORE IMPORTANT THAN MY KIDS. IT WAS STARTING TO FEEL LIKE A WEIRD SITUATION, LIKE A REALLY ODD USE OF A LIFETIME.
—DAVID STANFIELD, FREELANCER, DAVIDSTANFIELDIS.ME

Who made the rule that we have to work when someone else says we have to work?

When did we all relinquish control over our time and how we spend it—literally, our *lives*—to somebody else?

I don't remember agreeing to that, do you?

CHOOSE WHEN YOU WORK THROUGHOUT THE WEEK

Companies have regular hours, like nine to five or ten to six. That convention dates back to the late 1800s and early 1900s, when people worked in factories, and eight

consistent hours per day was deemed the most "productive" amount. That's right. You have to show up at the office at 9:00 a.m. because a hundred years ago, some car manufacturer decided that was the best hour to start the conveyor belt on the assembly line.

As a Motion Designer, you may not feel creative between 9:00 a.m. and 5:00 p.m. Your most creative time may be early in the morning or late at night, or it may come in fits and starts.

Does this ring true to you? Creativity is not like a faucet you can turn on and off. As a freelancer, I would sometimes wake up at four o'clock in the morning and crank out seven hours of amazing work. In three days, I could do more work than I did in a whole week on a nine-to-five schedule. The caveat is, to do that, you need to be freelancing remotely and not on-site at your client's office. Then you have the freedom to do creative work *when you are at your most creative.*

If you need a break, you can go for a walk or a bike ride and come back with a clear head. If you wake up hungover or burned out and you need a day off, you can take a day off. You don't ask for the day off; you just take it. Of course, you have agreed to a deadline for your client, and you need to meet it, but *when* you do the work is up to you.

> *FOR ME, FLEXIBILITY IS CRUCIAL. SOME DAYS I'M ABLE TO CRANK OUT TEN TO TWELVE HOURS OF WORK, AND THEN OTHER DAYS IT'S A STRUGGLE TO FINISH FOUR HOURS OF WORK. HAVING THE ABILITY TO BE IN SYNC WITH MY NATURAL PATTERNS HELPS A LOT. HAVING A POSITION WHERE I NEED TO SHOW UP FOR EIGHT HOURS EVERY SINGLE DAY WITHOUT A FINISH LINE BURNS ME OUT.*
>
> **—ANONYMOUS FREELANCER FROM OUR SURVEY**

That freedom can be a double-edged sword if you procrastinate because at some point, you're going to have to get the work done. That may mean occasionally grinding through it when you're not at your most creative. There are times when you need to make that happen as a freelancer, but when you're an employee, it's all the time.

When you're freelancing remotely, you've wrestled control of your time back into your own hands. You can work at your ideal times and create an ideal situation. Your work will be better, and you'll be happier. Your clients will notice the better work, and they won't care how you got it done. They only care that you did a great job for them.

CHOOSE WHEN YOU WORK THROUGHOUT THE YEAR

When you work on staff, you're on the same schedule as

everybody else. You go to the grocery store at 5:30 p.m., when everybody else is at the grocery store. You go on vacation over Thanksgiving, at the end of December, and whenever you can squeeze in a week during the summer. You travel when plane tickets are more expensive, hotels are more expensive, and everything else is more expensive. You stretch your flights from weekend to weekend to spend the maximum number of days on vacation, and you pay more for that, too, because that's what everybody does, and the airlines, hotels, and everyone else knows it.

When you don't fit into that system anymore, you can shop anytime, travel anytime, and do everything else you want to do whenever you want to do it. You get to enjoy the world outside of peak times, when everything is less expensive and less crowded. The first time you do this, you'll be stunned at how much cheaper tickets are, how empty the airport is, and how short the lines are for everything.

WE GOT [A] BIG SNOWSTORM HERE IN BOSTON. A COUPLE OF BUDDIES AND I WOULD GO OUT SNOWBOARDING IN THE STREETS BECAUSE WE HAD TIME DURING THE DAY TO BE LIKE, "ALL RIGHT, LET'S GO."
—KYLE PREDKI, FREELANCER, KYLEPREDKI.TV

Once you're a freelancer, you'll be ruined for the workplace forever. You'll go to the beach on Wednesday and have the whole ocean to yourself. You'll go to the airport on Tuesday, and there will be no line. You'll wonder why you didn't do this sooner. It's like being in a secret club.

CHOOSE WHERE YOU WORK

As a new freelancer, you may have to work in the client's studio at first. Once you're working remotely, you can work wherever you want.

When you don't have to show up at a studio, you don't have to commute. That may seem trivial until you stop commuting and realize how crazy it was to spend two hours a day in your car, on a bus, or on a train getting nothing done. Working at Toil in Boston, my schedule was tied to a train, and I gave up ten hours of my life every week to commute. When I later freelanced from home, I went from fifty to forty hours a week devoted to work, simply by killing the commute.

You can work other places, too. Some work can be done on a laptop, so you're limited by only your Internet connection. If you don't feel like working in your home office, you can work at the local coffee shop or the library. You can do a working vacation and work in the morning and

the evening, while the family's asleep, then hang out with them all day and enjoy your vacation.

According to our survey, about one-third of Motion Design freelancers work remotely most of the time, and that number will likely go up. The primary obstacle to working remotely is trust. When a company hires you to work off-site, the client can't look over at your screen and see what you're doing. She has to rely on you to get the work done and communicate with her regularly. Hiring a freelance Motion Designer to work remotely is only successful if the freelancer is responsible, sticks to deadlines, and hypercommunicates.

There are tools that make it easy to appear like you're working in the same room with the staff and encourage more trust from the client. While you're working inside of Photoshop or After Effects, sometimes it's useful to get quick feedback before you take that time-consuming step of rendering. When you're in the studio, you call someone over and they come and look at your screen. When you're remote, you can do the same thing by sharing your screen in real time using something like Skype, UberConference, or Screenhero. Frame.io and Wipster are useful once you've rendered a video. Sites like Slack, Dropbox, and Skype allow you to send large files, collaborate, and share your screen. (All of these tools are described in more detail in the appendix at the end of this book.)

As a successful freelancer, it's your responsibility to be current on and to become adept at these tools, so you can educate a client to allow you to work remotely. You have to understand, accept, and manage their fear, so they eventually come to trust you.

One advantage that may drive acceptance to hiring remote freelancers is the lower cost to the employer, an important factor given the competitive landscape of starting a Motion Design studio. Adding a full-time employee is expensive, but adding a workspace and a computer for a freelancer is also expensive. An employer might have to spend $10,000 for the hardware and software to accommodate an in-house freelancer.

A remote freelancer with their own space, system, and software presents very low overhead for the employer. If you're good at communicating, meeting deadlines, and doing good work, a client will come to trust you very quickly. Most freelancers, unfortunately, are not very good at working remotely. But you can learn to be good at it, and I will teach you how. Once you nail that, you will have more freedom to choose when and where you work.

ENJOY A POLITICS-FREE WORK ENVIRONMENT

To put it bluntly, when you're on staff, your professional

interests and goals may be in direct opposition to the company you work for. Because the company dictates the work you do, you have very little control over your career path.

Sometimes your career on staff goes in the wrong direction—not because you're doing a bad job or your boss doesn't like you, but because a company is like a machine. A machine is made up of different parts, and if you're currently playing the role of a certain part, removing that part can break the machine. The company is not going to break itself to make you happy.

I worked with an on-staff employee whose job was fixing hardware that broke down frequently. He also did some very simple Motion Design work like rotoscoping. Rotoscoping, if you've never heard the term, is tracing objects in a video frame by frame, so you can cut them out and manipulate them in a compositing app like After Effects. It is one of the most tedious tasks in the field and requires a fair amount of practice to get it right. Most Motion Designers don't like to do it, but *someone* has to do it. This guy was very good at it, but he didn't want to be a rotoscoper; he wanted to be an editor. He wanted to be one of the guys making creative decisions. But the company needed a roto guy, and allowing him to pursue his goal of being an editor

wasn't in the company's best interests. They just didn't need another editor at the time.

That's one example of office politics that will hold you back on staff. You're unfortunately so good at the job the company wants you to do that you will never be free to pursue your own career goals. In that situation, your only option for fulfilling your goals is to leave the company.

There are also typical office politics to deal with when you're on staff. You may not get along with everyone at work. Coworkers may try to undermine you, and your supervisor might be a jerk. As a freelancer, you'll have to deal with people like that occasionally, but it's a temporary situation, and that makes it easier to deal with. You can see the light at the end of the tunnel. You know that once you're done with the project, you will never have to deal with them again, and that makes it much more bearable. Office politics are irrelevant when you know they're short term and won't limit your future as a Motion Designer.

I've worked for people I didn't like and chose to never work for them again. Whenever they tried to book me again, I always seemed to be busy. It's a wonderful feeling, being able to choose your employer instead of the other way around.

CHOOSE WHOM YOU WORK FOR

About two years into my freelance career, I had a large client base and could regularly turn work down. Having too much work is a good problem to have. At the time, I was charging everyone the same rate, so that removed money as a consideration for whether I accepted work from a client.

But there are other aspects to consider when choosing clients, like the type of work you do and whom you do it with. For a while, I chose to work for a client doing a lot of great work for HBO and the Discovery Channel. They had a wonderful team, and I enjoyed working with all of them, but I had to work in their office, so I commuted for three months. The studio was a typical high-end, creative Motion Design shop, and I worked long hours and put in a lot of overtime. When there was a deadline, it was all hands on deck. After a while, I had had my fill of doing all that cool work with that great team. I didn't want to commute anymore. I wanted to get home earlier, spend more time with my family, and have less stress in my life.

I left that gig to work for a nearby ad agency that paid the same, doing easier work that was less technical and a lot less demanding creatively. It was a giant company with less supervision. I would come into this enormous machine, do my thing, and leave. The work was creatively

dull, but the situation was exactly what I wanted at that point in my life.

Getting to a point in your career where you can pick and choose your employers is empowering. Life comes and goes in seasons, and there are seasons when you want to make money and seasons when you want to feed your inner Artist. There are seasons when you need a break, too, and your clients play a role in that. When you're on staff, you don't have a choice, but as a freelancer, you can pick your clients to match your seasons in life.

I HAVE SAID NO TO SO MANY MORE [PROJECTS] THAN I'VE SAID YES TO. IT'S A GREAT PROBLEM TO HAVE. IT'S A BLESSING, AND I DON'T SAY THAT IN A COCKY WAY. IT'S CAUSING ME TO REALLY SIT BACK AND EVALUATE... STEP BACK AND EVALUATE WHAT AM I GOING TO SAY YES TO, AND WHY AM I SAYING YES TO IT.

—DAVID STANFIELD

BE MORE MOTIVATED

It's easier to show up for work every day when you don't have to. That may seem counterintuitive, but it's true. Knowing you can work when you want, where you want, and for whom you want makes a big difference in how

you feel about your job. Because you aren't locked into a long-term contract with a single employer, you never start to dread going to work. Even if you don't like a particular project, there's always a light at the end of the tunnel.

You can also take a break when you need one, and that will keep you motivated, too. You can finish a booking and start a new one, or you can say no to the next gig and take a whole week off to binge on Netflix. You won't get fired or lose your health insurance, so as long as you've budgeted for the time off, there will be no repercussions to worry about. Your attitude will be more positive, and you'll bounce back from low points quickly.

CHANGE YOUR LIFE

Going freelance is a life-changing decision. It's scary, exhilarating, and a little like learning to ride a bike. You're going to be wobbly at first and afraid to go fast, but once you get the hang of it, you'll have access to a whole new universe. Sadly, most people will never give freelancing a shot, even though they would have a much better quality of life. They could do work they care about and enjoy, spend more time with their families, and be more financially secure. But they will never freelance because they cannot overcome that fear of quitting their job. Some people think they're not "cut

out" for freelancing. Deep down, it's fear that's holding them back.

When I started freelancing, it was like discovering a secret that was right out there in the open, yet most people seemed oblivious to it. I still feel like that. Until you do it, you have no idea how transformative it is. Our education and corporate systems are set up like a funnel that points you toward being a W-2 employee working for someone else. Nobody tells you there's a way to get all the benefits without all the headaches. You don't have to show up from nine to five or settle for two weeks' paid vacation and an incremental raise once a year.

You don't even have to settle for what someone wants to pay you because as a freelancer, *you tell them what you cost*. Once you get the hang of it, you will wonder why no one told you freelancing is an option. Most people don't talk about it. I'm telling you now: It's an option.

Another interesting thing happens when you're freelancing. You show up at a company to do some work, and sometimes the people on staff look at you like an alien, a different species. Not in a bad way, but they do sort of envy you because you're making a lot more money per day than they are, and you can leave whenever you want. There are no shackles holding you down.

Companies know freelancing can be an amazing fit for people, but most of them want to keep their staff on salary in nine-to-five positions because it's easier for them to manage. I should point out that not all companies work this way. The best companies create environments that mimic freelancing. Their people are given creatively challenging work, opportunities to learn and improve, and some of the same flexibility you have as a freelancer. But those companies are rare.

Freelancing allows you to rearrange your work to match your life priorities. You can scale up to make more money or down to have more free time. You can work with people you enjoy being around or choose a shorter commute. The longer you freelance and the more clients you gain, the more options you have, and the more precisely you can design the life you want.

That's an alien idea to a lot of people, designing your life. You don't have to react to life or play only the cards you're dealt. You can sit down with a piece of paper and decide how many hours you want to work, how much money you want to make, and what kinds of clients you want to work with. You can draw a map of how to get there. It might take a few years, but you can design your life and live it. I truly believe you can.

IF YOU WANT SUCCESS, FIGURE OUT THE PRICE, THEN PAY IT. IT SOUNDS TRIVIAL AND OBVIOUS, BUT IF YOU UNPACK THE IDEA, IT HAS EXTRAORDINARY POWER.
—SCOTT ADAMS, *HOW TO FAIL AT ALMOST EVERYTHING AND STILL WIN BIG: KIND OF THE STORY OF MY LIFE*

Today, I live the life I designed five years ago, and I tweak it whenever I want to make a change. It's the life I wanted, and the map I drew to get here made it possible. But it didn't happen overnight. It took a long time for me to learn these lessons and overcome a lot of mental baggage. If you can get the cobwebs out of your brain and do what I'm telling you in this book, you will eventually be able to design your life, too. Isn't that a crazy idea, believing you could actually decide what you want to do with your life, then doing it? What a concept!

CHAPTER 3

FREELANCING MYTHS

You probably still have many fears about freelancing, and we need to talk about those. It's too easy to use those fears as an excuse to stay in your current situation. Therefore, the sooner we talk about freelancing myths and you understand how trivial they are, the sooner you will become comfortable with uncertainty so you can move forward with your freelancing life.

DEALING WITH UNCERTAINTY

You have to give up some things to freelance, including the security of being an employee. When you work on staff, it's your boss's job to worry about where the next project is coming from. If there is no project, he acts as a safety net, paying you a salary and benefits, even if you're sitting there twiddling your thumbs. As a freelancer, it's up to

you to find the next job, and there isn't always one out there, so you have to learn how to deal with uncertainty.

When there's no work, you don't get paid. There's nothing I can tell you that will make it easier for you the first time that happens. The phone doesn't ring for a week, and you have only one month's rent in the bank. Your friends will abandon you, and you'll probably end up homeless and addicted to crack. Except none of that will happen. You'll be fine. That's just your survival instincts kicking in, your lizard brain scaring the crap out of you. That's the part of your brain responsible for anger, rage, and fear, and it used to keep us from getting eaten by saber-toothed tigers. Being out of work for a month is not a saber-toothed tiger, and you'll survive. Over time, you'll develop a sort of callous over that lizard brain and learn to ignore that primal fear. You'll learn to manage your cash to weather the peaks and valleys of freelancing, and you'll develop a resilience to that uncertainty, so it will stop being so scary.

No matter how good you are, you can't control the market. If there's a giant crash like there was in 2008, you may have a slow month or two. But you're working in media or advertising, and businesses will always advertise. The market always comes back, and there will always be work. If you're good enough, and you're doing the things I tell you to do in this book, you're going to get work.

That is your mantra to get you over the humps, so you better believe it: *If you're good enough, and you're doing the things I tell you to do in this book, you're going to get work.*

Accept the uncertainty and deal with it. In *The 4-Hour Workweek*, author Tim Ferriss describes a brilliant technique for dealing with uncertainty that he refers to as "fear setting." Allow yourself to imagine the absolute worst-case scenario. This is different for everybody, but as a freelance Motion Designer, it might be that you never get booked again, you go completely broke, your Internet gets cut off, you lose your apartment, and you have no food.

What are the odds of it getting that bad? Not high—let's call 2 percent at the most. If there's a one in fifty chance of the phone never ringing again, then you shouldn't be losing sleep over it. But you might be thinking, *What if it happens anyway? What if I'm that one in fifty?* Let's think about what you can do to avoid that awful fate. You could get a job. You had one before; you could get one again. No apartment? Couch surf at your friends' apartments or move in with your mom and dad for a few months. They have Internet and food. It is not likely that a few weeks with no work is going to leave you homeless, offline, and starving to death. You'd be fine, with your ego a little bruised, and you'd move on with your life. Doesn't sound so bad, does it? And that's the WORST scenario.

This worst-case scenario is unlikely to happen, and even less likely if you follow my instructions. Personal finance is beyond the scope of this book, but needless to say, you should be smart with your money and keep a cushion of a few months' expenses to protect yourself in case of slow periods. But those slow periods will come less frequently than you think if you're applying the lessons in part two.

YOU CAN'T REALLY "JUST GO SURFING"

The second part of dealing with uncertainty is how you spend your time when the work's not coming in.

WHEN NO GIGS ARE COMING IN, IT'S EXPENSIVE TO HAVE SPARE TIME.
—ANONYMOUS FREELANCER FROM OUR SURVEY

When work slows down, you might feel like you can't just go on vacation. You won't have a good time because you'll have to spend a lot of money on a vacation, not knowing when you're going to get paid again. You won't have fun spending that money. The lizard brain fear will creep in and ruin your vacation. It's a vicious downward spiral.

Be patient and ignore that voice in your head telling you you're never going to work again. Trust in the fact that

people hired you once, you did a good job, and they will hire you again. It may take a little while, but as long as you actively manage your freelance career, you'll get work, and once you internalize this deeply, you won't be as afraid to let loose on your next trip.

You need to know this immutable law of freelancing: If no work is coming in and you book a trip, the phone will ring, and the work will come in after you've booked. Even if you've booked your vacation ahead of time—when the work *was* coming in—you will still probably get that call right before you begin your travels. At that point, you can either cancel your vacation and take the work—bad idea—or explain to the client that you can't do the work, which isn't as big of a deal as you might think.

[WHEN I TRAVEL] I LET EVERYBODY KNOW LIKE, "HEY, GUYS, I'M GOING TO BE AWAY." I MAKE SURE THAT MY OUT-OF-OFFICE RESPONSE WAS ON GMAIL. I WAS LIKE, "I'M GOING ON VACATION, AND IN AN EFFORT TO HAVE A REAL VACATION, I'M NOT GOING TO BE CHECKING MY E-MAIL. SORRY. SEE YOU IN A FEW DAYS." I ACTUALLY GOT SO MANY POSITIVE RESPONSES FROM CLIENTS BECAUSE... THEY THOUGHT THAT WAS JUST REALLY REFRESHING THAT I WAS BEING HONEST ABOUT IT, THAT I'M NOT GOING TO BE ANSWERING YOUR E-MAILS RIGHT NOW.

> *THAT'S THE ONLY WAY THAT I WAS ABLE TO DO IT, WAS JUST PUT MY FOOT DOWN AND SAY, "THIS IS TIME TO TAKE A VACATION. I'M NOT GOING TO MAKE ANY MONEY, BUT THAT'S OK." BEING A REAL HUMAN IS MORE IMPORTANT.*
>
> —ADAM PLOUFF

Again, if you're actively managing your freelance career, you can turn down work and go on that vacation. You have to manage the fear and deal with the uncertainty. That's the small price you pay for being a freelancer.

YOU CAN'T WORK FROM THE BEACH EITHER

Sometimes you actually *can* work from the beach. For certain work, all you need is a laptop and After Effects, so it's plausible that you could do your job spread out on a towel with the sand between your toes.

The main problem with working from the beach is that as a freelancer, you need to be hypercommunicating with your client. If you want them to dream about you at night and write ballads about you by day, you need to answer e-mails instantly. You need to upload work for your client when you told them you would.

TO WORK REMOTELY, WE NEED INSTANT RESPONSES TO E-MAIL. NO EXCUSES ABOUT TIME ZONES OR WI-FI SIGNAL. BE AS RELIABLE AND PROMPT AS YOU WOULD BE IN STUDIO.
—ANONYMOUS PRODUCER FROM OUR SURVEY

As a freelancer working remotely, you need high-speed Internet, and it has to be reliable and fast because you're often moving big files around. Even if you're in a major city and have a good mobile hotspot, your connection may not be reliable, and you don't want to stake your job and reputation on slow Internet. At some point, working on a laptop is going to slow you down, and being slow as a freelancer is not an option. You're going to need to be at your desktop computer to do a lot of the work.

Accept that you need to split your time between surfing and working, and don't try to combine the two. It's a myth that you can get your best-quality work done while you're actually having fun. The work won't be your best, and you won't really be having that much fun. If you're on the beach, is your brain focused on the work you're doing for a paying client? Are you putting your best into work that's going on your reel? Or are you distracted and operating at 50 percent capacity? Your client—and your reel—deserve better than that. And you deserve a day on the beach without your laptop.

Those same problems can come into play when you work from home. Remote workers are initially excited about working from home and the idea that you can wake up, roll out of bed, and start working. In reality, it's harder to collaborate with people because you can't just turn your head and see what your coworkers are doing or ask them to look at what you're doing. There are a lot of technologies that make it easier, but there are still challenges. There are distractions, too. You may be able to work from home if you live by yourself or have a separate workspace, but it becomes impossible the second you have children.

Motion Designers need to concentrate for hours at a time. Children don't care about your powers of concentration. They want hugs, and they're super cute. You love them. The minute they toddle over and put up their arms, you're distracted, and you've lost your concentration. That After Effects comp with two hundred layers you're working on requires total focus, and if that focus scatters for even a moment, you've set yourself back at least twenty minutes because you need to be back "in the zone" to work on it. This phenomenon is called context switching, by the way, and it's a doozy if you don't protect against it.

So, once you've hugged your kids and handed them off to your spouse, it takes about twenty minutes to get back to where you were before you got distracted. If you're

distracted four times in one day, that's eighty minutes lost. It's horribly inefficient to work from home when you're regularly interrupted, and it's not just children that distract you. Your spouse, girlfriend, boyfriend, or roommate might interrupt you. They don't mean to, but they see you sitting there in your underwear and think, *I'll just say hi and see how it's going.* And you just burned twenty minutes.

Working from home may not be as great as you expect it to be. I tried it for a while, then moved into an office space with no distractions. I got my work done more efficiently so I could go home and enjoy my lovely family.

If you live alone and want to work from home, you still need to separate your life and your work. If you're eating dinner and thinking about work and your computer is right there, it's too tempting to spend two hours working instead of enjoying your dinner. Separate your work environment and home environment, and you will get more work done and be happier, too.

BUSINESS HASSLES

As a freelancer, you need to deal with cash flow. That sounds like a very "businessy" term, but what it means is simple. Cash flow is the money coming into and going out of your bank account.

When you're on staff, cash flow is predictable because you get paid every two weeks or twice a month. It's easy to budget when you know that every two weeks, X dollars will be inserted into your bank account. You can count on that money being there. Once you freelance, that luxury goes away. When you do a job for a client and send them an invoice, they may not pay you for a long time. Companies usually pay "net 30." Net 30 means that, in theory, they will pay you within thirty days. In practice, they usually pay you on the very last day, day thirty.

Some clients pay freelancers net 45. If you go from being a freelancer to opening your own studio, you may have to deal with clients that pay net 90, and some gigantic clients even pay their invoices net 180. That creates a cash flow problem where you've done work and know you're going to get paid, but you don't know when. In the meantime, you have bills to pay, the rent is due, and you're out of diapers. You have to start managing your finances at a higher level because it's not all that uncommon to be owed five figures' worth of invoices from your clients.

All businesses have to deal with cash flow. For a free-lancer, it can be a big hassle. Freelancers get into trouble by spending money owed to them before the money's in the bank. This book is not an instruction guide for managing your finances, but know that cash flow can cause

problems if you don't manage your money. There are loan programs for freelancers, and you can consider that as an option, but basically, you need to know how much is coming in and going out and not count on that paycheck being deposited in your bank account every two weeks.

Dealing with contracts can be a hassle, too. When you're an employee, you don't worry about your employer's contracts with clients. Freelancing requires you to deal with client contracts, such as work agreements that clients want you to sign. You may also have your own contracts that you want the client to sign, where you define the terms of your work. There are important questions to consider when you create a contract. For example, how many rounds of revisions are you willing to do? What sort of benchmarks and goalposts are you setting for the job? What are the job's parameters? What happens if the client asks for one thing, then changes their mind, and you have to do a lot more work? To deal with business contracts effectively, you need to know how to talk to clients about work parameters and possible issues, and you need to know how to not get screwed over.

Another business hassle you have to manage is sales and marketing. When you're an employee, someone is out there getting all the gigs for you. When you're a freelancer, you're getting your own gigs. You're doing all the sales and

marketing. That part of freelancing is a gigantic fear for Motion Designers, and that's why I spend a lot of time in this book showing you exactly how to do it.

NO MATTER HOW BIG OR HOW COOL OR AWESOME A PROJECT IS, WHEN IT ENDS, AND I GET PAID FOR IT, IT'S OVER. NOW I STILL HAVE TO GO OUT AND GET MORE WORK. THERE IS NO ONE SINGLE PROJECT THAT IS GOING TO SEND ME AND MY FAMILY OFF INTO A GOLDEN SUNSET OF NO MONEY TROUBLES EVER AGAIN.

IT TOOK ME...SIX OR EIGHT MONTHS INTO FREELANCING, I THINK, [BEFORE] I HAD THAT REALIZATION, WHERE THERE'S ALWAYS GOING TO BE THIS CYCLE OF GETTING REALLY EXCITED ABOUT A JOB, GETTING INTO IT, DOING IT, FINISHING IT, SHARING IT ONLINE, WHATEVER, GETTING PAID FOR IT, AND IT'S NEVER GOING TO GO AWAY. THEN THERE'S GOING TO HAVE TO BE SOMETHING ELSE AFTER THAT.

—DAVID STANFIELD

Before we go any further, let me just define *sales* as the art of telling people what value you can bring to them. That's all it is. It's not cold-calling. It's not showing up with a briefcase at their office and asking to speak to the owner. Sales is just the way you let a potential client know that

you have something to offer them and that it's something they're already paying other people for, so it's not like they don't need it.

If you've never done sales, it can seem icky to sell your art, but the harsh reality is, if you don't, no one will buy it. To be a professional Motion Designer, you have to do sales and marketing, but it's not hard or icky, and I'll show you exactly how to do it.

So now you know why I'm so jazzed about freelancing and why I believe—I *truly* believe—every Motion Designer should try it. I've told you the good, the bad, and the ugly, and you should understand by now that freelancing isn't all sunshine and puppies, but it's pretty damn great. You want to know how to do it? I'm going to tell you what you need to know right now in *Part II: The Freelancer's Field Guide*.

PART II

THE FREELANCER'S FIELD GUIDE: FIVE PHASES OF YOUR FREELANCE CAREER

Becoming a freelancer can be scary. There's a lot to learn, and it can be overwhelming. There are five phases to this covered in *The Freelancer's Field Guide*, and I'll lay them out for you and make it easy. Yep, I know. "Five easy phases" sounds like an infomercial, but I split things up into five phases because I want to give you a framework to follow that makes sense, is easy to understand, and gives you quick wins. You'll be able to get through each phase in succession without too much trouble and see progress. It's not scientific—just a convenient way of organizing the information for you.

This book gives you most of the business knowledge you need to be successful, and no previous business experience is required. What isn't covered in here, you don't need to know right away—or maybe ever—to freelance, but if you do, you can do more research on any particular subject. For example, I'm not going to go into tons of detail about whether you should set up an LLC because there are experts out there who can help you with that, although I will give you my opinion on the matter. Instead, we'll spend a lot of time on sales and marketing, which is going to be more important to you starting out and is the biggest sticking point for freelancers.

You'll learn how to build awareness, then likability, then trust, and then confidence in a systematic way. *But why not just wing it? Why do I need a system?* Well, because it's scary as hell to e-mail someone you don't know and ask them to pay you money, so I'll show you how to do that without feeling gross about it.

If you're looking for a quick-and-easy plan to Motion Design fame and riches, put this book down because there is no magic bullet. Nothing will turn you into a six-figure-always-booked freelancer overnight, but I'll show you that it's possible and not as difficult as you might think. Let's get to work.

CHAPTER 4

PHASE ONE: I KNOW YOU

There are a lot of clients out there who need a Motion Designer, but how many of them know about you? Hopefully, it's obvious that people won't hire you unless they know you exist. The reason I dedicate a whole chapter to this subject is because so many freelancers put up a reel on Vimeo and then sit by their e-mail waiting for the clients to just start rolling in. It doesn't work that way, and so, in this first phase, you'll learn how to introduce yourself to prospective clients and let them know you're a freelancer and available for hire.

The goal of phase one is *really* simple: inform a potential client of your existence. That's it. Seriously. Once you do that, you're on to the next phase. But how do you accomplish this in a smart way?

Gird your loins. You're about to do something that makes you a little uncomfortable. You're going to e-mail people you've never met. Sweet. Fancy. Moses. Feel those butterflies in your stomach?

But first, you need to find the right companies and the right contacts to send those e-mails to. Are you worried about bothering people with your e-mails? Keep reading.

MOST COMPANIES HAVE TROUBLE
FINDING FREELANCERS

Why does e-mailing someone you've never met and asking for work feel icky? It's because you think you're nagging them, being "salesy," or you're afraid they'll reject you in favor of the hundred other, more talented freelancers they already have on their roster. Get that nonsense out of your head right now. In our survey, we asked producers and studio owners if they have trouble finding freelancers. About four out of five responders, 82.3 percent, said they do have trouble finding freelance Motion Designers.

Think about that for a second. You might assume that with all the great work being done, there must be many more talented Motion Designers than projects for them to work on. Fact: It ain't so, and the strange truth is that unless you're trying to get in at well-known studios, you're in a seller's market. Clients need you. They're excited when a new freelancer contacts them. Your e-mail is a ray of sunshine on an otherwise bleak day. There's nothing icky about being that ray of sunshine in a client's e-mail inbox.

I READ ANY E-MAIL THAT I CAN TELL
IS FROM A FREELANCER.
—ANONYMOUS PRODUCER FROM OUR SURVEY

MAKE CONTACT WITH THE RIGHT COMPANY

There are, broadly speaking, two categories of clients that need your services. "Starter gigs" include clients on places like Craigslist or UpWork, and they typically have a budget of less than $5,000 per project. You should only consider contacting those clients if you have absolutely *no* experience and *no* reel or portfolio, and frankly, if that's your situation, you may want to get a full-time job for a year so you can get some experience and a reel. Freelancing from scratch is not recommended, but if that's your situation and you really want to give it a go, starter gigs give you an opportunity to do some freelance work. They almost never pay you what you're worth, but they give you an opportunity to create some Motion Design for your reel to show other clients. Starter-gig clients might become references—or even bigger clients—someday, but don't count on it. Another advantage of taking on starter gigs is for the business experience of managing clients, responding to client e-mails, working with deadlines, sending invoices, and getting paid. Think of them as practice for the real thing, though, because starter gigs aren't going to pay your bills for very long.

If you have some experience and a reel, skip the starter gigs and go straight to the "real gigs." Real-gig clients include Motion Design studios, postproduction houses, advertising agencies, marketing companies, cable and

broadcast television networks, and direct-to-client work. Focus on companies with higher budgets—a minimum of $5,000 per project and much higher whenever possible. To be clear, the budget isn't what *you* get paid as a free-lancer; it's the total dollar amount your *client's client* pays *your client* for an entire project, so $5,000 for a project budget is *really* low, but it's enough to pay you a day rate for a few days. If a client is bringing you projects where the budget is less than that, they generally won't be able to pay you a day rate long term, so it's probably not going to be worth it for you to invest your time with that client.

A great place to find real work is direct-to-client work, an area of freelancing that's growing fast and has opened up a new world of opportunities to Motion Designers. Traditionally, a client would go to an ad agency or other third party for Motion Design work. That's what PTC, a technology company in Massachusetts, used to do. PTC is a huge software company that makes, among other things, 3D CAD software. They would tell their ad agency they needed a video and give them a huge retainer, and the agency would put an art director, creative director, and copywriter on it and hire a studio or freelancer to do the Motion Design work.

A few years ago, PTC got rid of the ad agency and added an in-house video department. They cut out the middleman,

and now it costs them much less to produce videos. They have more creative control, are nimbler, and can execute more quickly. This model has made its way to Google, Apple, Airbnb, Amazon, and thousands of other businesses that used to have an extra layer between you, the Motion Designer, and them, your client.

Businesses are always looking for ways to be leaner, and for companies that require a lot of video for training, marketing, and advertising, skipping the expensive outsource model to bring the work in-house is one way to cut costs.

Who benefits? Freelancers benefit, that's who. Companies that bring production work in-house tend to have less expertise in Motion Design, at least initially. As a freelancer, you have an opportunity to go beyond just doing the work; you can become the go-to expert for work outside the client's scope of expertise. And although freelancers cost more per day than employees, we are still a great deal for the company. When you bake in health insurance, Social Security and employment tax, benefits, hardware, software, and office space and utilities, plus the cost of paying an employee whether or not there's work to do, hiring freelancers is a very appealing alternative. There is a lot of direct-to-client work out there that didn't exist ten years ago, and that's one reason there has never been a better time to be a freelancer. Between

studios, postproduction studios, Motion Design boutiques, ad agencies, marketing firms, and direct-to-client work, there are many, *many* opportunities out there for real freelance gigs.

Check out episode 11 of our podcast to hear me interview Chris Do about this exact subject. Chris is the founder of Blind, an incredible shop in Los Angeles that has produced killer work for decades. He admits that this trend is tough for companies but an amazing opportunity for freelancers.

You can listen to the episode here: freelance.how/chris.

FIND THE RIGHT PEOPLE AT THE RIGHT COMPANIES

It's the right PEOPLE—actual living, breathing human beings, not faceless companies—you are looking to contact. Your goal is to contact the people who can hire you at the right companies that are looking for someone like you.

Start local. It might be tempting to reach out to Buck in New York City and try to get on their radar. However, if you live in Ohio and you're not an experienced freelancer, the odds of getting a gig from a top-shelf company in another state are very small.

There are a lot of advantages to starting local. You're more likely to get a response from someone in your area, and when you do make contact, it's easier to make a personal connection because you already have something in common. You can talk about sports teams, the weather, and local places, events, and activities. Also, when you first start out, freelancing may not involve working remotely, and you could be working in-house, which requires you to be within commuting distance.

HERE'S HOW TO FIND THEM

For this example, we're going to pretend we live in Cleveland, so we're targeting producers, executive producers, creative directors, and art directors at companies there. We want to contact people with those titles, in that order. If you can't find those people, settle for editors, video or media specialists, and even Motion Designers on staff. We're looking for those titles at studios, ad agencies, marketing companies, media companies, postproduction companies, and even product companies (more on that later). The point is that we aren't just looking on Craigslist or other job boards for work; we're actively seeking out, selecting, and *targeting* the best potential clients we can find. We're being proactive about whom we want to work for, instead of reactive.

OK, so watch me do this, and then I want you to try it. You'll see how easy it is and that it works.

In broad strokes, I'll use Google and LinkedIn to find the right companies, and then I'll use LinkedIn and company websites to identify specific people or *contacts* at those companies. The end goal is to get an e-mail address and make contact with that person.

By the way, you can actually WATCH me do this exact thing by heading to freelance.how/cleveland.

I'll start by Googling "Cleveland Motion Design." Pretty simple so far—and by the way, this works in almost any city. You can also try "Cleveland MoGraph" or "Cleveland Animation." Try different search terms to see what pops up. If you live in an especially small place, you may need to search in the closest medium-sized city to you.

Several companies show up in the search results, along with job boards like Indeed.com and Monster.com. We'll avoid those for now and focus on the companies.

24 Motion Design Agency - 24motiondesign.com
[Ad] www.24motiondesign.com/Motion-Design ▾
Creating The Best Animation Video Creative and Experienced Team !
Types: 3D, Animation, Flat Design, Infographic, Motion Graphics...

 Contact us USA social media 2014
 Kite explainer video The Apple timeline

Motion Design - We Design Videos Customers Love
[Ad] motion.propointgraphics.com/ ▾ (347) 754-5167
Let's Team Up. See Work Samples Now
Stay on budget · Great for professionals · Trusted by top brands · Premium visuals
Product Demo Videos · Branding Creative Design

Motion Graphics Jobs, Employment in Ohio | Indeed.com
www.indeed.com/q-Motion-Graphics-I-Ohio-jobs.html ▾ Indeed.com ▾
Jobs 1 - 10 of 26 · 26 Motion Graphics Jobs available in Ohio on Indeed.com. one search. all jobs. ...
Cuyahoga Community College - 113 reviews - Cleveland, OH ...

Motion Graphics Design gives energy to your presentation.
collisioncommunications.com/Motion_Design ▾
Collision provides Motion Graphics Design including 3D Modeling and Holographic Illusions for videos,
meetings, exhibits, websites and multimedia apps.

Motion Graphics Cleveland | Marketing Animation | thunder::tech
www.thundertech.com/services/multimedia/motion-graphics ▾ Thunder Tech ▾
Our team has produced engaging videos consisting entirely of motion graphics, animation,
infographics, music and voiceover to help illustrate what a business ...

Motion Graphics Designer Jobs in Cleveland, OH - Cleveland Motion ...
www.monster.com/.../q-motion-graphics-designer-jobs-I-cleveland,-oh.a... ▾ Monster.com ▾
Find Cleveland, Ohio Motion Graphics Designer jobs and career resources on Monster. Find all the
information you need to land a Motion Graphics Designer job ...

Triplet 3D - Architectural Illustration, Rendering, Visualization ...
www.triplet3d.com/ ▾
Triplet 3D are specialists in the multi-disciplinary arts of 3D Visualization, Animation, and Motion
Graphics.

Classic Style Transducers | Cleveland Motion Controls
www.cmccontrols.com/classic-style-transducers.shtml ▾
Cleveland-Kidder's current product offering, the Ultra line, utilizes a full-bridge semiconductor strain
gage design. The Classic line is still available and supported ...

If there are studios in the area, they'll appear in the search results, along with marketing firms, ad agencies, video production companies, and anyone else who advertises Motion Design services. Here's one that looks good: Collision Communications. It even says in the search result, "Motion Graphics Design gives energy to your presentation."

Motion Graphics Design gives energy to your presentation.
collisioncommunications.com/Motion_Design ▾
Collision provides **Motion Graphics Design** including 3D Modeling and Holographic illusions for videos, meetings, exhibits, websites and multimedia apps.

But just to confirm, let's check out their website. Once we click through to their site, we see a link for *Services*, which is common on sites for production studios and marketing firms, and lo and behold, Motion Graphics Design is right there.

3D modeling and motion graphics design
bring life to static content

Clients who want to take their project to the next level may choose to visually engage their audience with 3D and Motion Graphics Design. These animated graphics move your content and bring energy to your video, speaker support, websites, and multimedia applications. Impact's animators and editors bring still photographs to life, give logos motion with special effects and create 3D models of your products. Scenery is added to a video and text graphics become part of the story in a visually compelling way. You want motion graphics that make multimedia production slick and contemporary. Impact will provide you with the visual effects to capture your audience's attention and help them to retain your message long after the showing. Impact produces Motion Graphics Design for:

- Videos
- Speaker Support
- Websites/Social Media
- Multimedia Programs
- Exhibits
- eGreetings

Pretty slick. Even better, we know that four out of five companies have trouble finding freelancers to do Motion Design, so there's a very good chance this company would love to hear from us, local Motion Design freelancers that we are. We can click on *Work* or *Portfolio* and see if their work is the kind of work we do. Is it within our skill set, in our wheelhouse? Or is it beyond what we can do? (Head over to School of Motion if that's the case for you. Just sayin'...) After looking at their work, I think we'd fit right in there and be able to offer a ton of value to this client.

Next up, we need to find the right person to contact. So, obviously, we should go to the *Contact* page and use the convenient contact form they've set up because that's clearly how they want us to contact them. Actually, that's

usually the worst way to contact a company because there is a slim chance in hell that the message will get to the right person. More likely, it will go to the sales department, and they don't want to talk to you or take the time to forward your message, so they'll just delete it. E-mailing a generic *Contact Us* inbox is not a good strategy for us freelancers to reach the right person.

Instead, it's time to do a little snooping. If I click on the *About* page and then go to *Our Team*, we can see the names and photos of everyone at the company, along with their job titles. Jackpot!

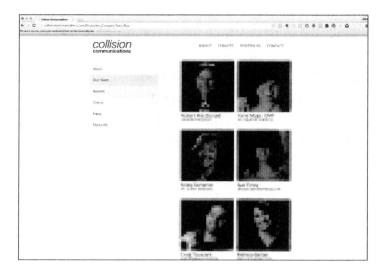

The photos and names have been blurred in my image to respect the privacy of these individuals, but it's important to remember that the information we're gathering is publicly available. If you follow along, you'll find this website and these people just as I have, and the fact that many companies have *Our Team* pages should tell you something about how worried they are about being contacted by freelancers. (Hint: They aren't worried AT ALL.)

These days, many companies have a page like this on their site, which is very helpful for identifying the right contact. Look for the titles I mentioned earlier: producer, executive producer, or anyone who makes or influences hiring decisions. While you're at it, look for the Motion Designer. If they don't have a Motion Designer on staff,

but you see Motion Design in their work, they're hiring someone else to do it, probably freelancers.

Ideally, we want to start with the producer as our first contact because she's the person most likely to get us in the door. Later in this chapter, I'll show you how to get the producer's e-mail address, but even if we can't find her e-mail address or if she doesn't read our e-mail, we can go to the next best title on the *Our Team* page. If we have to contact someone low on the list of titles, we can just ask them who it is we should be contacting, and they will usually help us out.

I'm going to take you on a little detour here. Don't worry, we'll be back soon. I really am going to show you how to get the producer's e-mail address. Bear with me.

So, what happens if a company doesn't have an *About* or *Our Team* section, and you can't find out who their team is very easily? Lucky for us, a lot of studios post examples of their work, with credits, so you know who worked on each piece. Check out Buck's site at Buck.tv, and I'll show you what I mean. (Interestingly, Buck now lists freelancer opportunities under its *Jobs* menu, so check that out as well, but keep in mind that most companies don't advertise for freelancers.) In any case, I click on the link that says *Portfolio*, which leads to examples of their

work. There's work on the site that I *can't* do and work I *can* do, so I focus on projects that are within my skill set. My strength is animating in After Effects, so I'm not going to focus on super technical 3D jobs. After I check out the projects and see which ones I can do, I'll click on one to load that project's info, then scroll down and click on the *Credits* link to get the names of the producers, art directors, and other people who worked on the piece. That's another way to get the name of someone to reach out to when you can't find these people on an *About* page.

Getting back to the producer. The producer on a project is typically the person who books freelancers. They aren't a designer or an animator but handle the business end of the project, work out the rates, set the schedule, and

have the most input on hiring decisions. You want to get on the producer's radar.

The producer may already have a Rolodex of freelancers and other contacts, and, although she may not be the final judge of whom to hire, she's the person who's going to show your work to animators and designers who will evaluate your work. Based on that feedback, the producer will decide if she's going to consider you for projects.

So, back in Cleveland, looking at the names and titles of everyone at Collision Communications, we find a few with "producer" in the description. And that's it. We now have a specific person at a specific company to reach out to. Ann Johnson (not her real name), step right up!

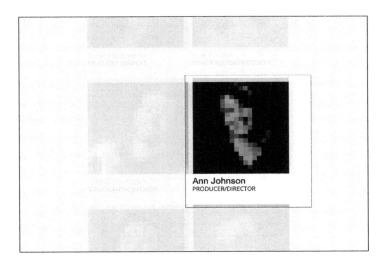

Ann Johnson
PRODUCER/DIRECTOR

There she is. Now we know her name. So, we've identified a local company and discovered the name of a producer at the company, whom we'll call Ann Johnson. Now we need to make contact.

FIND THEIR E-MAILS AND ENSURE CONTACT

We have a name and a company to contact, but we still have two problems: we don't know the producer's e-mail address—an easy problem to solve—and we need to make sure she READS any e-mails we send her—a harder problem to solve. Here's the main issue. Our survey of freelancer hirers uncovered a startling statistic: Producers and other people who hire freelancers often get more than fifty e-mails a day. Fifty. E-mails. A. Day.

Do you think producers actually have time to open every e-mail, read it, respond to it, and—oh, by the way—also produce a whole bunch of projects? I'll leave that as a rhetorical question.

So, we'll need some help to get her e-mail address *and* make sure our e-mails are opened. I'll show you some tools to find e-mail addresses and some other tools to ensure the e-mails we send are opened. You can assume that if a client opened your e-mail, they also read it.

Remember, in phase one, the goal is simply to make contact and let the client know you're a freelancer. If you send them an e-mail and they open it, success. You win phase one. But you need to know for sure that they opened it to be confident of your success.

All right, now, let's find an e-mail address. We'll be using several online tools to help us out. All the tools from this book, as well as the URLs to find them, are listed in the appendix at the end of the book. You can also find this list by going to freelance.how/tools. We'll talk about each service as we use it. You should note that new tools come online all the time, and a simple Google search for things like "E-mail open tracking in Gmail" can get you even more options.

We'll also need to organize our information, with Google

Sheets or any other spreadsheet application. There's a Google Sheet template you can use to do this at freelance. how/tracker, and I'll show you how to use this spreadsheet shortly.

We're going to find Ann Johnson's e-mail address. My go-to tool for finding e-mail addresses is Voila Norbert. It's dead simple. You can, as of this writing, get a free account and fifty free searches before you have to pay for more. It works like this. You log in to the site, type in the person's first and last names and the domain URL of their company, which in this case is collisioncommunications. com. Hit Search, and after a moment, you'll get the e-mail address. It seems to work 50–60 percent of the time, and with smaller companies, the hit rate is even better. In this case, it didn't work for Collision Communications.

Don't Worry If One Tool Doesn't Work; Just Try Another.

If Voila Norbert doesn't work for you, try another tool like Hunter.io. Hunter works by showing you a list of known e-mail addresses at a company. In this case, it actually showed the e-mail of the producer we were looking for. Yahtzee!

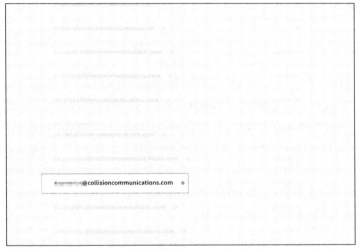

Sometimes It's That Easy.

But even if you don't find the e-mail address you need, the site is still incredibly useful because it will show you the e-mail address *format* that the company uses. It might be first name-dot-last name@company.com (joe.shmoe@ motion.com), or it might be first initial-last name@company.com (jshmoe@motion.com), but whatever it is, we can try putting the producer's name in that format with that extension—@collisioncommunications.com—and then verify the e-mail address to see if it's correct.

The Format This Company Uses Is Typically first name@collisioncommunications.com.

The easiest way to verify the address is to install the Rapportive Chrome extension on your browser, then go to Gmail and compose a message to the e-mail address you've discovered. Rapportive will cross-reference the e-mail address with LinkedIn and pull up any information it finds. If it finds any information, you know you've got a correct address. Boom!

That Wasn't So Hard, Was It?

You may have to try a few sites because they all work differently. Try them out until you get it. RocketReach.co is one of the newer services that seems to work incredibly well, and there are more being created every day. The important thing is to be patient and don't give up easily. Got it?

Of course, sometimes the e-mail address just comes right up the first time. For example, if we go to Voila Norbert and plug in the producer's name that we found in the credits on Buck's site, the e-mail address pops right up.

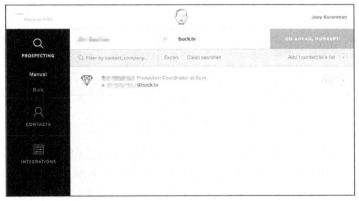

Easy Peasy Lemon Squeezy.

Now that we've got our first "lead"—I know, this is a gross salesy word, but it's convenient to use it—document the name and URL of the company, the lead name and title, and her e-mail address in your spreadsheet. We're

building a list of contacts, and we need to keep track of this information.

The Beginning of a Freelance Empire.

Notice the columns at the right side of the spreadsheet that say *Contacted, Phase One, Phase Two, Phase Three*, etc. You'll check those off as you move your contacts—your leads—through each phase. What we're doing is building a list of potential clients and keeping track of which phase they're in within the process.

CONTACTED	PHASE 1	PHASE 2	PHASE 3	BOOKED!	PHASE 4	PHASE 5
X	X	X	X	X		
X						

I Put Xs in the Cells for Each Completed Phase.

As you work through *The Freelancer's Field Guide*, you can check off each phase for each lead as it's completed: *You contacted them. They know you. They like you. They trust you. THEY BOOKED YOU! They need you.* These are the phases each lead will go through on your list, and this is how you build your client list.

Awesome. So now we have some e-mail addresses. The next step is to make contact.

CHECK THE JOB SITES, TOO

There are other places to find clients, like job sites. Let's go back to our search engine results, when we Googled "Cleveland Motion Design." We're looking for companies that have job listings for Motion Designers because if a company is looking for a full-time Motion Designer, it's a good bet they also hire freelancers. Here's a posting on Indeed for McGraw-Hill, and they're looking for a Motion Designer.

Motion Designer - Full Time
McGraw-Hill ★★★★☆ 30 reviews - Berea, OH 44017
At McGraw-Hill Education, we believe that our contribution to unlocking a brighter future lies within the application of our deep understanding of how learning happens...
15 days ago - save job - more...

McGraw-Hill is a huge publishing company, and we'd probably never think to contact them for Motion Design work because they're not an ad agency, studio, or production house. But here they are on Indeed, looking for a Motion Designer. Waddya know?

If you find an enormous company looking to hire a Motion Designer in your search, contact them. This is the direct-to-client work I was telling you about. The work you do for huge companies isn't usually as sexy as the highly technical and creative work you do for smaller companies, but it probably pays very well. That company could become one of your Pain clients with a big paycheck that allows

you time to chase your Rainbows. When you find one of these companies, zero in on it, and you could become their go-to MoGrapher.

So, whom do we contact there? First, we'll do a Google search for the name of the company—in this case, McGraw-Hill—to find the domain name or URL of the company, which is also going to be what comes after the @ sign in their employees' e-mail addresses.

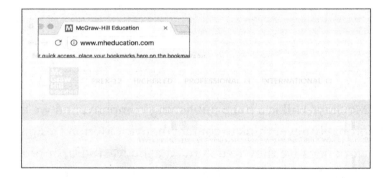

Because they are a massive company, we probably won't be able to find the right contact on their *Our Team* page, and they won't have a page showing examples of their work because Motion Design isn't their specialty. Instead, we can go to the professional networking site LinkedIn to do our sleuthing. But there's a catch.

In early 2017, LinkedIn removed many of the advanced search features from their site and moved them into a new

paid product they call LinkedIn Recruiter. The downside is that now you need to pay a monthly fee to have the best search features on the platform, but the upside is that that the monthly fee will scare off much of your competition from using LinkedIn, and you'll have an incredible unfair advantage. If you get just one freelance client using the software, it pays for itself instantly—and you'll find way more than one. Plus, they offer a free thirty-day trial, and you can get a TON of leads to contact in that time. The "lite" version of the Recruiter product is fine for our purposes, and here's how we'll use it to find our McGraw-Hill contact.

So, on the LinkedIn Recruiter Lite page, we're going to use the "Advanced Search" feature, right next to the main search bar, to hone in on the exact person at McGraw-Hill who can get us in the door doing some sweet After Effects animation. Here's how it works:

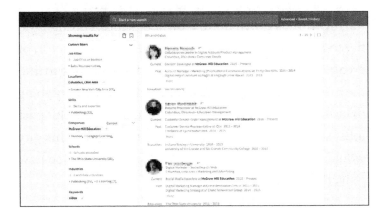

Here on the left side of the screen is an advanced search, and we can add various search parameters to zero in on the people at McGraw-Hill who might be our best contacts. For example, if we type the words "motion design" or "video" into the *Job Titles* field, we'll get only people with those words in their titles. A better way to get a wider range of results is to put your search term in the *Keywords* search field; that way, we'll get results if the search term is anywhere on someone's LinkedIn page. I sometimes like to use the term "video" instead of "Motion Design" because it's kind of a catchall term that usually gets me to the right people. But if "video" doesn't provide any results, we could try other keywords related to Motion Design. OK, let's search McGraw-Hill for people who are in Ohio and have "video" in their title.

Eighty-nine people popped up. McGraw-Hill has thousands of employees, so the advanced search helped us narrow things down quite a bit. Let's look through the list to find the best titles, like producer, art director, or creative editor. In this example, it didn't take long to find the manager of media production, and he's probably going to be a good contact for us. And holy crap, look at his past jobs: senior motion graphics designer. Think this guy would like to hear from a talented freelancer? See how powerful this is?

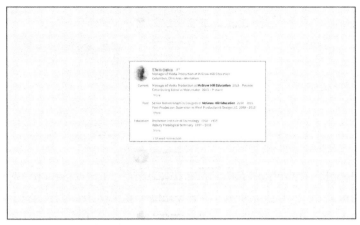

Jackpot.

You can also use advanced search to find people with the keyword "video" in their profiles in your local area. This will often help you find *hundreds* of companies that create videos as part of their business you may never have thought to look at. Try searching for "video," "animation," "motion," "After Effects," and any other words you can think of. You'll be drowning in prospects before you know it, and that's what makes this tool so darn valuable.

So, back to our manager of media production at McGraw-Hill. We now have an actual, in-the-flesh *person* to connect with, and we can plug his name and the company's domain name into one of our e-mail finding tools to get it. How about we give RocketReach.co a shot?

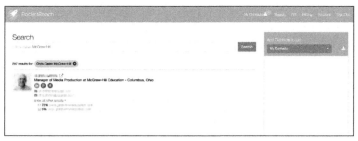

Not One, but Four Found E-Mail Addresses.

RocketReach.co gave us a few e-mail addresses to try, including the person's personal e-mail address from his MoGraph portfolio site. In a pinch, we could even reach out using that address, but it's best to find the lead's "professional" account. A quick Rapportive check confirms that we have a valid e-mail address. Let's not forget to add it to our spreadsheet, too. That thing is gonna be filled up quick.

There are other ways to find e-mail addresses. People sometimes post their e-mail addresses in their LinkedIn

profiles under *Contact Info*, or they might post a résumé on their profile and include it in that document. Sometimes people on staff at companies still maintain a personal portfolio page and leave their contact information there. Preferably, we want the person's business, not personal, e-mail address, but you miss 100 percent of the shots you don't take, so you might as well reach out any way you can. The main point I'm trying to make with all of these demonstrations is that it's possible, with a bit of legwork, to quickly find dozens of potential clients and their contact information, without ever putting your pants on.

In the hierarchy of e-mail verification, I've found that if you get a hit on Rapportive, you're good to go, and if Voila Norbert provides you with an e-mail, the results are usually dependable. If you try all the tools I've showed you and still aren't 100 percent sure about a contact's e-mail address, you can guess at it, then send an e-mail and track it to see if it gets opened. It's also OK to try several different addresses and see which one gets received. It's not like you're going to get in trouble for sending polite e-mails, and if four out of five e-mails get bounced back and one gets read, you win.

The last tool we'll use is MailTrack.io, which tracks received e-mails and e-mail opens (and link clicks, too, but we'll talk more about that later).

One Check: Received. Two Checks: Opened.

MailTrack is a browser extension that works with Gmail. It tells you if an e-mail was opened using an invisible tracking pixel. It also tells you if the e-mail ever made it to its destination in the first place, which lets you know if you had the right e-mail address. If you send an e-mail to a correct address and the e-mail *is* received, a green check mark appears next to it in your Gmail. When the person opens the e-mail, a second green check appears, along with the date and time they opened it.

We'll use MailTrack after we send our first e-mails, but first, I want to tell you about another way LinkedIn can help you connect with clients.

PROFILING

LinkedIn is great for finding the right contact at a company, but you can learn much, much more about a person from their LinkedIn profile than you might expect. Beyond the title and résumé, people give away a lot of personal

information that will help you connect with them more quickly. This might make you uncomfortable, but keep in mind that this information is publicly available, and you're not hacking anyone. You're not using this information for anything sketchy either. You're using it to connect with people who probably need a great freelancer, and you're that guy or gal. Don't feel bad about doing this; it's important and it works.

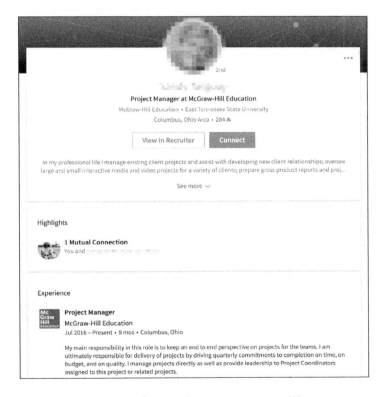

For example, here's another McGraw-Hill person to

contact with the title of project manager, which is another way of saying producer. Let's call her Janet. If you click her profile picture to reveal the whole photo, you can clearly see on the edges of the image that two children have been cropped out. Yes, I know we've pixelated the photo for privacy, and you can't ACTUALLY see this, but just imagine. They have the same color hair as her, and that leads me to believe she's probably a mom. Well, I happen to be a dad, so I already have a connection with her because we're both parents. I know this is getting weird. Stay with me.

If you're a dad, you can casually mention that detail in your initial e-mail. Showing Janet you have something in common creates an instant connection. She's going to like you immediately. Does that seem creepy? Your goal is to connect with Janet, to build rapport. Connecting with people involves making small talk, and you can't make small talk until you discover things you have in common.

Of course, you're not going to write to Janet and say, "Hey, Janet! I noticed some blond hair in your photo, and it looks like a kid, and hey, I have kids, too!" You won't ask her if she's a mom or say anything creepy, but you are going to mention in a natural way that you're a dad or a mom and let her connect the dots and make that personal connection. You'll see how in a bit.

Now obviously, if you're not a dad, don't pretend to be one. Look for something else in Janet's profile that you have in common. Because she's at a local company, you can talk about Cleveland. If you went to the same college or worked for the same business, you can casually mention that. If you have nothing in common with Janet, you can find out how her college football team—most people's alma maters are listed on LinkedIn—did in their last game and mention that. There's always something to mention that's personal but not creepy and will help you make a personal connection right away.

We're just collecting information right now, but we'll use that information when we write our e-mails. Adding that personal note proves to the person that you did not send a mass e-mail, and you genuinely want to connect with *them*. Your goal is to contact them, build rapport, and decide mutually if it makes sense to work together. Janet might tell you she doesn't need a Motion Designer, and that's OK. You had a pleasant exchange and made a connection that may or may not pan out in the future, but there is no harm done either way.

OK, now let's get to those e-mails.

FINAL STEP: MAKE THEM AWARE OF YOUR "FREELANCE-NESS"

Isn't it cool how easy this is? Once you have some names and e-mail addresses, you need to let your prospective clients know you're an available freelancer. You do that by sending them an e-mail and making sure they open it. We'll talk about the specific language you use in that e-mail in phase two, but first, let's step through the psychology of creating a subject line that gets your e-mail opened.

People like Janet—media coordinators, producers, project and hiring managers—get a lot of e-mail (more than fifty per day, remember), and 50 percent of people leave e-mails unread, so you can bet Janet isn't reading every e-mail in her inbox. You can make sure Janet reads *your* e-mail by writing the perfect subject line.

Think of your e-mail's subject line as a missile. It has one job and one job only, and that's to get your e-mail opened so your client gets to the body of the message: the payload. You'll need to use some tact and common sense for this next part, but the truth is, we don't particularly care what it takes to get the client to read the body of the e-mail—just that they read it. So, the subject line is, in a way, clickbait. Yep, we're kind of using the same psychology clickbait does, but we're not going to be scammy about it. We'll use subtle psychological triggers to make our e-mail stand

out. It works and will help you get a client you're going to impress the hell out of, so everybody wins.

There are some simple rules of thumb to crafting a perfect subject line. Let's go over them, and then we'll write some actual subject lines. First, the subject line must be concise. If your client has to open your e-mail to read the subject line, you failed. So keep it short.

Second, it has to tell them you're an available Motion Design freelancer. Make this obvious to your client, and don't try to be vague or clever. There's a time and a place to be clever, but when you're looking to freelance for someone, clarity trumps cleverness.

Third, it has to be friendly, and there are many ways to do that. You can use their name, the name of a referral, or "trigger words." Trigger words are words the person is sensitive to because they're specific to their own experience. Trigger words get people's attention, pique their interest, and usually make them smile.

Try to judge the client's personality before you write the subject line. Some people are friendly, and if you use their name, they'll think you're friendly, too. Other people are standoffish or introverted and using their name might backfire. That's something you have to learn to gauge. You

may be able to get a feel for the client's personality from their LinkedIn profile or their social media sites. When in doubt, don't use their name.

NOW WE'RE WRITING

All righty, let's write a subject line to our friend over at McGraw-Hill. Here's a simple one. Start with concise information that tells her your name and that you're a freelancer. For this exercise, I'm adopting the nom de guerre of Joe Motion.

Subject: Freelance Animator Available: Joe Motion

That's concise and gives her the information she needs, but it's too generic and could be stronger. Remember, this client lives in the local area, and for this example, Joe Motion lives in Cleveland. Here's my subject line:

Subject: Cleveland-based Freelance Animator: Joe Motion

"Cleveland" is a trigger word for the client because she lives in Cleveland, too. It jumps out in her crowded inbox, but the subject line is still concise, gives her the information she needs, and it's personal because we're both

in the same city. That's three strong tactics for getting her attention.

If the client is not in your area, you can personalize the subject line with information you discovered by looking at their Internet persona. (Remember, this is why we looked at Janet's profile.) For example, anyone can go online and with a little research discover that I'm from Texas, where we use the word "howdy." Most people from Texas will respond to the word "howdy."

Also, on LinkedIn, you'll often see what college the person went to, so if they live in Cleveland, but they went to the University of Mississippi, chances are they'll appreciate a little southern charm. Using the word "howdy" will probably work for them, too. My personal favorite is "y'all."

A hiring manager from Texas—or one who lived in the South at some point in their life—now living in Cleveland is definitely going to open an e-mail with the following subject line:

Subject: Howdy, Cleveland-Based Freelance Animator Here

That subject line hits all three rules and hits the third rule twice because there are two trigger words, "howdy" and

"Cleveland." It's concise, it's friendly, and it's localized. That e-mail is going to get opened!

There are also subject lines you should never use because they will prevent your e-mail from being opened. Never be vague. "Hey, there..." will not get your e-mail opened. "Freelancer looking for work" is a turnoff. No one wants to talk to you if you're looking for work. **Available is good, but looking for work is not good.** Never ask for anything in the subject line. Don't do it.

Remember that the subject line and the body of the e-mail are two separate beasts with two different jobs. They may not even be related. The subject line simply gets people to open the e-mail. Once the client opens your e-mail, that subject line is forgotten, and now they're reading your e-mail.

Sometimes it helps to get creative with your subject lines, especially if you're targeting someone who's especially tough to reach. For example, I wanted to reach out to a brilliant designer/illustrator named Lucas Brooking to see if he'd be interested in making a T-shirt for School of Motion. I didn't know Lucas. He probably gets a lot of e-mails because he's an extremely talented and pop-ular Artist. I went to his website and found a series of heavy-metal concert posters he designed. On the poster

descriptions, Lucas said he played in a metal band and made some illustrations for their shows. Lucas, like me, is into heavy-metal music. He, like me, appreciates a crushing breakdown and the occasional blast beat. Aha! I have a personal connection to Lucas. Lucas is in New Zealand, I'm in Florida, we don't know any of the same people...but we have a connection.

His affinity for death metal is publicly available information. I didn't hack his Facebook account and look at his music playlist; it's on his website. The subject line for the e-mail I sent Lucas was this:

Subject: Pig squeals and gutturals

"Pig squeals and gutturals" are death metal vocal styles, a kind of growling and yelling that singers use in that type of music. Look it up on YouTube. It'll entertain the hell out of you. I knew that would be the only e-mail in Lucas's inbox with anything even close to that subject line. It was concise, personalized, and friendly—a subject line trifecta that would get his attention. Lucas opened it up and replied. That subject line had nothing to do with the body of the e-mail, which was a request for him to design a T-shirt, but the subject line has only one job, and it did its job valiantly. Mission accomplished.

USE REFERRALS

Using a referral in the subject line is another method of personalization that's almost foolproof. Let's say I'm reaching out to someone in Sarasota—where I actually live—who's friends with my buddy Ed Cheetham. Ed told me about a potential employer who might be looking for freelancers. If you have a mutual friend or coworker, their name is a trigger word. Here's my subject line to the client:

Subject: Ed Cheetham sent me! Sarasota-based Freelance Animator here

The first words in the subject line, *Ed Cheetham*, will jump out in the client's crowded inbox and accomplish two things. If they like Ed Cheetham—and who doesn't like Ed Cheetham?—they now like you by association, so you've created a friendly, personal connection without trying very hard. You localized it with Sarasota, told them what you do, and were concise. That's five key connections and a guaranteed open.

If you can't find anything at all that connects you to a person, use their name and something about their work. Some people don't have professional or personal sites that are open to the public, but if you have their name and know they're in the industry, you can still personalize

the subject line. You should also do this if you're not sure who the proper contact at a company is. It's perfectly OK to e-mail someone else at the company and ask for the right contact's name. The same rules apply, but the e-mail subject line will be a little different.

Here's an example where I couldn't find an e-mail address or a contact for a producer, but I found a staff Motion Designer. I didn't know much about him other than the fact that his name is Andrew, and he's a Motion Designer at a company where I'm looking at for possible freelance work. Andrew will likely open my e-mail because it has his name on it, and we have something in common: animation. Remember, people like people who are like them. Be concise and friendly, and personalize the e-mail.

Subject: I, too, animate. Nice to meet you, Andrew.

Andrew will open my e-mail because it has his name on it and he has something in common with me. Using the person's name is kind of a last resort, but it gets you three connections, and you need to do that to ensure your e-mail gets opened.

And here's one more thing: Your subject lines won't always work. If you follow these guidelines, you'll have

a VERY good success rate, but the occasional whiff is to be expected. When it happens, just move on to the next lead and keep going. There are so many fish out there in the MoGraph sea that if one gets away, it's no big deal.

Once you've crafted the perfect subject line and sent your first e-mails, you need to find out if the e-mails are opened, and you can use MailTrack.io for that. Once the extension is installed, it does all the work. You will, of course, write an actual e-mail to go with your perfect subject line, but we'll get into that in the next section. So, assuming you've gotten a good e-mail address, written a targeted subject line, and put some good words in that e-mail, you hit Send. And then...

If they opened your e-mail, phase one is complete. They know you. Success! It's that simple. They don't even have to *reply*. Opening the e-mail is enough, and with MailTrack, you'll actually know when that happens. Slick, right?

Track the e-mails you send and the opens you get on the spreadsheet that's your contact list. If they don't ever open the e-mail, send the same one a week later, but tweak the subject line and send it a different time of the day or day of the week. There may have been something in the subject line that turned them off, or they may have been too busy to read it that day and it got buried on page five of their inbox.

If you're worried about their being annoyed because you sent the same e-mail twice, don't be. They most likely won't even remember your first e-mail because they had so many e-mails that day, and they likely didn't even open yours. So, try again. Send that same e-mail. It's worth the five seconds of discomfort it'll cause you.

OK, THEY OPENED IT

Once they open the e-mail, hooray! Update your spreadsheet.

Tracking your e-mails gives you a visual representation of your progress and takes some of the scariness out of the process. There's a bit of fear involved when you're reaching out to someone you've never met. Don't be afraid. As you send your e-mails and get responses, you'll realize how easy it is to make progress. This works. People who use this system often have to start turning down work after a while because they have too many people replying

to their e-mails. One of our School of Motion alumni started using this method, and this is what he wrote to me a few weeks later:

THE E-MAIL TECHNIQUE IS WORKING A TREAT IN BRIGHTON [UK]! SO FAR 8 OUT OF 20 STUDIOS I CONTACTED IN THE LAST WEEK HAVE REPLIED AND ADDED ME TO THEIR BOOKS, AND 1 HAS BOOKED ME FOR THE NEXT 2 WEEKS!
—BRENDAN COX, BRENDANCOX.UK

As you work through each phase in this book, keep adding new contacts until you have a list of twenty to fifty people in various phases of knowing, liking, trusting, and needing you. You really don't need a bigger list. You don't want fifty *clients* because that would be unmanageable, but you might need fifty leads to get five really good clients. Eventually, as clients hire you again and again, and as you get referrals, you won't need to worry about phase one at all anymore.

Congratulations! You completed phase one. Take a victory lap. Drink a beer. Then let's get back to work. Hopefully, you're beginning to feel like this process isn't as difficult as you might have imagined. It doesn't have to be scary. Now the real fun begins because we're actually going to interact with people.

On to phase two!

CHAPTER 5

PHASE TWO: I LIKE YOU

The subject line on your e-mails introduced you to clients and let them know, in a friendly way, that you're an available freelance Motion Designer. The body of the e-mail has a job, too.

MAKE THEM LIKE YOU

The three goals of phase two are to make clients like you, get them to click through to your site, and follow up with them. But why does your client have to like you? This is a business transaction, right? You're an Artist, the client is hiring you to do a job, and you're going to do it. Who cares about liking each other?

The reality is, people don't buy from people they don't like. Clients are *far* more likely to buy something they don't need from someone they really like than they are to buy something that will save their life from someone they don't like. It's Sales 101.

Ugh, there's that word again: sales. Boooooo. If this was a book for real estate agents, that word wouldn't bother you at all, but as a Motion Designer, you're probably having a visceral reaction in your mitochondria. I would love to use a different word, but the reality is, we're all adults here, so let's put on our big-boy pants and do what we have to do. You're a Motion Designer, and what you're about to

do is sales, but it's easy and necessary, and I promise you won't feel icky afterward. It does not make you a sellout. It gets you booked.

Remember, more than 82 percent of people who need freelancers have trouble finding them. You're not bothering these people. You're doing them a huge favor. They want to book you, but first, they have to like you.

WHAT NOT TO SAY IN AN E-MAIL

Freelancers sometimes say things in e-mail that automatically turn off a client. You might write an e-mail that seems innocuous from your point of view, but that's not how the client "hears" it. When you write an e-mail, read it back to yourself from the client's point of view. Think about how it makes you feel to read that e-mail. Does it make you feel bad or angry? Does it make you dislike the person? Does this person sound like the kind of person you want to hire?

In our survey, we asked hiring managers what freelancers should never say in an e-mail. Here's a direct quote from a producer who responded:

**ANYTHING WITH ARROGANCE. IF IT'S ALL ABOUT HOW
GREAT THEY ARE AND HOW THEY THINK WE NEED AN
ARTIST LIKE THEM, I DON'T WASTE MY TIME. I'M NOT
LOOKING FOR THAT TYPE OF PERSONALITY ON MY TEAM.**

—ANONYMOUS PRODUCER FROM OUR SURVEY

Now, this should be obvious, and most freelancers aren't consciously arrogant, but you can't control the context in which your e-mail is read. Something as harmless as "I think I'd make a great addition to your team" may appear arrogant to the client. They may be having a terrible day. They may have just fired an overconfident freelancer. Maybe the last person who sent them an e-mail like that turned out to suck. Don't tell the client how great you are; show them by being confident and letting your work do the talking.

Here's another quote from the survey:

**I DO NOT LIKE LENGTHY EMAILS. I WANT TO
KNOW THE BASICS. WHAT ARE THEY INTERESTED
IN, WHAT THEY DO, A LINK TO THEIR PORTFOLIO
AND THE BEST WAY TO CONTACT THEM.**

—ANONYMOUS QUOTE FROM OUR SURVEY

Your e-mails should be no more than seven or eight

sentences long. If a client gets a long e-mail, they're not going to smile when they open it. They may not even read it. Be as concise as possible. Every word in your e-mail should be there for a reason. If you have two words that could be expressed with one word, use one word. Never make them scroll down to read your e-mail. They should be able to look at their computer screen and read every word in your e-mail without touching the keyboard or mouse.

RESUMES AND CVS ARE NOT IMPORTANT UNLESS I'M ALREADY DAZZLED BY YOUR WORK.
—ANONYMOUS QUOTE FROM OUR SURVEY

I'd like to put that quote on a billboard outside of every career services department in every art school in the country. You should reread it ten times out loud and really internalize it, especially if you're a student who's been told to fluff up your résumé because you don't have a lot of experience. Résumés, cover letters, and curricula vitae are not important in this industry or, frankly, in most creative fields. If you send one, no one will look at it, and it's possible that you'll never even be asked for one throughout your entire freelance career. In Motion Design, résumés are almost useless, so don't waste your time writing one unless someone asks you for one—which may never happen!

If your work impresses people so much that they want to hire you full time, they might ask for your résumé to get a sense of your work history and see if you're responsible enough to hold a job, but you don't get there until your work has already impressed them. At that point, if they ask you for a résumé, make one.

GET TO KNOW ME FIRST OR LET ME GET TO KNOW YOU BEFORE YOU ASK ME FOR A JOB.
—ANONYMOUS QUOTE FROM OUR SURVEY

This isn't just business. You're working with people, remember that. People do business with people they like, so your first e-mail is your first chance to show them you're likable.

Also, never, ever mention you just graduated from college. When you're a student, companies will bend over backward to help you, but as soon as you graduate, that changes. It's OK to tell them you studied at a certain college, especially if you went to a well-known art school, but once you mention that you "just graduated," you might unwittingly come off as desperate or as expecting them to do you a favor because you're a recent grad. What, you just graduated? So, I should be a little less critical of your work than someone who's been working for two to three

years? It doesn't work that way. You're also inviting a lot of assumptions. They'll think you have no experience, and they won't be willing to pay you what you may be worth.

Remember this mantra: Never sound desperate, even if you are. Don't talk about your rate in your first, introductory e-mail. We'll get to your rate later in this book, but now, in the e-mail when you're getting the client to like you, is not the time.

SANDWICH THE SELLING

All righty, we're about to get to the actual "writing of the e-mail" part, but first, let's talk about one more concept.

There's a formula for selling without sounding like a salesperson, which requires you to connect with your client on a personal level. You won't start out with your rate and the fact that you want to work for them. There's foreplay involved. You're going to sandwich the selling with building personal rapport to make it a "soft sell." The simplest way to think of this is "make them smile." The client opened your e-mail in phase one, and now you want them to smile. If they smile, you've achieved phase two. It really is that simple.

There's a social awkwardness around selling that's not just

one-sided. It's awkward for the freelancer who's selling their services, and it can be awkward for the client, too. The techniques described here are designed to get rid of the awkwardness on both sides. Here's an example of an e-mail where the selling is sandwiched between friendly small talk that creates a personal connection, builds rapport, and makes the client smile.

Let's say that we've done our research and found a local Sarasota, Florida, company that does Motion Design. We found a producer there named Dan, and we found his e-mail address using the tools from phase one. We're ready to write Dan an e-mail.

Subject: Howdy, Sarasota-based Designer/Animator here

Great subject line. Dan opened your e-mail.

Hey, Dan,

Nice, friendly opening, and we're using Dan's favorite word: "Dan."

While looking at references for a project I'm working on, I came across your awesome studio on Vimeo. Your work is fantastic.

Say something nice first, but don't lay it on too thick. No sucking up. Make sure he recognizes you're already "one of them," not an outsider trying to get into his cool club. You need to show him you're just like him to be accepted.

You can say you were looking at references for a project you're working on, which lets him know this isn't an e-mail request for work because you're already working on a project. Did you really come across his company's site while researching a project? Probably not. You have to decide how far you want to bend the truth. But ultimately, the goal is to be a great resource for your client, and that won't happen if you can't connect with him. You could also say you stumbled onto his work, or his work popped up on your feed. Just don't say, "I have you on a spreadsheet where I track my leads."

If you told Dan you were looking for studios to contact and found his, that's potentially awkward for him to read. It's clearly a sales e-mail, and you've set an uncomfortable tone from the start. Saying you found his studio while doing research is a plausible, harmless white lie that removes the awkwardness and makes the communication more comfortable. Here's the next line in that e-mail:

> I'm a freelance Motion Designer/dad living in Sarasota, and I want to introduce myself. Animation is my specialty (After Effects and Cinema 4D), and if you're so inclined, you can see my most recent reel and portfolio here.

Let's break this down. We opened the second section with "I'm a freelance Motion Designer/dad." Why did we throw that in there? It's not random. We looked at Dan's public profile page on Facebook, LinkedIn, or Twitter, and determined he probably has kids. If you mention something like this in your e-mail, it has to be publicly available on the person's LinkedIn profile, Facebook, or Twitter. It has to be something that anyone could find in ten minutes on the Internet. You can't actually say you saw a picture of their kids or even mention you know they're a parent, but you can let them know you're a dad to create a personal connection. If they have kids, "dad" or "mom" is a trigger word.

Being a parent gives you an instant bond with other parents. It also lets them know they can talk to you about certain things, and that creates a lot of comfort. All groups of people—Motion Designers, musicians, marathon runners, and so on—like to talk about their "thing" even if no one asks them. Saying you're a freelance Motion Designer/dad is a natural thing, and of course you should only say that if you are in fact a dad. Does telling them you're a dad make them like you more? You betcha it does. This works.

You can replace the "/dad" with "/runner," "/musician," "/surfer," or anything else you have in common. If I was writing an e-mail to Lucas Brooking, I wouldn't say "/dad" because I don't know if he's a father. He's definitely a metalhead. That information was easy to find, and it won't creep him out, so I can call myself freelance Motion Designer/metalhead, and he'll connect with that.

Don't be creepy with this. Be subtle. That's key to using this trick. Don't ever ask about a client's kids or any specifics of their personal life. If they're a runner, don't ask how they did in a particular race, even if you know from the Internet that they ran it. Knowing the person is a runner gives you a lot of information about them. They're probably into fitness and healthy eating, too. You can get a lot of mileage out of knowing your client is a runner and use that knowledge to make a connection with them, even if you're not a runner yourself. But never get too personal with them. If they bring running up in their reply, you can ask, "Are you training for a race?" Then you're two runners talking to each other, and it's much easier to get booked when you get to that level with a client. You want to get to that level, but you don't start there, and you can't force it.

The point of the first line, *Hi, I'm a freelance Motion Designer/dad*, is to introduce myself and let them know my specialty. If you have a different specialty, this is where

you tell them that. You're giving the client an immediate check in a checkbox and letting them know you do something they need, and you're also getting them to like you.

GET THEM TO LOOK AT YOUR REEL

Clients want to see your reel, so don't hide it in your e-mail. Make it obvious. If the client has to search your e-mail for a link to your reel, you're doing it wrong.

The next part of the e-mail goes like this:

If you're so inclined, you can see my most recent reel and portfolio here.

There it is! The sell or "ask." You want them to look at your reel and portfolio, but you don't really ask them to do that. You say, *if you're so inclined*, you can see it here. You're letting them know it's there for them to view, while at the same time showing them you respect their time and you know they're super busy. **You know the deal** because you're like them.

Now, they're not naïve. They know you want them to click on the link and look at your reel, but imagine it from their point of view. If you ask them to watch it and they're too busy, you've created awkwardness in the relationship.

You don't want them to feel one iota of guilt if they can't look at your reel right this minute, so don't ask them to. Phrase the "ask" so there's no guilt, no pressure, and no downside for them if they choose not to watch it.

Follow that up with a link to your reel or portfolio.

Joe Motion - Summer 2017 Reel

It's important to put the link in its own line, with a line space above and below. Make it a pretty link, not http:// www.joemotion.com/videos/reel2017. In Gmail, all you need to do to make a pretty link is type out the link the way you'd like it to look: Joe Motion - Summer 2017 Reel, then highlight that text and hit Command + K on a Mac, or CTRL + K on a PC. A dialogue pops up so you can paste your long, ugly URL in and link your "pretty link" to that page. Boom! Easy pretty links.

Let's talk about what you should call the reel. In this case, it's "Joe Motion - Summer 2017 Reel." You can use a different format, but the text should mean something. It might be your name or the name of your business, but it needs to be easy to find in the e-mail and easy to read. It's a good idea to add the season when you completed the work—like Summer 2017—to the name of your reel. If you don't have anything recent, say from the past couple

of seasons, then leave the season off, and if you don't have anything from the past year, then leave the year off. You could call it "Joe Motion - Animation Showreel." You don't want to call attention to the fact that you don't have anything new to show them, but in reality, you really should have a recent reel. You should redo your reel at least once a year—ideally, twice a year.

Here's the next line:

> I love meeting and collaborating with talented folks. I just wanted to drop you a line to let you know I'm out here. Please don't hesitate to ask me anything about my work or my experience.

Again, you're not asking for work. *I love meeting and collaborating with talented folks*—this is how you call them talented without coming right out and calling them talented. You're not sucking up or coming across as fake; you're just kind of putting it out there. *I just wanted to drop you a line to let you know I'm out here.* Again, people like meeting people like themselves and making friends. People don't like being "sold," but they do like making friends with people who are like them. You're making friends—and also letting them know you're an available freelancer who thinks they're talented and has a reel they can look at if they want to, when they have time to do that.

NO OPEN LOOPS

An open loop is anything that creates an expectation of action on the part of the person reading the e-mail. For example, if I closed with "Thanks so much. I hope to hear from you soon," that creates an expectation. *Oh, they hope to hear from me. Well, I'm really busy. I don't think I'm going to get back to them, so now I have to feel a little guilty.*

Most of the people you e-mail are nice human beings, but if they don't like your work or you're not a good fit, they may not want to have to take the time to write you an e-mail to explain that. If you leave an open loop, they're going to feel a little guilty if they don't reply to your e-mail because you're clearly expecting something from them.

Open loops usually come at the end, when you tell them you want to hear from them, or worse, you ask them a question: *Are you guys working on anything cool at the moment?* You're expecting an answer from them, and they probably don't have time to talk to you, this person they just met. But now they feel guilty if they blow you off. Don't put them in that position.

Choose every word carefully to avoid creating open loops anywhere in your initial e-mail. You're introducing your-self, getting them to like you, and giving them a link to

your reel with no expectations whatsoever. That's it. There is a time and a place for an open loop, but it's not now.

You want them to walk away from your e-mail feeling good, not with a bad taste in their mouth. That bad taste is an unconscious thing, and the client usually doesn't even know why it's there. It's the expectation you set by asking them for or to do something. They're not going to like you if they walk away from your e-mail with a bad taste in their mouth, and they won't even know why.

Here's how we close the e-mail with no open loop:

> Thanks so much. I can't wait to see what you and the team come up with next.
>
> Joe

Or you can say:

> Please don't hesitate to ask me anything about my work or my experience.

Of course, you *want* them to ask you about your work and experience, but you don't want to come out and say that because again, you'll be setting an expectation. Instead, you're saying *don't hesitate*, which means, "I understand

you don't want to be rude and you might think that you're imposing on me by asking me about my work. Please don't hesitate." On an unconscious level, you're saying, "Listen, I will never inconvenience you. You can inconvenience me whenever you want."

Here is the e-mail in its entirety:

Subject: Howdy, Sarasota-based Designer / Animator here

Hey Dan,

While looking at references for a project I'm working on, I came across your awesome studio on Vimeo. Your work is fantastic.

I'm a freelance Motion Designer/dad living in Sarasota, andI want to introduce myself. Animation is my specialty (After Effects and Cinema 4D), and if you're so inclined, you can see my most recent reel and portfolio here.

Joe Motion - Summer 2017 Reel

I love meeting and collaborating with talented folks. I just wanted to drop you a line to let you know I'm out here. Please don't hesitate to ask me anything about my work or my experience.

Thanks so much. I can't wait to see what you and the team come up with next.

Joe

USING A REFERRAL IN YOUR E-MAIL

Let's talk about some other ways to structure this opening e-mail. If you have a mutual contact, you can use them as a referral. Remember to put the referral's name in the subject line like this:

Subject: Blame Ed Cheetham...Sarasota-based Designer/ Animator here

Here is how you would start that e-mail:

Hey Dan,

Ed is a good friend of mine. He knows everyone, doesn't he? We were chatting about the great work that's been coming out of this area. He mentioned you guys, turning me into a big fan in the process.

You're creating a personal connection, but you're not selling anything. You're also telling Dan that Ed likes him, and now you like him, too. Here's the next line:

I'm a freelance Motion Designer living in Sarasota.

You can leave out the "/dad" because you've already got a connection to Dan through Ed. No need to oversell.

Animation is my specialty, After Effects and Cinema 4D, and if you're so inclined, you can see my most recent reel and portfolio here.

Joe Motion - Summer 2017 Reel

I love meeting and collaborating with talented folks. I just wanted to drop you a line to let you know I'm out here. Please don't hesitate to ask me anything about my work or my experience.

Thanks. I hope we can connect in the near future. If so, I'll owe Ed a beer.

—Joe Motion

Because there's a personal connection to this person through Ed, you can get a little closer to an open loop, but you're still not asking Dan to do anything. By saying *I hope we can connect in the near future*, you're saying you hope it happens, but if it doesn't, it's not a big deal. You're not saying you hope to talk to Dan soon. There's a subtle difference. If Dan feels like you expect to talk to him, and he's busy, he'll feel guilty, and there's that bad taste again. *I hope we can connect in the near future. If so, I'll owe Ed a beer.* That's harmless. You're reminding Dan that you both know Ed and are telling him you might buy Ed a beer because that's the kind of person you are: you buy your friends beers. Starting to see how this works?

WHAT IF YOU'RE NOT SURE WHETHER YOU HAVE THE RIGHT COMPANY OR CONTACT?

If you're e-mailing a nontraditional client, such as a company that has an in-house studio, it may be hard to find the right person to contact. If you're not sure the person you're writing to actually hires freelance Motion Designers, you need to write the e-mail a bit differently. Let's say you're writing to Bose, a company in Massachusetts that makes audio gear and also has an in-house video production department, which you'd find out doing some LinkedIn Recruiter sleuthing. Change the subject line a bit. Instead of *Animator*, use the term *Motion Designer*, which is a broader, less specific term.

Subject: Boston-based Motion Designer here...

Susan,

First of all, as a father three, my Bose noise-canceling headphones may be one thing that keeps me alive on flights. How do they work so well?

We suspect Susan is a mom from our research, so we mention we're a parent, too, and create a personal connection. Susan works at Bose, where they make amazing noise-canceling headphones. (Do your research!) You're letting Susan know you're a parent who loves Bose headphones. She's probably also a parent who loves the headphones,

so you have that in common. If you're not a parent, you can use a different phrase and trigger word to create a connection, like "as a trail runner" or "as a constant traveler." You can easily find out that Bose is headquartered in Framingham, Massachusetts. Maybe your grandma lives there, and you can mention that. You can talk about local sports teams, too. Nearly everybody in New England is a sports fan.

If a company is based in Denver and the Broncos just won the Super Bowl, you can bring that up. You're just creating a personal connection by mentioning something you have in common that's not business related.

The next part of the e-mail is an example of a soft sell:

My name is Joe Motion. I'm a freelance Motion Designer living in Boston. I've been animating (2D and 3D) professionally for five years. You can see my most recent showreel and portfolio here.

Joe Motion - Summer 2017 Reel

If you're writing to someone at a studio who understands your niche, be specific about what you have to offer. If you don't know whether the company hires freelance Motion Designers, or even whether the person you're e-mailing is the right contact, broaden the description of your skills, so

they'll understand what you do and be able to put you in touch with the right person at the company. Again, don't ask them to do anything or give you anything. *You can see my most recent showreel and portfolio here. You can see it if you want to. If you don't want to, don't click it.* Put the link to your reel on its own line. The next part is:

I love meeting and collaborating with talented folks at awe-some companies, and I just wanted to drop you a line to let you know I'm out here if you ever find yourself in need of a freelance Motion Designer. Please don't hesitate to ask me anything about my work or my experience.

The second part is new: *if you ever find yourself in need of a freelance Motion Designer.* You've made it clear you're a Motion Designer, but you want to couch it this way to let them know that you respect their time because you're like them, and you understand they're busy. There's no guilt if they don't look at your reel, but they know it's there. No open loops and no guilt.

Thanks for your time. A grateful Bose customer, Joe

A grateful Bose customer creates a personal connection. It reminds the recipient that you're a Bose customer, so you have a connection, something in common. This e-mail isn't as powerful as the other e-mails because you have less information for creating a connection. You're not

even sure if the company hires freelancers or if Susan is the right contact, but you're still setting yourself up with the strongest possible first impression.

Use this formula, change it up to fit the person and company you're contacting, and make it your own. Always be friendly and always be confident. You'll develop a style that sounds like you, and the e-mails will be easier to write.

I JUST SENT A BUNCH OF E-MAILS—NOW WHAT?

Remember, the two goals of this e-mail are to get the client to (1) like you and (2) click on the link to your reel or portfolio site. The same tool you used to track e-mail opens can be used to track link clicks. Set up MailTrack.io so that when they click on your link, you get a notification.

Why is this important? Well, if they clicked your link, you succeeded at reaching that goal.

How do you know if they like you? You're not psychic, are you? You have no way of knowing if they like you or not, but if they reply to your e-mail, you can assume they like you. By the way, "like you" doesn't mean you're suddenly best buddies, but if you did everything right, they like you enough to reply to your e-mail, and now you're engaged with them and can begin to nurture the relationship.

One thing we didn't talk about is your e-mail signature or signature block. Don't get too hung up on it because our focus right now is getting the client to like you. Your signature is more important in phase three, but you can set it up now if you like, when you're sending out your first e-mails.

The subject line, the body of the e-mail, and your web page/portfolio/reel all have certain jobs, and your signature block has a job, too. It makes you look more professional. Here's mine:

Joey Korenman
Founder & CEO
School of Motion, Inc.

e. joey@schoolofmotion.com
w. http://www.schoolofmotion.com

I use a great Gmail extension called WiseStamp to automatically add that signature to every e-mail I send. You don't have to get that fancy, but it's just another subtle detail that adds to the first impression a client gets when they open your e-mail. At the minimum, include your name, your title—for example, Motion Designer, Animator—your phone number, and a link to your website or reel. If you have a logo and it looks good tiny, you can include that as well. Your signature is also a good place to provide links to your social media sites, so clients can get to know you a little without feeling creepy about it. There are social icons for Facebook, Twitter, LinkedIn, Tumblr, and other sites that you can embed, allowing your clients to learn more about you. Adding these icons to your signature invites them to click through to your sites and get to know you better. Of course, only share icons of sites you want them to see.

FOLLOW UP

Your prospective clients' responses to your e-mails determine your next step, the follow-up e-mail. Their e-mail response will let you know if they'll ever want to hire you or not.

Remember, you're tracking your outbound e-mails with MailTrack or another e-mail tracking tool, so if the client didn't open your first e-mail, wait a week, and then resend

the same e-mail with a different subject line. Maybe a different approach to the subject line will get them to click. It can't hurt. You can also try sending your e-mails on different days or at different times, when you think they might be more likely to see it and read it. Experiment with different days and times to see what works best.

The follow-up described here assumes they opened your e-mail.

COOL RESPONSES

Sometimes clients like you but don't have any work for you *at the moment*. Here's an example of a response from a client who isn't interested in hiring you right now:

Hey Joe,

Thanks for reaching out. It's always nice to meet another Floridian Motion Designer. Your work is great, and we will definitely keep you in mind for future projects.

—Dan

This is a cool response—cool meaning cold, not cool like Don Cheadle. They didn't tell you to go away, but they're not ready to hire you either. They did care enough to write back, so you have to respond. If the client says

they'll *keep you in mind for future projects*, don't rely on them to remember you're out there. Send them another e-mail with an open loop and an availability check. Here's an example:

Hey Dan,

Thanks so much. I hope I have a chance to meet you soon. Just FYI, my availability opens up a week from tomorrow.

—Joe Motion

It's OK to include that subtle open loop—*I hope I have a chance to meet you soon*—because this isn't your first e-mail. They responded to and expressed some interest in you. The availability check is also important in this e-mail. The availability check—*FYI, my availability opens up a week from tomorrow*—is a courtesy to them. It lets them know that you understand they don't need you right now and also lets them know you're currently booked anyway. It doesn't matter if you're actually booked or not. They're not going to hire you right now, so why not let them think you're working? More importantly, the e-mail tells them that if they want to hire you down the road, you'll become available at a certain time.

As a freelancer, you might feel like you're opening your trench coat and showing the client your wares with this

e-mail. Look at it through the client's eyes. This person is busy and may be juggling multiple jobs. They may have to hire many freelancers at different points in time to meet a schedule. **The freelancer who gets booked is often the freelancer the client knows is available when they need one.**

A client may have a favorite freelancer, one they always call. But if that freelancer is booked, which freelancer do they reach out to? They call the one they know is available—which is often the one who contacts them at the moment they need a freelancer—so they won't have to call anyone else. This saves them time. That availability check is like a worm on your fishing hook, and your hook may be the only one in the whole pond with a worm on it.

If they still don't book you, put them on your follow-up list. Every three to four months, send them an e-mail with a new link to your latest reel. They know who you are now, and you have implicit permission to follow up a few times a year. I'll show you exactly how to do this and how to *remember* to do this in a bit. But first...

WARM RESPONSES

You're going to get some warm responses from people who

are interested in you right now, too. Here's an example of a warm response from a client.

Joe,

Thanks for reaching out. It's always great to meet another Floridian Motion Designer. Your work is really great. How comfortable are you working with designers to animate their boards?

Typically we pair up designers and animators so they can play to their strengths. We have a busy month coming up and might need help. What does your availability look like, and what is your day rate?

—Dan

If a client asks questions about your work or your rate, they're thinking of hiring you. That's a very warm response. After you've gotten a few warm responses and a few not-so-warm responses, you'll be able to tell them apart quickly. If a client asks questions, it's generally a warm response. Here's how you respond to that warm e-mail:

Hey Dan,

Thanks for the kind words. I actually prefer to work with designers. My favorite projects (the HBO spot on my reel, for example) have all been done as part of an animation/design double team. I also like that the process is much quicker and more efficient this way.

My rate is $500 per day for an eight-hour day, and I'm available starting Monday.

Thanks again, and have a great weekend. We're bringing the kids to Disney World. Wish me luck.

—Joe Motion

Now, let's break this sucker down, section by section.

Hey Dan,

Thanks for the kind words. I actually prefer to work with designers.

They asked how comfortable you are working with designers to animate their boards. Everybody wants a Motion Designer who can do both animation and design, but most people are better at one skill than the other, and good producers know that. The client *really* wants to know if you're a good animator. Here is the rest of your response:

> My favorite projects (the HBO spot on my reel, for exam-
> ple) have all been done as part of an animation/design
> double team.

This confirms that you not only *like* working with designers, but you also *prefer* it, and you even give an example of some work you did that way. The example calls attention to something on your reel that proves you can do what they need. It also reminds them that you have a reel, so if they haven't watched the whole thing yet, now would be a good time for them to do that.

Close that section with:

> I also like that the process is much quicker and
> more efficient.

This tells them you agree with how they do things and think it's a smart way to do them. When you tell the client something they *do* is smart, you pay them a compliment that feels good to them. If you tell them *they* are smart, it's too overt and doesn't feel genuine.

They asked about your rate in the e-mail, and this is where it gets uncomfortable for a lot of freelancers. *Oh no, we have to talk about money!* Here's how you deal with that question: Say it as plainly as you can. Don't embellish

it, don't hide it, and don't couch it with the personal-connection stuff. Get it out there. They want to hire you. They already like the friendly you; now they want to hire the professional you. Make this straight and to the point.

My rate is $500 per day for an eight-hour day, and I'm available starting Monday.

That's it. Separate that line in your e-mail with a space above and below to distinguish it from the rest of your message. Make it easy for them to find. They like the friendly you, but when it comes down to it, they're hiring a professional, so now is the time to act like one. Lay out your terms. Don't be wishy-washy and ask them if your terms are OK or say something like, "Let me know that it's OK with you." Close the deal. They will respect you for it. These are your terms. They're still getting the friendly you, but they're hiring the professional you, too.

Close the e-mail.

Thanks again, and have a great weekend. We're bringing the kids to Disney World. Wish me luck.

—Joe Motion

This reminds Dan that you and he have a personal

connection. You're both in Florida, and you're bringing your kids to a popular destination this weekend. You know Dan has children, even though you haven't talked about it, because you saw his family photo on his public Facebook profile photo.

Close the e-mail with *Wish me luck*. That's a nice, easy open loop. You're asking him to wish you luck at Disney World; you're not asking for free tickets. You're basically just letting him know that you want him to write back at some point.

If your client doesn't live in Florida or doesn't have children, change your e-mail to fit what you do know about them. If they're standing on top of a mountain in their LinkedIn photo, you might write, *Have a great weekend. Looks like it's going to be nice. I'm going for a hike.*

Say something friendly about yourself that you know they'll respond to. You have the seeds of a relationship and can nurture it. Don't get too elaborate; just make small talk. Open up a little piece of your personality, and allow them to comment on it.

There may be more e-mails exchanged. If they keep talking, you keep talking. If they leave you an open loop,

don't leave that open loop hanging. Close that open loop. Keep talking to them until they're done with you.

You may have an e-mail conversation that leads to a face-to-face meeting, which is invaluable. Once the client meets you in person, you have a huge advantage over other freelancers. You're still not overtly asking for work. You're going to play the long game, and it will pay off.

THE FACE-TO-FACE MEETING

In phase one, I advised you to start local because it would give you an immediate connection to your client. Another reason to start local is that it will be easier to get a face-to-face meeting with the client. Don't be freaked out by the thought of an in-person meeting. You're not selling them anything, just building a relationship.

Say you've been going back and forth with that client in Sarasota. He's shown a lot of interest but hasn't booked you yet. So a week or two later, you want to try to meet him face-to-face to build that relationship. Here's how you get a meeting with him. Find the e-mail chain you already have going with him and just reply to it. That way, your e-mail will get to him with the same subject line, and he'll know he already has a conversation going with you. Remember, he gets a lot of e-mails and may not

remember you after just a couple of weeks. Replying to that e-mail thread with the same subject line is going to get you a much higher open rate. Here's what you write in the body:

Dan,

I'm going to be in downtown Sarasota today dropping off some drives for a client.

Are you guys slammed? I'd love to stop by to say hello and meet you in person.

No biggie if it's not a good day.

Hope you're well.

—Joe Motion

That first line about being in town for another client may or may not be true, but it's a viable excuse for being near their studio. Yes, this is another one of these little white lies, but it's a white lie in the service of taking the pressure off them. You're available to meet them, but you're not putting pressure on them to meet you. If they're too busy, there's no guilt and no weird, awkward feeling on their part.

Are you guys slammed? That question implies that you know they're often busy and gives them an opportunity

to say they're slammed without feeling bad about it. YOU KNOW THE DEAL. *I'd love to stop by to say hello and meet you in person. No biggie if it's not a good day.*

The way you ask your clients questions in e-mails affects the way they feel reading them and how they feel about you. At this point, you've shared a few e-mails, and they probably would like to meet you in person. You're asking to meet them in a friendly, no-pressure way and giving them an easy out. If they really are slammed, they can write back and say, *It's too bad we have clients in all day long. It's not a great day. Maybe a different day,* and they don't have to feel guilty because of the way you asked. If they have time, they will ask you to stop by.

Now you get to meet them. Remember, you set the expectation that you're stopping by to say hello. That's it. When you go to that meeting, that's all you do. Your mindset should be, "I can't wait to meet this person, and it will be cool to make a new buddy." Don't carry your portfolio, iPad, or anything to show them. Don't ask for work. Show them that you can be trusted to do what you say you will do. Don't make it awkward. You can tell them how nice it is outside or tell them how cool their office is, but you cannot ask them for work. Trust human nature. The whole goal of this in-person meeting is to make them your friend. Once they meet you, they'll probably ask you about your

work, and that opens the door for you to talk about it. But they have to ask you first.

If you're leaving, and they say something like, "It's been great to meet you. We'll definitely keep you in mind for future work," then it's OK to give them an availability check. You can tell them, "I'd love to work with you guys. Just so you know, I'm booked for the next two weeks, but after that, I'm free. So if something pops up, and you need a hand, let me know." You can only tell them that if they first suggest that they might want to hire you, though; you can't just make that assumption.

NO RESPONSE OR NOT INTERESTED

What if the client opens your first e-mail but doesn't reply? Or if they reply once, you write back, and you never hear from them again? Don't take it personally. They're probably not ignoring you on purpose. There are a lot of reasons clients don't write back. Remember, they get fifty-plus e-mails every day. They may not need a freelancer right now and are too busy to tell you. They may think you're brilliant and want to hire you, but they just don't have a job for you at the moment. Also, you might not be a good fit. You could be trying to "hit above your weight class" and reaching out to companies that you're not qualified to work for yet. If you're e-mailing producers at Buck, Giant

Ant, Psyop, and Royale, they're not going to book you based solely on a nice e-mail. You have to be an amazing Motion Designer, too. Also, some producers like to hire very specific skill sets. They want designers and animators whose work has a certain look. They may not see that look in your work.

So, what do you do if a client doesn't respond or stops responding? Simple: Follow up in three to four months with new and better work. If you're not doing better work and updating your portfolio regularly, how do you expect to get better clients?

You may get a response from a client who says they don't hire freelancers at all, and that's OK, too. Move on. The goal isn't to turn every single lead into a client; that's never going to happen. The goal is to identify as quickly as possible who's going to be a client, and who's not going to be a client. There are plenty of potential clients out there, and the more people you reach out to, the more clients you're eventually going to get.

REMEMBER TO KEEP FOLLOWING UP

Use a Gmail extension like Boomerang or Right Inbox to remind you to follow up. I prefer Right Inbox, and I'll show you how it works. If you write an e-mail to somebody and

know they read it, but after a week they haven't replied, select "remind me" with the plug-in and pick a date to be reminded to e-mail them again. You can now archive that e-mail, and in three months, you'll be reminded to resend it.

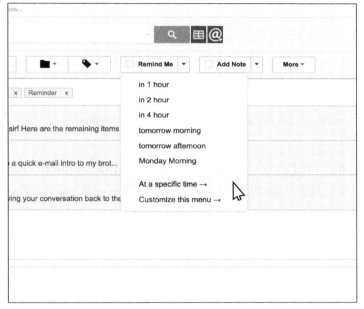

One of My Favorite E-Mail Tools.

If someone replied to you just once, and you're reminded three months later to reach out to them again, find that e-mail and reply to it, but change the subject line. You want it to remain in the e-mail chain, so they're reminded they had a conversation with you. There's a sneaky little button in Gmail that lets you do this.

Change the subject line to something like this:

Subject: Sarasota Motion Designer: Fall 2018 Reel

The point of this e-mail is to remind the recipient that they didn't get back to you, but in the meantime, you've been crushing it. Here's the body of the e-mail:

Dan,

I hope you and the team are having a great summer. Just reaching out to let you know I've got a new reel and a bunch of new work in my portfolio. I've been fortunate enough to get to work on several tough projects with some talented people. I think it shows in this new reel.

You're subtly letting him know that even though he didn't hire you before, a lot of other people did. He's kinda missing out. The word *fortunate* lets him know you're

not cocky: you feel fortunate that you got these great gigs. You're thankful that you got to work on several tough projects with some talented people. Talented people don't work with people who aren't talented, so if you're working with talented people, what does that say about you? Saying it like that also shows you're a team player and gives credit where credit is due.

Again, put the link to the new reel on its own line:

Joe Motion - Fall 2018 Reel

Thanks again for your time, and don't hesitate to reach out with any questions about the work.

Cheers,

—Joe Motion

Another reason you reply to the old e-mail is so the client will realize that they never got back to you. However, you are so professional and organized that you followed up, and that is a *rare* quality these days. If they respond to this e-mail, follow up. If they don't respond, set another reminder for three months later. Repeat the process until they book you. That's it.

We've been writing a whole bunch of e-mails in this chapter, and you may want to copy and paste parts of them to

use for your leads. To make this easier, we've collected every e-mail from the book here: freelance.how/emails. Feel free to use these as is or to tweak them to sound more like you.

THE BIG PICTURE

Once a client responds to your e-mail, you should update your spreadsheet to show that phase two is complete for that contact. You're enjoying an e-mail conversation with them or have set a reminder for a follow-up.

G	H	I	J	
TACTED	PHASE 1	PHASE 2	PHASE 3	BOO
X	X	X	X	
X	X	X		
X	X			
X	X			

Feels Good to Check That Box.

The purpose of going through this whole process is to find new clients, approach them, get them to like you, and start a conversation that will get you booked. In reality, you're not going to get booked most of the time. This is a numbers game that also depends on the strength of your work. You might get clients quickly and end up with more

work than you can handle. On the other hand, if you're new and your work isn't that great yet, you might e-mail twenty clients and get booked only once or twice. That's not only normal, but it's also completely OK. When studios look for work, they face a similar problem. They need a certain amount of work to pay the bills and a certain number of clients to get that amount of work, so they have to approach a certain number of leads to get those clients. It really does become formulaic after a certain point. Start thinking of this as a numbers game, and once you figure out how often you get booked based on how many people you approach, you'll know about how many companies you need to find and approach to reach your client goal.

And now, just like that, you're one step away from getting booked. Congrats! The most uncomfortable part of this process is over—and hopefully, it doesn't seem so scary anymore. Now comes the really fun part: getting booked.

CHAPTER 6

PHASE THREE: I TRUST YOU

Take a minute and reflect on what you've done so far. You're basically right on the brink of getting booked, and nothing you've done so far has been very hard, has it? You probably went into this a little bit nervous and thinking you'd have to do some really difficult things. Hopefully, you're seeing this isn't difficult at all. It might make you a little bit uncomfortable, but even that starts to go away after you've written a few e-mails and gotten some responses.

At this point, you're probably talking to clients who want to book you. But first, you need their trust to close the deal. After you get booked, you need to continue to establish trust so those clients continue to book you.

Gaining the client's trust just means reassuring them that if they hand you money, you'll do what you said you would do. As a Motion Designer, you're used to handling the creative side of your job, but you may not be used to handling the business end of the job. Don't worry, phase three is no harder than phases one and two.

The goals of phase three are simple. You need to show the client you're good enough to hire and won't flake on them. Then you need to get booked and paid.

SHOW THEM YOU'RE GOOD ENOUGH

"Good enough" varies depending on the client. If you approach one of the top studios in the world, you better be a damn good Motion Designer. If you approach a local marketing agency, you can be an average Motion Designer and still get work. You're going to show them you're good enough with your portfolio website and showreel.

FIRST IMPRESSIONS

The first impression you make with a client is critical. Just as you put careful thought into the first two phases, where you got clients to know and like you, you need to put just as much thought into that first impression that will make them trust you. It's not hard to create a good first impression, but it's very hard to overcome a negative one. When a client lands on your site, they need to see that you're a legitimate Motion Designer and can do the work they need. Here's how you do that.

GO LEGIT

Let's start with the easy stuff, the low-hanging fruit. Get your own URL. Never use a Vimeo or other video-sharing website link to showcase your work. This isn't 2003, when getting a URL was difficult. It's ridiculously easy, and in about five minutes, you can have your own domain name

with a website on it and your own e-mail address. If you don't do it, you seem lazy to clients. DON'T BE LAZY.

Getting your own domain and a URL that directs a client to your site is incredibly cheap, too: just a few dollars a year. It shows the client you care and take your work seriously enough to set up your own site. You can register your domain name on GoDaddy.com or any other domain-registration site. Pick a name that's short, simple, and easy to spell. You can use your own name for your domain or make up a name. You can use the standard ".com" extension or get fancier. It doesn't really matter. Many Motion Designers use the extension ".tv" because it insinuates their site has something to do with television. Fun fact: The ".tv" extension actually stands for Tuvalu, an island in the South Pacific, which has nothing to do with Motion Design. There are many other cool extensions like ".design" that you can find and use. But whatever you choose, make sure it's not so complicated that it will be difficult for your clients to remember it. Some good examples of Motion Designer domain names are TwistedPoly.com (cool name for Nejc Polovsak's site), RichNosworthy.com (first and last name, which is easy to remember), AxPope.com (Alex Pope abbreviated, clever), Michael-jon.es (Michael Jones, super clever), and Jodie.Work (for Joe Donaldson's work).

If you have a name that sounds good and is easy to spell,

that might be your best choice for your domain name. If your last name is difficult to spell, like *Korenman*, you may want to try a variation like JoeyK.com or JoeyK.tv. Your name is always a good choice for your domain name because it's your calling card and will never change. When a client goes to YourName.tv, they know they're looking at your Motion Design portfolio. You can update your website, reel, and logo, but your name will never change.

What if you don't want to use your name? You can make up a company name, but be careful to choose one that won't sound dated in time. It must be a name that will still be valid years from now. Pick a name that will have longevity and you won't want to change—ever. Also, I suggest you don't try to make yourself sound "bigger" by coming up with a name that implies a larger company. "Twisted Poly" sounds like the MoGraph version of a cool band name and works for a solo artist, but "Cleveland Design, Inc." sounds like an established business, not a freelancer. Be careful if you're not using your own name or some variation of it.

Another advantage of using your own name for your domain is that it shows your clients they're hiring you, not a faceless company. People don't care about companies; they care about people. You want your clients to care about you. People don't trust companies; they trust

people. Your goal is to get them to trust you. JoeyK is easier to like and trust than Sarasota Productions.

If you plan on becoming a company, then it's OK to come up with a company name; but if you do that, you're not a freelancer anymore. If you're a freelancer, it's usually best to stick with your name, or a simple nickname, for your domain.

Get your own e-mail address at your domain name. You can do this with Gmail for Business for a few bucks a month. A personalized e-mail address is inexpensive and will make you look far more like a pro. This may seem like a tiny detail, but it sets you apart from freelancers with an @gmail e-mail address. *joey@joeyk.tv* sounds a lot better than jkdesign47*@gmail.com.*

You'll need to choose a hosting service for your portfolio site that holds and maintains it on the Internet. Inexpensive, easy-to-use services like Squarespace, Wix, Adobe Portfolio, and Behance let you create a portfolio site from beautifully designed templates that work on mobile, iPads, and iPhones. These are cheap and easy to set up, so there's no excuse for you to not have a professional, great-looking portfolio site. I recommend keeping your site simple and easy to maintain, so doing a super custom WordPress site

might seem like a fun idea, but it's almost never worth the extra hassle for a freelancer.

WHAT DOES YOUR PORTFOLIO SITE LOOK LIKE?

You have your own domain, website, and e-mail address. You've e-mailed a new client and included a link to your site. Put yourself in their shoes and think about what they see when they click on the link. Again, the first impression is extremely important.

The first thing your client sees should be a bunch of beautiful work. They should not see a splash page or have to navigate menus or click on anything to see your work. It needs to be front and center. It doesn't matter if the work is commercial or not; in fact, your best work may be personal projects. This is what we heard from a client who took our survey:

"IF THE WORK IS BEAUTIFUL AND INTERESTING AND DIFFERENT, IT DOESN'T REALLY MATTER WHO IT'S FOR."

And here's an example of what a website should look like:

My buddy Nejc's site, TwistedPoly.com, has no fluff. You arrive, and you're presented with carefully curated thumbnails of selected works that show off his skills in the best light. That's all you need. It shows the client you're confident in your work.

The format of your portfolio is also important. Don't get too fancy. Use a simple grid pattern with thumbnails of your best work. This format works very well, so don't reinvent the wheel. Hosting services all have grid-format templates that make it easy for you to create your site. You can add

labels to the thumbnails to briefly describe each piece, or use a label that appears when you roll over a thumbnail like on Nejc's site. These features are built into platforms like Squarespace; you don't have to know any code or be an IT person. If you can do different types of work, like 2D and 3D, be sure to include that variety, so clients can see at a glance you're not a one-trick pony. To see another example of a great-looking site, go to axpope.com.

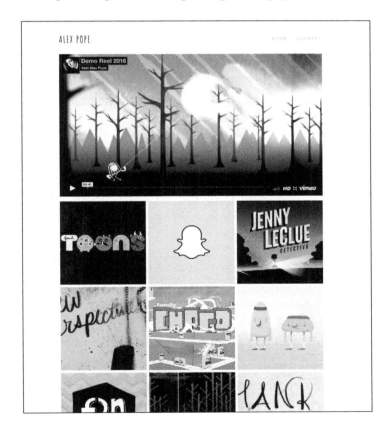

Alex Pope does beautiful work, and her site shows variety. Some of it is commercial and some isn't, and frankly, you can't tell the difference until you click through and start reading about each project. What's important is that it's all beautiful.

Look around at other freelancers' sites for inspiration. If you find a site that you really like and just want to use the same host/template, you can do a bit of detective work to find out. If we right-click on Alex Pope's page and select *view page source*, another browser window will open that shows the source code written in HTML. Scroll through the code and look closely to find the name of the hosting site.

```
 3
 4  <head>
 5    <meta http-equiv="X-UA-Compatible" content="IE=edge,chrome=
 6
 7    <meta name="viewport" content="width=device-width,initial-s
 8
 9    <!-- This is Squarespace. --><!-- axpope -->
10  <base href="">
11  <meta charset="utf-8" />
12  <title>Alex Pope </title>
13  <link rel="shortcut icon" type="image/x-icon" href="/favicon.
14  <link rel="canonical" href="http://www.axpope.com/"/>
15  <meta property="og:site_name" content="Alex Pope "/>
16  <meta property="og:title" content="work"/>
```

Alex Is a Squarespacer.

The HTML on Alex's site shows it's hosted on Squarespace, and while the template isn't readily apparent, you can now go to Squarespace and find that template to use for your site. If that's too much work, Google "Which Squarespace

Template" to find some sneaky ways to get that info from the HTML, too.

Alternatively, in the source code window, you can hit Ctrl-F to bring up the search bar to search for keywords, like *Squarespace*, *Adobe*, and *Wix*, which give you this information. If you find the word *WordPress*, you know the site is running WordPress. Then, search for the word *theme* to find the name of the template or theme. Here's the code for Adam Kois's site, AdamKois.com.

```
ant;
  href="http://www.adamkois.com/wp-content/plugins/contact-form-7/includes/css/styles.css?ver=4.5.1">
  href="http://www.adamkois.com/wp-content/themes/studiofolio/assets/css/bootstrap.css">
  href="http://www.adamkois.com/wp-content/themes/studiofolio/assets/css/responsive.css">
  href="http://www.adamkois.com/wp-content/themes/studiofolio/assets/css/light.css">
  href="http://www.adamkois.com/wp-content/themes/studiofolio/assets/css/fresco.css">
  href="http://fonts.googleapis.com/css?family=Lato%3A300%2C400%2C700&#038;ver=4.6.4">
vascript' src='http://www.adamkois.com/wp-includes/js/jquery/jquery.js?ver=1.12.4'></script>
vascript' src='http://www.adamkois.com/wp-includes/js/jquery/jquery-migrate.min.js?ver=1.4.1'></script>
vascript' src='http://www.adamkois.com/wp-content/themes/studiofolio/assets/js/vendor/modernizr-2.6.2.min.js
vascript' src='http://www.adamkois.com/wp-content/themes/studiofolio/assets/js/plugins.js'></script>
vascript' src='http://www.adamkois.com/wp-content/themes/studiofolio/assets/js/main.js'></script>
.w.org/' href='http://www.adamkois.com/wp-json/' />
  type="application/json+oembed" href="http://www.adamkois.com/wp-json/oembed/1.0/embed?url=http%3A%2F%2Fwww.
  type="text/xml+oembed" href="http://www.adamkois.com/wp-json/oembed/1.0/embed?url=http%3A%2F%2Fwww.adamkois
/css">
```

Adam Kois Is Running the StudioFolio Theme for WordPress.

You can look at the source code to discover the tools other Motion Designers use, and then you can use them, too. Again, don't reinvent the wheel. The client isn't judging you on the uniqueness of your portfolio-site layout; they're getting a first impression of your work and judging you on quality. It's really tempting to make your site fancy and unique to show how creative you are. If you're a Motion Designer, you're creative, and it's easy to go down that rabbit hole, but you're wasting your time because clients

don't care about that. They're not hiring you to design a website. Make it easy for them to view your work.

Once a client lands on your portfolio site, they're going to look for your showreel. Make it obvious and easy to locate on the page. Let's look at Zack Lovatt's page at zacklovatt.com.

There's a direct link to his reel on the left menu bar, and that's one way to do it. You can also make a link to your reel on one of your thumbnails, and label it *Reel*. That's what Rich Nosworthy did on his site, richnosworthy.tv.

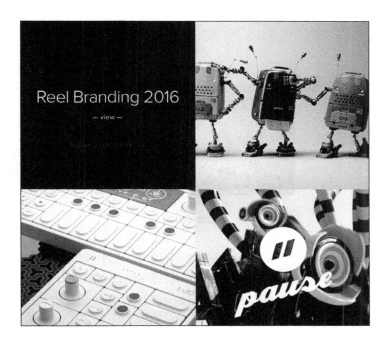

A trend I'm seeing more and more of is to just show the reel right up front and put the rest of the work in a separate "Work" section. This tactic almost guarantees your reel will get a look, but it does minimize the initial "wow" reaction a client might get when they see a dozen thumbnails with different art on each one. Either tactic can work. Here's Kyle Predki's site, kylepredki.tv, which puts his reel right in your face when you arrive:

However you show off your reel, make it obvious, so the client doesn't have to search for it. You may want to name it *Spring 2017 Reel*, or *Winter 2018 Reel*, or whatever the season and year is when you created it, so your client knows it's your most recent work. If it's old, don't note the season or year.

Reels work well for animators because they have video and Motion Graphics to edit together. If you're primarily a designer who creates style frames and boards, it's tougher to make a reel. Don't force it. The client is hiring you for your design work, so they don't expect to see a reel, but you should have a lot of great design work to show them on your site. Check out My Tran's site, misstran.com, to see how great a portfolio can look, even without a video reel.

SHORT REELS ARE BETTER

Keep your reel short. It may be tempting to make a two-minute reel to show a client all the work you've done and make it seem like you've got this *body of work*, but don't do it unless you are a serious MoGraph rock star. The old adage "less is more" applies here. If you look at the reels of the best animators in the world, you'll see they're not much longer than one minute.

Check out the reels on Sander Van Dijk's site at sandervandijk.com or Kyle Predki's reel on kylepredki.tv. Both are just over a minute. Your reel doesn't need to be any longer than forty-five to sixty seconds. If you're new, even just thirty seconds is fine. If you're amazing, go ahead and make a ninety-second reel but know that it might be too long to hold your client's attention. Think of the reel as the appetizer; its job is to make the client want more.

A MONTAGE IS JUST YOUR BEST BITS, I WANT TO SEE IT ALL. EVERY CLIP FROM BEGINNING TO END. AND WHAT YOU THINK IS GOOD OR RELEVANT MAY NOT BE THE SAME AS ME.
—ANONYMOUS QUOTE FROM OUR SURVEY

A short reel also shows you know how to identify your best work and curate yourself. You've got to have good taste in this business. If you put even one crappy thing on your

reel, the client will question your judgment. Bad work will also "dilute" the rest of your really great work. Don't put anything in your reel that isn't top shelf.

If your reel isn't sexy enough to get the client to stay on your site, you're not a good fit for them. They're not going to book you, so move on to the next client. If they're still with you, that's awesome. Now they're going to look at some of your complete pieces.

SHOW AT LEAST TWO OR THREE PROJECTS

Most producers want to see at least two or three full pieces. Obviously, more work is fine when it comes to showing the breadth and variety of your work, but you should also curate and prune which full projects are on your site. Every piece should represent your best work, so you need to regularly flush out the old and replace it with newer, better work. If you have one bad piece, the client is going to question the rest of your work. They'll wonder whether you did only a small part of some cool piece, and the people you collaborated with did all the beautiful work. Again, less is more, so show only your absolutely best work.

**IF I SPOT AN "EYESORE" THAT ISN'T FULLY REALIZED—
BUT IS STILL ON THE PORTFOLIO…I'LL QUESTION
TASTE AND WHERE THE REST OF THEIR WORK
CAME FROM/WHO ELSE DID THEY WORK WITH.**

—ANONYMOUS QUOTE FROM OUR SURVEY

If you have work that doesn't represent your skill, don't put it on your site. Here's a hypothetical situation. You're hired to work for one of the top Motion Design studios in the world. You're working on a project with some of the most talented designers on the planet, but they soon realize you're not very good. They still need someone to do some of the work, so they keep you on. You have to do multiple revisions, other people are fixing your work, and you're stinking up the place. The project is completed, but the client will never hire you again. That project is stunning, and you *did* work on it. Can you put it on your site? Yes, but maybe you shouldn't. That's a misrepresentation of your talent, and if a client books you and realizes you're not one of the most talented Motion Designers on the planet, they're going to be disappointed, and they'll never trust you again.

Or if you used After Effects to animate some type at the end of a sixty-second fully CG spot that you didn't do anything else on, it's a bit disingenuous to put that piece in your portfolio without any explanation. But if you were

a productive, valuable member of a larger team that created something awesome, there is a way to include the piece in your portfolio in a manner that highlights your role in the process.

USE PROCESS IMAGERY

If you were a small part of an impressive, collaborative project, you can include it by showing some process imagery and doing a write-up that explains your actual contribution to the piece. Frankly, this is one of the best ways you can get new clients to trust you. Case studies are a very powerful tool. Process imagery is also a great way to show the client all the work that went into a project. Let's go back to Alex Pope's page at axpope.com.

School of Motion hired Alex to create two characters for a course about character animation. She created the blue and orange guys you see in one of her thumbnails.

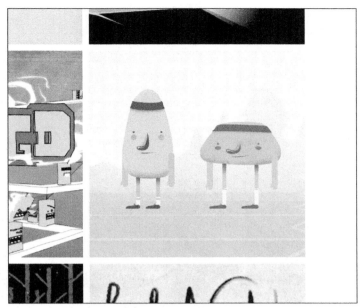

Squash and Stretch from Character Animation Boot Camp.

They're cute and well designed, but just looking at them doesn't tell you anything about how she created them. Click on the thumbnail below to view the final product, and you'll see she shows the entire process for creating the characters.

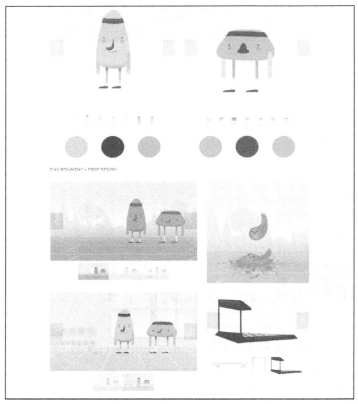

Early Tests, Value Studies, Color Palettes...the Process.

Alex started with pencil sketches, then moved into simplified versions in Adobe Illustrator with different looks, different noses, different mouths, and different eyes. She did some color-palette studies and shading and created seven different character designs before selecting the best ones. Alex shows you her process, and you can see she knew exactly what she was doing every step of the way. Her case study is a perfect example of showing clients that

she didn't just get lucky and manage to come up with some cute characters. She worked and made it happen through a consistent, repeatable process. Nothing on your site creates trust faster than letting a client see your process.

Don't worry about sharing your proprietary processes. You may have an inclination to keep those cards close to your chest—how you actually create your work—because you don't want to expose all your secrets. I understand that feeling, but the reality is, knowing how to do something and being able to do it are two different things. You could tell someone exactly how you did something, and they still wouldn't be able to do it. Share everything. It will come back to you tenfold.

Twisted Poly—my buddy Nejc, pronounced "Nates"—goes one step further with video breakdowns of projects showing what he does in Cinema 4D and how he does it. He records his screen as he's working and shows what worked and what didn't. He edits these screen recordings, failed renders, and final products into a short breakdown/tutorial of sorts and includes them on the page with the final pieces. These are fun to watch and show all the work that goes into his projects. They convince you, once again, that he's an expert. Notice he's not afraid that someone else is going to do what he does by looking at his breakdowns.

Check Out the "Mothership" Breakdown on Nejc's Site.

You can also add a blog to your site describing experiments you're doing with your work to show that you don't just do the work you're paid to do but are continuously working to improve your skills on your own time. Matt Frodsham, another incredible artist, blogs about his work at mattfrodsham.com/blog. He does write-ups about experiments he's doing, and he shows you how he does them. It's a very smart way to show his mastery of the craft and to let clients get to know him even better.

Finally, use your best judgment when showing a process. If you animated a simple logo, don't make it look like you had an elaborate process. Clients can see right through that. Here's a quote on that from our survey:

*IF THEIR PROCESS IS INTERESTING AND WORTH SEEING,
IT'S VALUABLE. IF IT'S AN OVER-THE-SHOULDER SHOT OF
SOME ASSHOLE HOLDING A PENCIL, THEY'RE AN IDIOT.*

—ANONYMOUS QUOTE FROM OUR SURVEY

YOUR FRIENDLY, CONFIDENT VOICE

Getting a client to trust you based on the quality of your work is the primary goal of your portfolio site and reel. These also give insight into your personality. You got them to like you in phase two, but they can come to like you even more in phase three. When they like you more, they trust you more, and this creates a feedback loop that gets people excited to book you on something because you clearly know what you're doing and seem so likable. You can really help this process along with a simple *About* page. Let's look at Nejc's *About* page at twistedpoly.com/about.

Nejc has the goods, and he could brag all day long about his awards, incredible 3D skills, and brilliant creative mind, but that's not what he does. His *About* page could not be any simpler. It's a picture of him looking friendly and a little paragraph about him that focuses mostly on how much he loves what he does. There's also a list of interviews, features, and awards, but most people don't even look at that. These are little trust indicators, but people are focused on the photo and the friendly paragraph. Here's my favorite line from his bio: "With 8 years of experience in the industry, the last 5 years of that being freelance, I've been fortunate enough to collaborate with some of the world's top creative studios, agencies and individuals."

Does that wording ring a bell? Nejc feels "fortunate" to have been able to collaborate with talented people. It's very close to what we wrote in our follow-up e-mails in phase two. See the pattern here?

The first impression a client has of Nejc is that he's a talented Motion Designer who's also humble, friendly, and probably a cool dude to work with. The goal of your *About* page is to show clients you're friendly, confident, and a nice human being. You're not a brilliant Motion Designer who's also a jerk or pretentious Artist they will regret hiring.

Nejc also has his e-mail address clearly listed so clients can contact him directly. If you want work, make it easy to contact you. Don't use a contact form, despite the fact that you might get some spam by having your e-mail address out there publicly. It just creates *friction,* an extra hoop your client has to jump through to book you. You *may* get some unwanted e-mails, but it's worth it to make it easy for clients to connect with you directly. You can also list your phone number if you're OK with clients calling you. By listing your e-mail and phone, you're telling clients you trust them, and it will be easier for them to trust you.

Another good example is Bee Grandinetti's page at beegrandinetti.com/about. There's a cute self-portrait illustration that's in keeping with her skill set, and the story she tells is one of a worldly, humble, and very likable person. Your impression is that Bee is warm and fun, and you want to work with her.

Sure, you can also list your awards, what software you know, and your college degrees on your *About* page, but your photo and the friendly paragraph you write about yourself are much more important.

Check out Nejc's and Bee's *About* pages, and follow their lead. They're doing it right.

SHOW THEM THAT YOU WON'T FLAKE

You need to show your clients you won't crash and burn on them and fail to do what they hire you to do. They should feel comfortable that you'll get it done. Convince them that you're a reliable Motion Designer, and this is your professional career, not something you do in your spare time. There are several ways to show your client you won't flake.

REFERRALS

Using a referral to prove your credibility is a slam dunk. It's harder to get a referral when you're starting out, but once you freelance for a while, you'll meet other freelancers, as well as producers and studio owners. These people are all potential referrals.

Let's say you want to get your foot in the door at a cool Motion Design studio called Newfangled. You know from their website that your contact is an executive producer named Macaela. Your buddy Ed, another freelance animator, worked at Newfangled, and you want him to refer you to Macaela. Here's your e-mail:

Subject line: Hey, Ed, I'm about to owe you a beer

Ed,

I just updated my reel. I want to shoot it over to the fine folks at Newfangled. I know you've worked with them before. Macaela's the EP, right? Would you mind doing a quick e-mail intro?

Thank you so much. All the beers will be on me.

Joe Motion

You can also say, "I'll owe you a coffee" or "I'm about to

owe you a high five." Beer, coffee, high fives—those are all things you can barter with for a referral.

Now, there's one more move, a ninja, black-belt e-mail move you can pull that will increase the chances of getting a referral and speed up the process. We're going to make one tweak to that e-mail we just wrote Ed. At the bottom, we would say something like, *By the way, I know you're slammed, so if you're cool to do this intro but don't want to write an e-mail, just use this one.* Then you literally write the referral e-mail for Ed so he can copy and paste it.

Here's an example of the referral e-mail you'd provide:

Subject line: Macaela, meet Joe (freelancer/Animator/bud)

Macaela,

I'd like to introduce Joe Motion, a local freelancer who's worked with me in the trenches many times. His animation skills are top notch, and with all the growth Newfangled has seen lately, I thought it might be a great time to put you two in touch.

Joe,

Macaela runs Newfangled, one of the best studios in town, and I'm not just saying that because they book me and let me use their coffee machine. Ha, ha, ha. Great people, great work. I hope you two hit it off.

This is a really strong move because if you have a good relationship with Ed, he's probably going to be floored that you actually took the time to include a boilerplate for him. If he wants to refer you, he literally just has to hit Copy/Paste into a new e-mail and it's done. Obviously, use common sense here. If you ask someone you barely know to do this, it won't work. And it works best if you've already also referred that person to a client, so don't be stingy with referrals for others.

Notice that the subject line in the referral e-mail is similar to the one you wrote in phase one: *Macaela, meet Joe (freelancer/Animator/bud)*. Macaela's a busy studio owner who gets a lot of e-mail, so you need to use trigger words to ensure she opens the e-mail. Using Macaela's name is appropriate because Ed knows her. Then, in a few words, Ed introduces her to Joe, a freelance animator who's also Ed's friend. Short, to the point, and trigger-rich, the subject line guarantees an open e-mail.

The body of the e-mail is written as if you're addressing two people in a room. Address the studio contact, then address the referred freelancer. Ed reminds Macaela that she booked him and let him use her coffee machine. Change this detail to whatever makes sense. It's less "salesy" and more personal and reminds Macaela that she and Ed have something in common—work and

coffee. Then Ed introduces Joe. He doesn't tell Macaela she should hire Joe because that would be an open loop. He merely makes the friendly introduction laced with compliments about Newfangled and information about freelancer Joe.

Ed may choose to write his own e-mail, but by *suggesting* how that e-mail gets written, he'll likely follow your lead and use the tactics that we've been talking about in this book, without even knowing he's doing it.

Once Ed has introduced you to Macaela, don't wait for her to make the next move. "Reply all" to the e-mail, addressing Macaela:

Hi Macaela,

Great to meet you, and for the record, I agree with Ed. New-fangled's work is fantastic. Ed put it very eloquently, so I'll just leave this link to my reel and portfolio here:

JoeM Reel

I hope we can connect soon, and don't hesitate to con-tact me with any questions you may have about my work or experience.

Thanks for your time.

Joe Motion

E-mail address

Phone number

You don't have to sell yourself in this e-mail because Ed's already done that for you. You do have to provide a link to your portfolio and your contact information. Use friendly and concise language because you're a nice person and respect her time. Because Ed connected you, Macaela is ready to trust you, and she's convinced you won't flake.

Using a referral is easy and builds trust with far less effort on your part than a lot of the other things you have to do to freelance, which might give you the impression that it's just "sort of" effective. This is *insanely* effective. If you get a referral from someone who's already freelanced

or worked in some capacity for a company, you're in. You get to skip phase one and phase two and go right to phase three.

SOCIAL PROOF

Another way to prove to a client that you won't flake is with social proof. Social proof refers to the subtle, often subconscious signals we pick up on that tell us things about people. They aren't blatant or obvious, but we notice them. You can use social proof to show a client you're a seasoned professional and can be trusted without having to come out and say it. This can be done in a very heavy-handed way or with a light touch, and you probably don't need me to tell you that you're going to want to use the light touch.

When you create a grid of thumbnail images for your portfolio site, you choose an image from each project to display in each thumbnail.

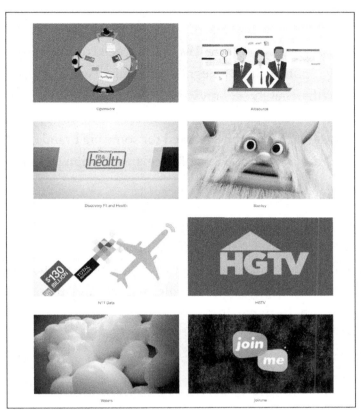

Colin Jackson's Site: colindavidjackson.com

Some templates automatically pick a thumbnail for you, but you can change that and select an image that's going to get the client's attention. If you've worked on known brands, choose images that show the logos in some of your thumbnails. For example, on Colin Jackson's site, colindavidjackson.com, one of the thumbnails shows the HGTV logo nice and big. If you look at the work on that project, the logo is the least cool part of it, but featuring

a well-known brand like that in the thumbnails is a subtle way to say, "I've done real work." You need to do this sparingly. Sprinkle those types of thumbnails in with the sexier ones that merely say "my work looks good." Using brands sparingly is social proof. Just a couple of logos or labels show the client you've worked for some big brands, and you're a talented and reliable freelance Motion Designer.

Here's another example. Lilian Darmono does a "rollover state" on the thumbnails that shows the client's name, which is very cool and subtle. Without seeing the client, you just see amazing work, but when you go to click on a thumbnail, suddenly "Google" pops up and impresses you with the name drop.

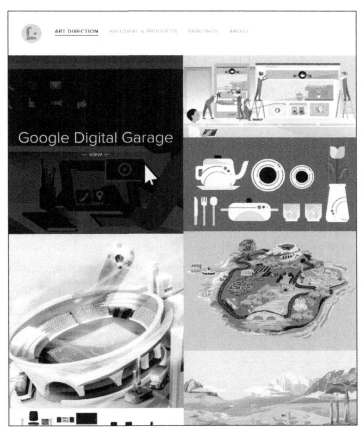

Until You Rollover This Tile, You Don't Know This Project Was for Google.

If you're starting out, remember that cool work trumps a well-known logo every time, but you can still give social proof even if you don't have any big brands to show off.

If you haven't done much or any work for a known brand, use whatever you have that looks the most "legit." For example, if you did a commercial for a local store's Black

Friday sale, use a frame from the spot where "Black Friday Sale" is visible—assuming it's a good-looking frame—because clients associate those sales with big companies like Macy's, Target, and Best Buy. When the client clicks the thumbnail, they'll see what the project really entailed, but that initial burst of social proof sticks.

Zack Lovatt has a thumbnail on his portfolio for what appears to be a lottery of some kind. When I see it, I think of big state-run lotteries, which tend to spend serious money on advertising, suggesting that somebody trusts Zack enough to hire him for something of that magnitude. Instant social proof. Upon further inspection, it's a spot for an in-store promotion at a supermarket, but that first impression from the thumbnail sticks.

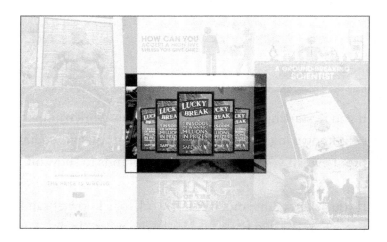

Having name brands on your site isn't critical, but it helps. A creative director told me:

BIG BRANDS TELL ME THERE'S A HIGHER LIKELIHOOD THEY'VE BEEN BATTLE TESTED AND I DON'T HAVE TO WORRY AS MUCH ABOUT THEM FLAKING OUT IF WE GET CRAZY REVISIONS OR HAVE TO PULL SOME LATE NIGHTS.

—ANONYMOUS QUOTE FROM OUR SURVEY

The trust phase is about convincing a client that if they give you money, you'll do what they ask you to do. That might involve late nights or last-minute revisions. Using big brands bolsters their trust in your reliability so if they have to ask you to work late, they know it won't be a big deal because you've probably done it before. So show it if you have it, but keep in mind that big-brand work often involves low creativity, so these pieces may not be the best examples of your talent. Use them sparingly, but use them.

THE HOLD SYSTEM

And now we get to the dreaded hold system. It's an unfortunate reality of getting booked as a freelancer. You can love it or hate it, but either way, it exists. Most clients use the hold system, and you have to abide by it. There's

nothing inherently wrong with the system, but the potential for abuse gives it a bad rap. Here's how it works.

Think of the hold system as dibs—calling dibs on your time. The system was invented because your clients aren't always sure when they're getting a new job. A company might ask them to bid on a project, but the company may or may not select them to do the work. Your potential client has a potential job, and they potentially need a freelancer to help them. They're not ready to book you because the work isn't guaranteed, but they need to line you up in case they win the bid. There are also other circumstances that can create this situation. Maybe a staff artist is going on vacation, and the company is worried they might get busy while they're gone, so they want a backup on deck. Whatever the reason, clients are not always positive they will need a freelancer, but if they do, they need to know they can get one right away. It's really tough to book a freelancer on super short notice, so the hold system helps producers plan ahead. Here's a common scenario that plays out all the time.

Client A calls to let you know they may have some work in two weeks. You're open in two weeks, so you allow them to put a "first hold" on you for that time. They're calling dibs on your time and might book you in two weeks.

M	T	W	R	F

First hold - Client A

Client A Has Dibs on That Week.

Then another client, client B, calls, and they might need you in two weeks, too. You have to tell them another client has a first hold on you, but they can have a second hold in case the first job falls through. Client B has the second hold on your time.

First hold - Client A
Second hold - Client B

M	T	W	R	F

Client A Has Dibs; Client B Can Book You If Client A Falls Through.

It might seem terrific to have two clients holding your time, but all you really have is a whole bunch of nothing. No one has booked you. Then client B calls with good news. They were awarded the job and want to book you. Hooray, you think, you're getting booked. The problem is, client A has a first hold on you so you need to remind client B of that and give client A twenty-four hours to book you for the same amount of time as client B's offer, or else they "release" you and lose their hold. Often, what happens is, client A doesn't release you and tells you they want to book you. This works out great for client A because

they can wait until the last minute to book you. It screws client B, who still needs a freelancer, and now you have to tell them you're not available. They'll understand; it's part of the game, but it stinks for them. You're going to feel bad about it. The system, while fair in theory, leaves a bad taste in client B's mouth, and they may be reluctant to call you the next time.

Another issue with the hold system is that some clients abuse it. I had a client who used to put first hold on me for two months at a time, so every time I got a call from another client, I had to wait up to twenty-four hours to accept or decline the job, which sucked because it made my life difficult and probably cost me time and money.

Here's the biggest issue with the hold system. Say you have a bread-and-butter client A who books you all the time and pays your bills. They're in the Pain category and the work is crappy, but they pay so much you don't care, and you always give them first hold. Then Buck calls. You've been trying to get into Buck for three years and this is your dream gig. But you have to call client A before you accept the offer because they have first hold, and you know they're just going to book you.

You can't blow off client A. The surest way to never get

booked by a client is to back out of a booking or a hold. This topic was mentioned in our survey.

> *IF THEY BACK OUT OF A BOOKING, MESS AROUND WITH FIRST AND SECOND HOLDS, OR IN ANY WAY MISCOMMUNICATE THEIR AVAILABILITY, THEY WILL NEVER BE BOOKED AGAIN.*
>
> **—ANONYMOUS QUOTE FROM OUR SURVEY**

Yeesh! Producers take this stuff very seriously, and if you bail on them once, they'll never call you again. That may seem harsh, but look at it from the client's point of view. When that producer has a hold on you, it's a huge weight off their shoulders to know if a job comes through they have someone to do it. You can't back out of a hold. Your other option is to turn down the offer from Buck, and you definitely don't want to do that.

There's a solution, and it's especially helpful if you work with clients who keep lengthy first holds on you and seldom or never book you. It's not perfect and has its downsides, but it can be a lifesaver if applied to the right clients. The solution is to have a first hold on yourself all the time. Keep in mind, your clients never know who has a first or second hold on you, and you are under no obligation to tell them. You never discuss that with other

clients. No one knows that but you. If you have a permanent first hold on yourself and that bread-and-butter client calls, tell them someone else has first hold, but they can have a second hold or challenge the first hold to book you immediately. They don't need to know the person who has the first hold is you.

First hold - Yourself				
M	T	W	R	F

Hold Yourself Tightly.

Let's say your client accepts the second hold. Now if a different client calls with work, you can accept it if you like, and then let the first client know your first hold came through and you won't be available. If that second client called to put a hold on you, tell them they can have second hold. Now you have two clients who believe they have second holds on you, and you have some time to decide which job you're going to accept if they both come through. You have more control over the work you choose to accept, there are no bad feelings, and you won't damage your reputation with either company or put your future work with them at risk.

First hold - Yourself				
Second hold - Client A				
Second hold - Client B				
M	T	W	R	F

Two Second Holds—Pick Which One You Want.

There are some risks with playing the hold system. If a client has you on second hold, they may feel less confident that you'll be bookable should they need you and may reach out to other freelancers, so you may not get the work. Also, you need to keep track of the days you promised clients who have holds on you. Block out those hold times on a calendar so that if a client calls, you can tell at a glance if you're available or if they're a second or third hold. Don't get double-booked or make a mistake and have to back out of a booking, and **never, ever tell a client you have a first hold on yourself.**

The hold system is well known among studios, but some smaller marketing agencies may not be aware of it. Explain it them, and they will appreciate learning about it.

GET BOOKED

If you're doing everything I've shown you so far, eventually this magical thing called "getting booked" happens. Congratulations! You got through phase three, and a client wants to hire you. Holy crap, now what?

If you aren't booked yet, there's a little more work to do: following up. You might think this is scary or difficult, but it's not.

The e-mails you sent in phase two have a half-life. Even if the client read your e-mail, clicked on the link, looked at your portfolio, and wrote back to you, they may not have booked you because they didn't have any work for you. Now they've forgotten you. You need to remind them of how awesome you are—in a nice, humble way, of course. Use your Right Inbox tool to remind yourself to reach out to them every three to four months until they book you.

Choose a specific date & time

Select date time timezone (optional)

OR

Type date & time or duration show examples

in 3 months Fri, Jun 30th 8:00 AM (local time)

Add reminder Close

Let the Internet Remember for You: You'll Just Forget.

Use this e-mail template to remind them how awesome you are, to praise them, or as an availability check—you remember that from phase two, right?—to let them know you have some time if they have work for you.

For each of these, reply to the original e-mail chain, so they have the history of e-mails to remind them that you've already reached out to them. Change the subject line of the e-mail to reflect some new information. Here's an example of an "I'm still awesome" e-mail:

Subject line: Sarasota Motion Designer, Summer 2017 Reel

Stewart,

I hope you and the team are having a great summer.

Just reaching out to let you know I have a new reel and a bunch of new work on my portfolio. I've been fortunate to get to work on several tough projects with some talented people, and I think it shows in the new reel.

Joe Motion - Summer 2017 Reel

Thanks again for your time, and don't hesitate to reach out with any questions about the work.

Cheers,
Joe

Remember, the goal is to position yourself as a professional who's working and isn't desperate but wants to keep in touch and let them know what you're doing. You're also giving the client a link to your new reel, but you're not asking them to look at it. You're not asking them for anything. *Don't hesitate to reach out*...that's my favorite line because you're basically telling the client, "I'm not

going to inconvenience you. You can inconvenience me whenever you want, though. Don't hesitate to inconvenience me."

If you don't have a new reel to share, send the client a "praise remind" e-mail like this:

Subject line: High Five—Love It!

Stewart,

Woke up this morning, checked my Vimeo feed, and saw that amazing spot you guys just dropped. Bravo! Bravo!

Hope you and the team are having a great summer.

Joe Motion

The subject line has to be short to stand out in their inbox, and the compliment has to be real: You can't send this to someone if they didn't actually impress you with a new spot. You're not asking for anything at all with this e-mail, just reminding them that you exist and making them smile. This e-mail only works with someone you've already e-mailed, someone who's going to remember getting that earlier e-mail from you and responding. They liked you the first time, and now they like you more. You're

"top of mind" and the first person they think of when they need a freelancer.

Clients have a roster of freelancers they use, but sometimes those freelancers are booked, and they need to find someone new. They're not going to search through their e-mails for a new freelancer, go to each of their sites, and view all their reels. They don't have time for that. They're going to call the one they think of first and know is available and appropriate for the job. So, in addition to the "I'm still awesome" and the "praise remind" e-mails, there is the availability-check e-mail. You sent availability check e-mails in phase two, and you can continue to send them until you get booked. Here's an example of an availability-check e-mail you would send to a New England client on a Monday after the Patriots destroy whatever team they're playing. This is for a phase two client, so check your spreadsheet first and don't send it until you've gotten to that phase with them.

Subject line: Freelance availability - Open 11/12 through 12/31

Susan,

Wow! Tom Brady's [or insert the name of any local sports legend] completely unstoppable!

Also, I wanted to let you know that, just in case, I'm wrapping up a huge project next week, and after that, I'm available through the end of December.

Hope you guys are busy. No reply necessary.

Cheers,
Joe Motion

That subject line may seem salesy, but think about it from the client's perspective. They're playing the hold game with half a dozen freelancers, and they don't know who to book, but they need someone in December. They're looking at that e-mail from Joe Motion and remembering that you're that nice freelancer who sent them a link to your great reel a few months ago. They might not even read the body of the e-mail. They might just call and book you.

If they do read your e-mail, they'll smile at your opening line. They won't feel pressured because there's no open loop. And here's the best part: *No reply necessary.* Who puts that in an e-mail? Well, Tim Ferriss does—Google him and head down a deep rabbit hole—and that's whom I learned this trick from; but regardless, it works gangbusters. If

you tell someone "no reply necessary," they're probably going to reply. They're so busy and everyone is demanding something of them—everyone except you, who just told them they don't even have to reply to your e-mail. They will reply.

The rest of the e-mail should look familiar to you by now. You're wrapping up a huge project, not just any project but a huge one. In reality, maybe you haven't been booked in a month and you're freaking out, but you don't tell them that. You're sending this e-mail as a courtesy to them to let them know when you're available in case they need you.

You can't control the number of jobs that need freelancers, but you can control everything else. You can increase your odds of getting those jobs. At this point, you're moving your clients through the phases of knowing you, liking you, and trusting you. Now they're going to start booking you.

GET PAID

As a freelancer, you're responsible for making sure you're paid what you're worth. You need to be clear on your rate and exceptions to your rate, so you can discuss these confidently with your clients.

WHAT'S YOUR RATE?

Clients are going to ask for your rate when they book you. You might think there's a clear correlation between freelance Motion Designers' skills and their rates, but when we surveyed studios, we found that isn't the case. We're talking about rates in the United States, but while the figures may be different in other countries, the same tactics and concepts explained here hold worldwide.

Rates may as well be made of fairy dust. Currently, there is almost no correlation between what freelance Motion Designers charge and their talent. Students right out of school try to charge $700 a day, while some of the best artists are working for half that amount. Why is that? There's an economic principle called price transparency, which is the ability to know all of the prices that are being charged for a good or service. Walmart can easily see what Target is charging for a roll of toilet paper and vice versa. This tends to equalize prices. Freelancers don't have price tags on them, though, and rates are rarely talked about in public. One goal of this book is to get this information out in the open so we have a better idea of what we should all be charging our clients.

Some freelancers charge $200 per day, and in fact, we even had some freelancers tell us in our survey that they sometimes charged only $150 per day. That's too low to

be sustainable. If you're a freelancer, you're responsible for paying your own federal, state, and local taxes and buying your own health-care insurance. You might be renting or buying equipment and services. A few hundred bucks a week is not enough to make ends meet. You should charge at least $350 a day because that's really not a ton of money to a "real gig" client, and it's enough for them to take you seriously as a Motion Designer. Charging less than that creates the impression that you're a low-value freelancer and can actually keep you from getting booked. On the high end, freelancers who responded to our survey said they charge up to $2,000 per day. How do you know where you fit on that scale? The average rate is between $500 and $750 per day, and the median rate—the rate that's quoted most often—is $500 a day. Here's how you decide your rate.

Are you new to the game? Did you just graduate from school? Did you just leave your first job and don't feel very confident? Your rate is $350 a day. That rate is low enough to get you booked but not so low that a client is going to question your talent. At this rate, companies might even book you for a few days to "try you out." It's a low-risk investment for them.

Are you confident? Do you have a decent reel? Have you been doing this for a few years? Charge $500 a day. The

first time you quote that rate to a client, you might feel uncomfortable, but you shouldn't be uncomfortable if you're worth it. That's a common rate, and a real client isn't going to blink at that rate. This was my rate when I started freelancing.

Do you have many years of experience? Are you multi-disciplined? Can you do 3D animation and 2D? Can you design and animate? Can you also edit? Your rate is $650 a day. At that rate, clients will expect a lot out of you. If you're worth it, they'll be happy to pay it every day, but you better be worth it. You need to be qualified to earn that much money every day. You must have several years of experience and be able to do the work with minimal hand-holding and few revisions. It really helps to be qualified for multiple jobs, so the client can have you work on different pieces instead of hiring another freelancer.

Has your work appeared on *Motionographer*? You can charge $750 a day or more. Again, you have to prove your worth every day, doing the work of two freelancers who charge $500 a day. Along with minimal hand-holding and revisions, you have to make your client look good, help them solve problems, and show them better ways to get the work done.

Could you run your own studio? At this level, you're doing

more than just executing. You may be helping to produce a job and subcontracting pieces of it out. You might be managing the client's client or design team. You might be hired as a freelancer to come into a studio and direct the entire team on a job. At that level, you can charge $800 to $1,000 a day. You pretty much need to be capable of running your own Motion Design studio before you charge that much.

If you happen to become incredibly specialized and fantastic at one thing, you can charge very high rates. The top Realflow or Houdini artists in Los Angeles can charge $1,500 a day or more because they are amazing, and only a handful of people can do what they do. They may not work as frequently, but when they do, they bill at a high rate.

Finally, some Motion Designers get to the level of super duper specialist, like GMUNK, for example. This is rock star status, and if you get that good, you can charge thousands of dollars a day. There are only a handful of people at that level.

If you're unsure about what to charge, start a little high. A client will tell you your rate is too high, but they'll never tell you it's too low—well, almost never. More about that later. So start high and negotiate down. And remember that when it comes to rates, just say it as plainly as you

possibly can. By the way, this rate discussion can also happen over the phone, which is a little more nerve-racking, but you deal with it the same way. Don't embellish, make excuses, or keep talking. State your rate and wait for them to respond.

Charge based on your *value*. Your value is not based solely on how talented you are but many other factors. Ask yourself how valuable you are to the client.

Be honest with yourself about your value and charge what you're worth. If you're charging $500 a day, and you're worth $650, raise your rate. For you, that's a huge raise, an extra $750 a week. To a medium-sized studio or ad agency, it's not that much if you're doing work twice as fast as the other freelancers they're hiring. The client would rather hire a freelancer worth $650 a day who's worth it than hire someone for $500 a day they have to babysit and wonder if the work is going to be done right or completed on time. They will pay more for that peace of mind.

OVERTIME

As a freelancer, any aspect of your working relationship with your client is negotiable, and that includes working overtime. Motion Design studios rarely pay their staff

overtime. When you're a freelancer, you can set that up as part of the parameters of working with you. When you give a client your rate, that dollar amount implies you'll work a certain number of hours each day, usually eight or ten. What happens if you have to stay until midnight a few times to finish a job? If you want to get paid overtime, you have to set it up at the start. You can't spring it on them the day they ask you to work late. Typically, overtime is time-and-a-half pay. Figure out what your hourly rate is, based on your day rate—your rate divided by ten for a ten-hour day—and then multiply that by 1.5 to get your hourly overtime rate. Let the client know your overtime rate up front when you tell them your day rate. That's your hourly rate for the next ten hours, the ten hours beyond the first ten hours you worked that day. If you have to pull an all-nighter and work beyond twenty hours, then your rate beyond twenty hours is twice your day rate, or double time. So figure out your hourly rate based on your day rate and multiply it by two, and that's how much you charge per hour after twenty hours of work.

It's a little confusing, so here's an example. If you work at a studio that has a ten-hour day and your day rate is $500, then you're charging them $50 an hour. Your overtime rate is $75 an hour, and your double-time rate, effective after twenty straight hours of work, is $100 an hour. So, a normal day is ten hours for $500. Fourteen hours would

be ten hours at your normal rate ($500) plus four hours at time and a half ($75 x 4 = $300), so that's $800 ($500 + $300) for that day. Now if it's crunch time, and you're burning the midnight oil and you work a twenty-two-hour shift—which happens to be my personal record for one day—and your rate was $500 a day, then you would charge ten hours of regular time ($500) plus ten hours of time and a half ($750), plus two hours of double time ($200), or $500 + $750 + $200 = $1,450 for that twenty-two-hour period.

Yes, that's a lot of money, and there are a lot of well-known Motion Designers who take pride in being a hard-ass about their terms and making their clients bend to their will. Maybe that works for them, but you can miss out on opportunities by being that strict about overtime. Some clients flat-out refuse to pay it; they just won't. Talk about your terms up front, and if you insist on charging over-time after a client has made it clear that they don't pay overtime, you will likely not get booked by them again. Think about what that client is worth to you and make the best decision for yourself.

So, if you plan to charge a client for overtime, you have to tell them that before they book you. In an e-mail, you would write: *My rate is $500/day, time and a half after ten hours, double time after twenty*. Plain English.

Freelancers don't always charge overtime because it can piss off the client. No one else in the studio—not the producer, or the director, or the staff—gets paid overtime, so sometimes it's best not to expect it and keep everyone happy. I know how crazy this sounds, but a well-run studio will rarely ask you to work overtime, so if it's an hour here and there and a few late nights at crunch time, I say just let it go. Some people disagree with that philosophy and think you should get paid for every second you're "on," but my advice is to focus on keeping the client happy and getting yourself booked the next time around. If you work for a client who takes advantage of your generosity, do the work and, when the job is done, let them know that you'll be charging overtime rates the next time they book you. Talk directly to the producer who booked you. Don't be a jerk about it, but let them know that you generally do not charge extra for overtime, but because it was excessive on this job, you'll want to negotiate overtime rates the next time they book you. Producers will understand if you put it that way. It's a touchy subject, so it's best to quote it up front or not charge it at all.

Here's a pro tip: If your client agrees to your overtime terms, and a job goes poorly and requires tons of overtime, you can also win a fan for life by waiving your overtime fees to help them keep the job under budget. The money you lose in the short term is generally made up tenfold in

the long term, when you become their favorite freelancer for being so cool about the extra hours.

DEALING WITH CLIENTS WHO PAY SLOWLY

Working on staff, you get paid every two weeks like clockwork. As a freelancer, you send an invoice to the client, and they pay you based on the terms of the invoice. "Net 30" is a common payment term that means the client will pay you within thirty days of receiving your invoice. In reality, invoices get paid late all the time, and it's your responsibility to remind clients they owe you money. This can be hard to manage if you're not tracking your invoices, so get a tool like QuickBooks online or FreshBooks, both of which are inexpensive and easy to learn. I use QuickBooks to send invoices and track how long ago I sent invoices, when I get paid, and when invoices become overdue and a client needs to get reminded. If someone doesn't pay on time, you need to send them a reminder e-mail. These apps can even automate reminders, so you don't even have to think about it.

Now, how often should you expect a client not to pay you on time? In my experience, it varies wildly from client to client. Some clients pay you like clockwork, and some, no matter how hard you try, will always pay you thirty days late. This is an issue every freelancer has to

to talk about a lot of them. This is far from an exhaustive discussion of all those things, but my goal is to give you what you need to get started and feel comfortable talking about rates, getting paid, getting your own health insurance, contracts, and things like that. There are lots of resources out there that can teach you about the messy details, and you really shouldn't be worried about them until you need to be worried about them.

If you live in a country with government-provided health insurance, you're lucky. The United States has, in my opinion, the worst health insurance setup of any first world country. If you live here and have a full-time job working for a company that provides health insurance, you may feel like your health insurance is cheap or free. Heck, it feels like you get a salary and FREE health insurance. That's not what's actually happening, and you're thinking about it the wrong way. The company is essentially paying your insurance premium and then paying you less than it would if you bought your own insurance—which is totally fair, by the way.

So, you might be disappointed to discover that as a freelancer, you suddenly have to pay for your own health insurance. The truth is, you've been paying for it all along. You just never saw the money change hands because it was going directly from your employer to the insurance company, instead of from the employer to you.

The last time I had an employer that paid for my health insurance, I was still paying $600 a month for coverage for myself and my family. My employer covered the other half, but my salary was lower because they paid that other half. Companies don't pay for insurance out of the goodness of their hearts. They do it as an incentive for you to work for them because they know that psychologically, it feels great to get "free" health insurance, but it's an illusion. You're not getting free health insurance. Whether you get insurance from an employer or you pay for it yourself as a freelancer, the costs aren't wildly different. Larger companies do get better rates for insurance than individuals, but as an individual, you can get a cheaper plan because you may not need all the features of the "Cadillac" insurance plan many companies provide. If you're young, single, and healthy, you can still get health insurance pretty darn cheap in this country.

Choosing the right health insurance for your specific needs is beyond the scope of this book, but you need it, you should get it, and it's not a big deal. It takes ten minutes on a website to get health insurance. Go to healthcare. gov or find out if your state has its own exchange. Google it and find out how to sign up.

If you have to pay for health insurance for your family, it may cost lot of money.

There's something nice about having that cost hidden in your salary. Paying for it out of your own pocket as a freelancer makes it more "in your face." Be ready for that. If you do the math, you'll see that the cost is close to what you and your former employer were paying. And remember that you may have had a top-level plan with your employer with all kinds of bells and whistles that you never used. You may not actually need that level of insurance.

So, at my last staff job, I paid $600 a month for insurance, and the company paid $600 a month. This was for a plan that included me, my wife, and our three kids. As a freelancer, I paid $1,350 a month. I'm probably a worst-case scenario because I have great insurance for my wife and three small children and no deductibles. Yes, it costs me $9,000 a year more now because my employer got a better deal. But as long as I make $9,000 a year more than I did when I was on staff, I'm ahead. Most freelancers make more than six figures. If you do it right, you can afford your own health insurance, and it may cost you only a few hundred bucks a month.

Health care is an incredibly complex topic in the United States and probably in other countries, too. Just understand that for a Motion Designer going from on staff to freelancing in the United States, you're going to see the

expense for health-care insurance, as opposed to having it hidden from you. Don't be freaked out by the fact that you're seeing those dollars leave your bank account every month. Do your research and pick a plan that makes sense for you.

CONTRACTS AND LAWYERS

I'm not a lawyer or an accountant. When it comes to incorporating your business or creating contracts and hiring lawyers, please do your homework. Don't take legal advice from me—or anyone—on faith. However, I will tell you my philosophy on both.

It's not a bad thing to have a contract with your client. It can, however, be one of those "penny-wise and pound-foolish" things. Some freelancers have contracts for every job and believe the contract protects them. My own lawyer once told me, "A contract is only worth what you're willing to spend to enforce it," and that's true. Even if you have a contract and a lawyer, it may end up costing you more to enforce the contract than what the client owes you. Are you willing to spend a month and thousands of dollars in legal fees to chase down a late $1,200 payment?

In more than ten years of freelancing, I've had only a couple of contracts—actual legally binding, signed

contracts. In all those years, exactly one client didn't pay me, and ironically, I did have a contract with that client. The reason they weren't paying me was a reason that a lot of clients don't pay you, which is, their client hasn't paid them yet. In my opinion, that's not really my problem, but what can you do about it? I had a few options. I could have hired a lawyer and taken them to court to enforce that contract, which would have probably hurt their reputation significantly. It might have hurt my reputation, too, and it would definitely have cost me days of my life, tons of stress, and thousands of dollars. Instead, I made a deal with them: they paid me 75 percent of what they owed me, and I didn't take them to court. They agreed and wrote a check. I never worked with them again either.

I learned an expensive lesson with that experience: that I would never work for that client again. In those situations when you're learning lessons, a contract doesn't really help you very much, unless you're willing to go through a ton of pain and expense to enforce it, and in general, it's just not worth the bother compared to losing a little money now and then. Companies almost always pay. The cost and hassle of hiring a lawyer and negotiating contracts with every company that books you can be a real pain and may not be worth it.

From a big-picture standpoint, keep in mind that if you

want big, good things to happen to you, you have to let small, bad things happen to you. That's a lesson I learned from Tim Ferriss's book *The 4-Hour Workweek*—I'm such a fanboy—and it applies here. If your philosophy is to avoid loss at all costs, you're going to be losing out on big opportunities, so let some of those small losses happen. You'll make up for it tenfold in having less stress and anxiety and not having to hassle all your customers with contracts. Think of those painful lessons that cost you money as investments in your freelance education. Accepting 75 percent of what I was owed cost me about $2,500, but I looked at it as a $2,500 education in the art of choosing clients. I never worked with clients like that one again. The lesson was worth the price.

You may have heard the opposite advice from anyone working in visual effects. This can be confusing to Motion Designers because Motion Design and visual effects are closely related industries, with a lot of crossover. However, it's very common to have contracts in visual effects because you're often booked for nine months to a year to work on a feature film. There's tons of intellectual property protection, and you'll have nondisclosure agreements to sign because you're working on something you can't talk about or show anyone. There are millions of dollars being invested in the project, and it's a completely different ball

game from Motion Design. If you're at that level in your career, you should talk to a lawyer and get a contract.

For a freelance Motion Designer hired by a studio or ad agency, a contract is not necessary. I would rather make it easy for clients to work with me and not have to deal with all the paperwork. I know, you've heard the opposite: It's like walking a tightrope without a net not to have a contract. But, at least in my experience, the downsides of dealing with lawyers, legal fees, contract negotiation, and the like totally outweigh any positives for the relatively small freelance jobs we do most of the time.

Now, if you're doing a huge project worth $50,000 and working remotely, you might want to set up the terms of the deal with a "deal memo." You can negotiate the terms with the client when they book you. The terms might stipulate that you get paid a certain amount up front and the rest of the payments at intervals, or when the work is complete. I usually include the deal memo as part of my bid or estimate for projects like that.

Here's an example of a simple deal memo I put on a bid, and you can download a pdf of it from my site: freelance. how/dealmemo.

Client: Brain Hole, LLC
Project: Brand Essence Video
Dates: September 12-22

Design	$150/hr	12 hrs	$1800
Asset Preparation	$125/hr	8 hrs	$1000
Animation	$150/hr	20 hrs	$3000
Editing	$150/hr	6 hrs	$900
Mix	$150/hr	1 hrs	$150
Rendering	$2000	FLAT	$2000
Posting / File Prep	$1000	FLAT	$1000

total : $10,350

Total cost includes:

Design - Creation of Style & Production Boards
Asset Preparation - Creation of Production-Ready Assets
Animation - 2D or 3D animation of Assets
Editing - All picture / music editing tasks, including final conform
Mix - Audio mixing of all music, VO, and SFX elements into a final track
Rendering - Use of computer(s) to render animation
Posting / File Prep - All file hosting, compression, and preparation of deliverables
Voiceover - All recording and usage fees

Total cost does not include:

Stock Music licensing fees
Any tape-related costs, if any (layback, masters)
Shipping costs, if any

Start Date of project is September 12, 2017. End Date of project is September 22, 2017.
If project extends past the End Date, overages may be assessed. Joe Motion will be
responsible for delivering a broadcast-ready file to Brain Hole, LLC. based on specifications
to be dictated by client.

Payment shall be divided as follows:
50% to be billed upon awarding of job
50% to be billed upon delivery
Payment terms are NET 30.

Thanks so much for your consideration.

Joe Motion
555-123-4567
joe@joemotion.com

The terms are incredibly simple:

Total cost includes:

Design - Creation of Style & Production Boards
Asset Preparation - Creation of Production-Ready Assets

Animation - 2D or 3D animation of Assets
Editing - All picture/music editing tasks, including final conform
Mix - Audio mixing of all music, VO, and SFX elements into a final track
Rendering - Use of computer(s) to render animation
Posting/File Prep - All file hosting, compression, and preparation of deliverables
Voice-over - All recording and usage fees
Total cost does not include:
Stock music licensing fees
Any tape-related costs, if any (layback, masters)
Shipping costs, if any

This part is simple. Here's what I'm doing. Anything other than these items, I'm not doing. Note that I'm including variable costs like shipping and licensing fees. Doing this makes it easier on the producer who is hiring you because you're taking extra work off their plate.

Start Date of project is September 12, 2017. End Date of project is September 22, 2017.

If project extends past the End Date, overages may be assessed. Joe Motion will be responsible for delivering a broadcast-ready file to Brain Hole, LLC, based on specifications to be dictated by client.

You can negotiate a set number of "rounds" of revisions for a project, but I think that leaves the client feeling a little more nervous. What if you agree to one round of revisions, and they hate what you show them, so now they have to like whatever you show next because they've used up that one round? Also, what constitutes a "round" of revisions?

Instead, what I like to do is to define a Start Date and an End Date. That's it. It's then up to me to manage the clients and communicate *very* clearly when they start to ask for more than can be accomplished by the end date. That way, if I need to steer them away from something they're suggesting, I can say, "That would be cool, but I don't think it's possible to do that and still hit our End Date."

If they still want those revisions, then they now know it will cause the schedule to go over the End Date, and you've already agreed that this means there will be "overages" charged. At that point, let the client know that this change extended the End Date out by three days and will cost an extra $1,200 in animation and editing fees, and the whole thing becomes much simpler.

Payment shall be divided as follows:

50% to be billed upon awarding of job

50% to be billed upon delivery

Payment terms are net 30.

I like simple. Half up front. Half on delivery. Net 30.

So, to recap, the way I look at it is that there is a cost of doing business, and at some point, you will get burned. There's no surefire way to prevent it. Your client might argue about paying you overages, and you might have to eat the extra time. Learn your lesson, move on, and don't work with that client again. But don't hassle the good clients just because of one or two bad-apple clients.

TAXES AND INCORPORATION

Again, a disclaimer: I am not an accountant. I'm not a CPA. Consult a professional about the best way to manage your taxes. In the meantime, take this advice at your own risk. This section really applies to the United States, as in other countries, the laws may be different.

Here's the short version: You probably don't need to incorporate because it's not likely to save you any money on taxes and can be a pain in the ass to set up and maintain.

Here's the longer version: One main reason companies

incorporate is because at higher revenue levels—let's call it $150,000 and up—there are tax benefits. They'll set up an S corporation or sometimes a C corporation to lower their tax burden, and it works, but it's costly to set up and maintain corporations. There's yearly paperwork to file, plus fees and other expenses. Are you going to do all of the filings yourself each year to maintain the corporation? If not, you'll be paying a lawyer to do it, and lawyers aren't cheap. Freelancers traditionally incorporate with an LLC—a simpler type of corporation—but even so, it costs money to set up an LLC, and every year you have to pay a renewal fee. Plus, with most LLCs, you don't see any tax benefits in comparison to being a sole proprietor, and to be a sole proprietor, you typically just have to fill out one form and pay a very small fee. Every state has a different procedure for this, but five minutes of Googling will point you in the right direction.

Now, taxes aren't the only benefit to some companies that choose to incorporate. LLCs and other types of incorporation provide protection from any liability the company may face. This is really important for, say, a tire company. If a tire pops, causing a car crash where the driver is injured, someone has to pay. If the owner of the tire company hasn't incorporated the business, their business *and* personal assets are at risk. They can lose not just the business, but their house, car, and personal

savings. The injured driver can take everything in damages. But if the tire company is a corporation, only the corporation's assets are at risk, not the owner's personal assets. (It's slightly more complex than this, so consult a pro if you incorporate, please.) So, if you make tires, incorporating makes a lot of sense. If you're a freelance Motion Designer, you're probably not at risk of injuring anyone with your key frames, no matter how buttery and smooth they may be. I suppose one could come up with a scenario where a freelance MoGraph artist gets sued for damages by their client, but unless you're being *really* stupid, the odds are very small.

I incorporated when I started freelancing for the same reason most freelancers do: because I thought it was "what you do" and it made me feel like a grown-up. But now that I know better, I wouldn't do it again. It cost hundreds of dollars to start up, then hundreds more every year to maintain, and there are extra costs for preparing your taxes if you have an LLC.

My advice? Don't worry about incorporating until you're consistently making six figures. If you make $125,000 or more a year, an S corporation might actually save you money in taxes, but until that time, I think it's overkill to incorporate. If you want to learn more, talk to your accountant or lawyer. They can tell you if it makes sense

to incorporate as an LLC or an S corporation based on your circumstances.

FOCUS ON THE WORK FIRST

It's easy to get distracted by playing "business." You may be tempted to spend your time on a lot of details around becoming a freelancer. Always focus on the work first. You need a website and a reel. With the money you spend for an LLC, you could hire designer to create a cool personal logo for your freelance "brand." That brand will get you booked; an LLC won't. The focus has to be on finding clients, making them like you, and doing good work. If you focus on contracts and incorporation, you'll never get started and never get booked. You don't even need a résumé to freelance. Spending your time on those things is a form of procrastination. They might make you feel like you're making progress, but you're putting off the important stuff. If you're doing this, ask yourself why you're doing it. What are you avoiding? What are you afraid of? Are you nervous about the prospect of having a client pay you money and expect good work from you? Are you afraid of...*success*?

Stop focusing on the nonessential stuff. You got this. You need to contact clients, send them your work, get booked, and have that conversation about money. It seems scary,

but it's easier than you think, and you need to do it. All that other stuff is distraction, creating self-imposed barriers to your becoming a freelancer.

And now, we're on to phase four.

PHASE FOUR: I NEED YOU

Once you've completed phase three, you are a bookable freelancer. You can stop there and have a successful freelance career with a six-figure income. But the goal of freelancing is more than financial success. The goal is to achieve a career and life that you consciously *design*, and to do that, you have to make conscious decisions about the work you do. Phase four will empower you to make those decisions.

When you achieve phase four freelancer status—I know that sounds like something a telemarketer would say, but let's run with it—you can charge a lot more money, which lets you work less, which lets you dedicate more time to the work you want to do. You'll also be able to spend time doing things you love—things beyond Motion Design that make you happy. To be a phase four freelancer, you have to become the first Motion Designer your clients call.

BECOME THE FIRST PERSON THEY CALL

When you're at phase four and your clients have a job that needs doing, they will always call you first. They depend on you—above everyone else—to get the job done, and they will pay you practically whatever you ask. To reach this level with a client, you have to make them need you—*really* need you.

Saying a client "needs you" isn't strong enough. You want your client to have an awful, tight feeling in the pit of their stomach when they call you. They're afraid you're going to say, "I'm already booked. Sorry." But you answer the phone and say, "Hey, you know what? I'm available. I'm going to take this project, and you don't have to worry about it anymore. It's as good as done." That tense feeling in their stomach releases, a wave of relief and ecstasy washes over them, they look to the heavens, and a single tear falls to the ground. They've booked you. Now they can sleep like a baby.

How do you get to that point? Getting to phase four simply requires that you're always doing certain things for your client.

First and foremost, you must be reliable.

In our survey, producers and other hiring managers were asked to list five qualities they consider when booking a freelancer, in order of importance. The choices were talent, reliability, personality, rate, and hygiene. Reliability scored the highest, beating talent two to one.

Let that sink in: *Reliability beats talent two to one.*

Personality and talent were tied. You have to be good,

but you have to be likable, too. And hygiene trumped rate. Apparently, it's better to smell good than be cheap.

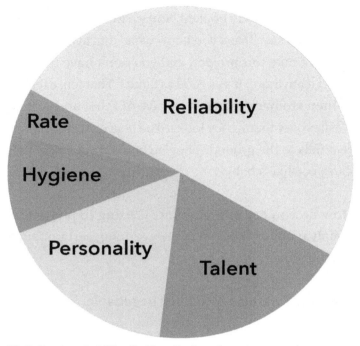

What's More Important When Booking a Freelancer?

To get to a phase four relationship with your client, reliability trumps everything. Look at every interaction with your client through that lens.

The difference between a reliable employee on staff and a reliable freelancer is essentially this: as a freelancer, you're held to a *much* higher standard. Here are some

easy ways to show the client you're reliable. You must follow these rules consistently to get to phase four status.

Do show up on time, every day. Do we really need to talk about this? Be five to ten minutes early to everything. Abide by the maxim, "If you're on time, you're late."

Don't leave early, ever. If you're working on-site at a client's office and you finish before the workday is over, don't leave. The full-time people on staff might leave early, but as a freelancer, it's not OK for you to skip out. Let the producer know you're done, and ask if they have any more work for you. The company is paying you for the whole day, so you can't just leave. If they have more work, then do it. They may just tell you to take off, but that is their decision to make, not yours.

Do move heaven and earth to hit deadlines. Your client would rather have a B-plus video a day early than an A-plus video a week late. That doesn't mean you should be churning out crappy video, but you must always be on time, every time, and early if possible. If you have a choice between going home on time and delivering something late the next day, or staying late and getting it done on time, stay until the job is done. It may seem like a real pain to work late, but—hopefully—it doesn't happen that often, and the occasional inconvenience is trivial compared to

the power and control you're going to have over your life when you reach phase four status.

Don't engage in office politics. You may be hired to work for a company on-site for months at a time, get to know everybody, and feel like part of the staff. People will tell you things. As a freelancer, if you get involved in office politics, it's very easy to be let go. It's not hard to fire a freelancer. The client just doesn't book you again. What you say could also get communicated to other studios, and that hurts your reputation and your chances of getting booked there, too. Again, you're being held to a higher standard, so live up to it.

Do stay focused on the work, not on social media or personal sites. When you're working as a freelancer at a company, there's a big dollar sign over your head. You're viewed differently than staff employees, and everyone is aware of how you spend your time. There's a fine line between hanging out, having conversations, interacting with people, being friendly, being a nice person to work with, and so on, and wasting time. The wasting-time part you need to be hyperaware of. If you're making small talk and building rapport, that's OK, but if you're wasting time, that's never OK when you're a freelancer. They are paying you to work.

Don't whine about anything. When things get tough

around the office, people complain. It's human nature. As a freelancer, you don't whine. You don't complain because you're a hired gun, brought in to get the job done. You are an animation assassin. That should be your attitude.

Do underpromise and overdeliver, always. Promise the client less than you know you will deliver, and deliver more—more, earlier, better—than you promised.

Don't panic. There will be times when a project falls apart. It will seem like the client's world is going to hell in a handbasket, and the entire staff will be freaking out. This is your opportunity to be a rock in the storm. Take a deep breath, and don't give in to the panic and hysteria. Remind yourself that it's a job and you're a professional. The panic will pass. Let your client cling to you and not be blown away.

Do be über-proactive with concierge-level freelancing. Think ahead about your client's needs. If you're booked all week with client A, and client B calls on Wednesday to book you for next week, you might be tempted to go ahead and let them book you. That's a rookie move. Client A has come to think of you as part of the team, and she's not thinking about which day the booking on you ends. It's your job to ensure she isn't going to need you next week before you book yourself with another client.

Look at it from your client's perspective. You could put client A in a tough spot because she was counting on you for another project but forgot to actually extend your booking. The solution would be to use your first hold on yourself and tell client B you have to check with a client who has a first hold on you, but you'll get back to him in twenty-four hours. Then you can check with client A to see if she needs you for the following week. Let client A know there is another client who wants to book you but that your first responsibility is to her, so she can keep you longer if she needs you.

This gives the producer a no-pressure opportunity to hire you again because you're saying, *"Hey, you can book me next week. But if you don't, someone else will. You don't even have to feel any guilt that I'm not going to make money next week because I will either way. But I think I can make your life easier if I'm around, so I'm just going to throw it out there."*

Very often, client A will want to book you again, so you'll have to call client B back and tell them client A booked you. If they don't, then you can book yourself with client B.

When you're proactive about scheduling, you make your client's life easier. It's good practice to give your current client preferential treatment and not leave them shorthanded.

Don't ever pass up the opportunity to add value or make your client look good. You have to actively look for opportunities to do this, but the more you work with clients, the more natural it will become to you.

REAL-WORLD FREELANCING TALES

Let's talk about some of these items in more detail. I have stories to share from real freelance experiences where following these steps saved my butt with a client and helped elevate me to that glorious place: phase four freelancer status.

BE THE ROCK IN THE STORM

When you're freelancing at a studio, sometimes its client will crap all over a project you're working on. You and the staff put a lot of effort into it, and for some reason, the client hates it. The staff gets really worked up when this happens. Everybody panics, and it turns out that panicking is a terrific form of procrastination. You could panic right along with all your fellow artists and be part of this big panic attack. *"Oh, no! We're screwed. What are we gonna do? Let's drink beers and not think about it right now."* It's actually kind of fun to panic with a group of people you like, but it's a trap.

You, the freelancer, cannot get sucked into that. You're

a rock. You're the one who, when the shit hits the fan, goes to the producer with a clear head, calm words, and solutions. "Here are some options," you say. "Don't worry, I'll take care of this. We'll get through this, OK?"

A phase four freelancer is part Motion Designer, part psychologist, and part personal coach. When you have freelanced a while, you will eventually find yourself in a situation where you have to be all three. I found myself in that situation while freelancing at a studio that was doing a job for HBO.

At the end of every year, HBO does a long commercial called a "year-ender" that features all the shows they aired that year, along with previews of upcoming shows. These spots always feature really unique and beautiful design and animation techniques. I was freelancing at a studio that was creating that end-of-year commercial. HBO's concept, their vision for the commercial, was a super elaborate visual effect where footage of actors from their shows and movies dissolved into thousands of letters. Most of the letters would float away, but some of those letters would stay and assemble into show titles. The studio designers took this idea and made some incredible boards, really amazing stuff. But the other animators and I also started to wonder how the hell we'd actually create the effect.

It was a very complex, tricky thing to pull off. Several of us were working the problem to figure out the best way to do it. There's no one-click effect you can buy to do something like this; it takes hard work and experimentation. It's very technical, and you have to have a certain amount of faith that you'll be able to figure it out. I was part of the team tasked with doing that.

We came up with a solution, did a test, and were impressed with how it came out—and even more impressed with ourselves. "Wow," we said, "that was so hard! But it looks amazing!" We showed it to HBO and got on a conference call with them. To put it mildly, they were not impressed.

It was one of those *dreaded* client calls where the client doesn't like something, but they don't know why they don't like it. Those are the worst calls to have because you have no clear direction and don't know what to fix. We went back to the drawing board and came up with another solution. It was better. We relaxed a bit.

But HBO didn't like that solution either, and again, their feedback was incredibly vague. "I see the actors and I see the letters. I don't see the actors dissolving into the letters." We worried they might pull the job away from us and have another studio do it, literally the worst thing that can happen on a project.

That was terrifying. Losing that project would have been a major blow to the company from both a financial and image standpoint. HBO is a big client. Everyone started to panic. The intensity was rising, and everyone was so exhausted from trying to do something about the problem and not knowing what to do that they were almost paralyzed. Deep panic set in.

I panicked, too—for five seconds. Then I remembered I was a freelancer, a hired gun, the animation assassin. When everyone is panicking, that's who you have to be. I went back to my computer and replayed the client's comments in my mind. By thinking about what they had said, really thinking about it, I realized they were probably responding to one specific part of the effect.

They liked it overall, but one thing didn't work for them. By ignoring the panic around me, I was able to have a moment of clarity, so I could hone in on the client's objection and attack the problem. I came up with a solution. It wasn't even that hard because we had already done so much research and development, and we were almost there. Many times, the difference between a client loving and hating something is one tiny tweak, and you just have to zero in on what that tweak is. That day, we solved the problem and kicked out another test. HBO liked it. I paid for zero drinks that night.

There are two lessons in that story. Being a rock in the storm made me a phase four freelancer for that client. After that, they booked me *constantly*. Sometimes they kept me around even if they didn't have any work, in case something came in. I had proven myself to them.

The experience also taught me that sometimes a client's feedback is vague. Sometimes they don't even know what they don't like, so you don't know what to fix. You have to learn to listen really well and put yourself in the client's shoes. It may be one teeny detail. They may even say it without being aware of it, so you have to pay attention and really listen. In this case, that's exactly what it was.

For this specific example, the client said, "I see the actors and I see the letters. I don't see the actors dissolving into the letters." That's very vague. I went back to my computer and thought, *Well, you have actors disappearing and letters appearing in their place. What if, as the actors disappear, we show letter-shaped holes in them? OK, cool. I'll add some letter-shaped holes to the actors as they disappear.* That's literally all I did. I didn't change anything else.

Sometimes you have to think about the client's words, interpret them, and try to really understand them to solve a problem. You can't do that in a panicked state of mind,

so you have to be a rock in the storm. To see the spot I'm talking about in this example, go to freelance.how/hbo.

MAKE THEM LOOK GOOD

Staff employees don't always care about making the boss look good. They have a role as an animator, designer, editor, or director. They're part of a creative team, responsible for their piece of the project. But there's almost always someone with more responsibility for how good the piece comes out—a creative director, art director, or producer—and it's their ass that gets chewed if it doesn't.

As a freelancer, it's your job to make your client, usually the producer, look good by doing quality work and turning it in on time.

If you're assigned to animate or design something, and the expectations are too high, speak up immediately. It's better to let a producer know the work will take longer than they expect so they can make adjustments, as opposed to waiting and springing it on them at the last minute, when it's too late for them to do anything about it.

Here's a quote from a producer who responded to our survey:

I'LL TAKE THE HARD NEWS UP FRONT SO I CAN ADJUST VERSUS THE INFO I WANT TO HEAR UP FRONT AND A DISASTER WHEN SOMETHING IS DUE.

—ANONYMOUS PRODUCER FROM OUR SURVEY

Don't tell the producer what you *think* they want to hear. That's an easy trap to fall into, especially when you're new to freelancing. There's a skill to managing expectations that you can develop. It's learning to say no without actually saying no. It's also a good example of underpromising and overdelivering. Here's an example.

I was working on a very long video project. I had been working on it for weeks, and it was almost finished. At 5:11 p.m. the day before it was due, I got an e-mail from the client. The subject was "Last-minute changes." The e-mail said, "Hi there. Still waiting on client approval. The account team sent over some additional changes to the script." There was a pdf attachment with a whole bunch of changes, the kind of changes that the client thinks are really simple but actually require retiming several parts of a three-minute-long After Effects comp with seven hundred layers in it. You know what I'm talking about.

There's more. They knew it would cost more money for me to make all those changes, but the increase in the budget wasn't approved, so they told me to hold off making the

changes until they had approval. But they still expected the work to be done the next day. "Can you make this happen?" they wanted to know.

If I started right away, I had a good chance of making the changes and getting the work turned in on time. But they didn't have budget approval, and I had to wait. Now, I know how this works: my client's client will call them at 11:00 a.m. the next day, my client will have a meeting about it, and *maybe* I'll hear from them around noon. At that point, it would be impossible to get it done by the end of the day. The answer to their question was *no*, but I don't ever say no. Here was my response:

Client,

If we hear tonight, I can get it done by end of day tomorrow. But if we don't hear until the morning, I don't think there would be enough time to make these changes, rerender the animation, reconform it, and reedit the music. If the timing changes drastically, I may have to reedit the voice-over as well. Let me know what you need. I can hustle hard if that's what needs to happen.

No worries,
Joey

That's a gentle no with reasons. It resets their expectations. It also gives my client ammo because they have to go back to their client with an answer, too. The end of the e-mail

let them know that regardless of how this played out, I had their back. I would get it done, whatever it took, so they didn't have to worry. They could sleep well tonight, like a swaddled baby.

I was really thinking, *Crap. Now I have to call my wife and tell her I'm gonna be working late. I'm going to miss bath time with the kids. This stinks. I don't wanna do it.*

But I'm phase four, and if I took care of the client when they really needed me, I could raise my rate next time. Then they'll be a client that pays more and that paycheck will free up time for me down the road. Maybe it will allow me to take a whole month off and go on vacation or work on my reel. As a staffer, when you go above and beyond for a client, you might get a pat on the back or a small bonus. As a freelancer, you can get a lot more because you're in charge of your day rate. You just have to be worth it.

I started on the changes right away, even though they told me not to. It was the only way I had any hope of getting the work done on time. I went home for an hour and had dinner with my family, then I worked until 2:00 a.m. and got the job done.

The next morning, the client told me they had approval and I could go ahead and start. They had also gotten me

a whole extra day to work on it. They got that extra day with the ammo I had given them about all the extra work I was going to have to do.

I didn't tell the client I was already done. That would have been a rookie move and wouldn't have allowed me to underpromise and overdeliver. Sometimes it's smart to maintain a poker face and hold your cards close to your chest. If you give the client the impression that the work is easy, they'll start throwing you last-minute curveball changes and expect you to always get them done, and they won't value the work or effort.

Telling them I'd already finished would cheapen the extra effort I put in, and I *did* put in extra effort. I wanted to go home and hang out with the family, not work. I had a big Netflix night planned. But I didn't. I put in a fourteen-hour day and got the job done.

I wrote back and said, "No problem. I can have a link to the team by end of day today. Does that work? I'll jump on this right now."

Here's the magic. Right after I sent that e-mail, I wrote a second e-mail. The second e-mail had the subject line, *[Project Name] Revisions + Deliverables.* This told them everything was in the e-mail, all the deliverables with the

changes. I put a big link in the e-mail that they could click on to watch the video and another one where they could download a zip file with the full-quality QuickTime and Windows Media files. *"Let me know if you need anything else before the meeting. Thanks. —Joey."*

I didn't send this e-mail—yet.

When you send work to a client, it generally has to be approved before you send them the big, high-resolution files. Quite often, they might ask you to make a few changes before sending the hi-res files. I don't usually send the hi-res files right away, but I knew this client was under pressure to get this done, and they were stressed out. They wanted this project to be done. If they asked me to make changes, I would do them, but they were going to see those big delivery files all set and ready to go and know they could be done with this right away.

I used another killer feature of Right Inbox to schedule the e-mail to go out at 2:17 p.m., a seemingly random time that beat the deadline I had given them by several hours and beat their client's deadline by a whole day. If I sent the e-mail too early in the day, they wouldn't appreciate all the extra work I did. Also, that would give them time to have a meeting about it before lunch and probably come up with revisions. Getting it at 2:17 p.m., they would get

into a room to look at it around 3:00 p.m. They'd start thinking about revisions and realize around 3:30 p.m. that everybody just wants to go home. Plus, they have the hi-res files all ready to go.

I sent the first e-mail and scheduled the second e-mail, so I could take the rest of the day off to ride my bike or take my kids to the park. I underpromised, overdelivered, was proactive, and made my client look good. And I never said the word *no*.

There's a character in *Pulp Fiction*, the Wolf. He's the guy you call if you need to dispose of a body. That's who you want to be. Not literally, but you do want to be the guy who takes care of problems your client doesn't want to deal with. Then they can go out to dinner and have some wine. They can go home and sleep like a baby. They'll remember how valuable you are when you charge them more the next time, and they'll pay it, gladly.

FIND THE BACK DOOR

Speaking up when expectations are too high also gives you an opportunity to be a problem solver. The average freelancer might tell the producer they need more time, but you're not typical: you're a phase four freelancer. Before you even speak up, you're going to come up with

an alternative way to get the work done. You'll provide a solution that will make your client look good. Here's an example of how I came up with an alternative solution and avoided a catastrophe for a producer. At some point in your freelance career, this will happen to you, too.

A producer booked me to create a three-minute, fully animated video. No problem. Then he said he needed to show it to his client in two days. You can create three minutes of *bad* animation in two days, but it's not possible to create three minutes of *good* animation in two days. I could have told the producer it was impossible, or told him to lower his expectations because it wasn't going to be good. I could have said it was going to be late. I asked if it was possible to get more time, and the producer said we had to show them *something* in two days.

He made a mistake by setting that expectation with the client, but now it was my problem. I didn't want to deliver bad or late animation. I pitched a different idea to the producer. "Listen," I said. "How about instead of showing them the full animation in two days, we show them an animatic?"

If you're unfamiliar with the term, an animatic is still frames—usually storyboards—edited together in sequence with very little animation and maybe some music and

voice-over. In addition to the animatic, I would fully animate the first thirty seconds of the video and make it polished and amazing.

That solution shows the client two things: the entire video in a rough, easy-to-understand form so they can imagine the overall product, plus thirty seconds of really good animation that shows them what the finished piece will look like. The producer never would have thought of that solution because he's not an animator.

I went to the producer and said, "We cannot do a really good three-minute animation in two days. But we can do this in two days and have something polished to show the client. The animation, or motion test, will look good and show them the animated style, and the three-minute animatic with music and voice-over will show them what the full three-minute video will feel like."

The producer liked the idea. Because the concept was new to him, I went one step further: "I will even get on the phone with the client when you present this and talk them through it because I've done this before, and I can explain exactly what they're seeing and manage their expectations if that would be helpful to you."

Producers don't usually want a freelancer on the phone

with a client because it's their job to know how to talk to clients. Putting a freelancer on the phone can be risky. But a phase four freelancer knows how to talk to clients.

He took me up on my offer. We had a client call, and he introduced me as the animator on the project. I was an expert in the animation process, so it was easy for me to explain the two-day solution to the client. They were happy with the solution, and my producer was relieved because I had gotten him out of a tight spot.

I could have approached this the wrong way. I could have had the attitude that many freelancers, and even many staffers, have: "I'm not the one who overpromised. I'm not the one who told the client they were gonna have this done in two days, OK? So it's not my problem. I'll do the best I can, but you gotta talk to your client."

Instead, I came up with a creative solution to a very common problem. It took ten minutes of thinking, *What's the back door? What's a different way of getting around this problem?* There's always a back door, a better solution. Overpromising work to clients is a common problem that you, as a phase four freelancer, should know how to deal with. Offering to talk to the client for the producer was the cherry on top because that put him completely at ease and made him look good.

ADD VALUE: THE INFORMATION BOMB

Think of yourself as an infinite well of goodness who gives graciously to your client with no expectations. That is your mentality as a phase four freelancer. Give freely, and it will come back to you tenfold. You can give your client a solution to a problem, or you can offer to speak to their client as a Motion Design expert. You can make them look good and get them out of a tight spot. And sometimes you can drop an "information bomb."

I was contacted by a producer looking for a freelance Motion Designer. The project seemed interesting, so I asked her for more information. She sent me two videos as examples of the type of work she needed. Each video showed two dancers morphing from one into the other. The first dancer spun around and metamorphosed into the second dancer. There was obviously a green screen shoot involved and a lot of rotoscoping and effects work. The producer wanted an estimate of what it would cost to create a similar video.

Now, one of the reference videos she sent was a polished, brilliantly produced piece. The other video was a total piece of crap. I couldn't understand why she sent me two videos with such a huge difference in quality. I could have sent her an e-mail telling her the videos were completely different, not even in the same universe, and it would cost between

$3,000 and $100,000 to create a video with that effect, depending on if she wanted it to look good or look crappy. I thought about how she would feel reading an e-mail like that. Instead, I reached into my infinite well of benevolence and drew out an info bomb. An info bomb is an e-mail you create that educates your client about the process in extreme detail. You offer it up on a platter with no expectations.

The well-produced reference video, an ad for hair gel, was called *Evolution of Style*. The client assumed it was created with expensive, specialty software like a Flame system because it looked so good. However, I did some research on the spot and let her know it was actually created with After Effects, software every Motion Designer has. I sent her an article about the making of the piece so she could learn more about it. I explained to her how the video was precisely choreographed and each piece of clothing rotoscoped, and how hand-animated transitions were added to make the finished piece look so amazing. The piece-of-crap video, by comparison, was a bunch of still images of Lindsay Lohan pieced together with very crude morphing effects. I compared and contrasted the techniques used in the videos, as well as the time required to pull off each technique. Giving her a bite-size education about the differences between those two videos allowed me to segue into a discussion about the time and cost for her video. I researched the video and found out a French

company called Noside did the postproduction on *Evolution of Style*. It took a team of two or three people a couple of months to do the work and required on-set supervision from a visual effects supervisor.

Don't assume your client understands how much time or how many resources it takes to create a video. Educate them, but don't patronize them. Speak to them as a friend and colleague. Then you can talk about money. I let the producer know the difference in time and cost between the low-quality and high-quality videos and quoted her between $60,000 and $80,000 for the "good" version of her video. Typically, throwing out a number like that can be dangerous because it's a lot of money. Because I took the time to do some research and educate the client, that number didn't shock her.

I also advised the producer to get the effects person, whomever that turned out to be, involved in preproduction, so the morphing could be worked out ahead of time. You can't assume the client is going to hire you to do the work, and you shouldn't even imply it, so the information and advice I gave her—and that you should give when you're in this situation—is for whomever she decides to hire. I let her know she could contact me if she needed any more information or had any questions and thanked her for reaching out to me.

Here's the full text of the e-mail:

Subject: re: Morphing VideoClient

I've seen that *Evolution of Style* video before. It's really cool. They did an amazing job on it. As a matter of fact, it was all done in After Effects. Here's a little behind-the-scenes article:

Behind the Scenes of "Evolution of Style"

That video is obviously a lot more complex than the Lindsay Lohan thing. The Lohan piece is just a bunch of stills and some crude morphing. The Evolution piece was very precisely choreographed to allow for all of that stuff, and they basically had to roto individual pieces of clothing and hand-animate the transitions. It takes a ton of work but looks amazing. The company that did the post on that is a French company called Noside, and it took two months to do all the work and probably a team of two to three people.

So, ballpark...it's at least a month of work, plus on-set supervision (doesn't have to be me, but a VFX super should be there). Here's a very rough range:

Lindsay Lohan quality: 2 weeks, $10K–$15K

Evolution of Style quality: 6–8 weeks, $60K–$80K

I also think that you may need whoever does the FX to be very involved in the preproduction so the morphing effects can be worked out somewhat ahead of time.

Let me know if you have any questions or if this is enough information for you at this time.

Thanks so much for reaching out!

Joey

I didn't say, "This would be so fun. I hope we get to work together." That would be an open loop and put pressure on her to hire me. Instead, I gave her all the information she needed to make a decision and left it up to her to decide.

That e-mail elevated me to instant phase four freelancer status. The producer wrote back thanking me *profusely* for all the information and asking me questions about my work. We had exchanged a couple of e-mails and had never met, but she was immediately ready to hire me because she liked that e-mail so much. That's what going above and beyond with an info bomb can do for you. An info bomb adds value and puts you on a higher level with the client. They will like you, trust you, and need you if you add value. Instant phase four.

You have to be aware of these opportunities. They usually appear as challenges, and most people avoid them. When you see a challenge, that voice in the back of your head usually tells you to run and hide. It tells you to keep your big mouth shut because that's the easy thing to do. When you hear that voice, it's a sign that you're standing at the precipice of going to the next level. It might scare you, but it's those challenges and opportunities—and how you react to them—that will define your career. No risk, no reward. No pain, no gain. All of those little platitudes apply.

Those opportunities are far more common when you're a freelancer working for marketing companies, advertising agencies, and doing direct-to-client work because those types of clients are not as well versed in Motion Design as a typical studio staffed with producers, creative directors, art directors, designers, and animators. Nonstudio clients may have experience doing web advertising and live action, setting up shoots, and editing, but they usually have little experience with Motion Design. You're the expert. Leverage that.

THE OPTIONS TRICK

Opportunities to add value are obvious when there's a challenge presented to you, but you don't have to wait for an issue to pop up. Sometimes you have to *look* for a better way to do something. You have to be proactive about it and not settle for satisfying the client's minimum expectations. When I was running Toil, my good friend and business partner Kevin Moore taught me a lesson that completely changed the way I thought about client service. It involves being proactive, overdelivering, adding value, *and* making your client look good. Here's how it works.

You might be hired to animate a logo for a client. The client says, "Take my logo and animate it in this specific way." You look at their logo and think, *Ha! I have a much cooler*

idea. Now, you can't just throw away their idea. You have to do *their* idea, but what about your *better* idea?

This is painful for some freelancers. As humans, we can be lazy creatures. The easy thing to do is just animate the logo the way they want it, but that's not the way of the phase four freelancer. If you have a better way to do something, provide the client with three choices: their way, your way, and a third way. The magic number is three. This obviously works for small projects like animating a logo, but you're not going to prepare three versions of a five-minute animated video. If the situation fits, and you have the time, make three versions. Show the client the animation done the way they asked, your way, and split the difference between the two for the third version. That third choice will be kind of like theirs and kind of like yours, too. The conversation might go something like this:

You: "Hey, listen. So, I actually have some options for you. Here's what you asked for."

Client: "Cool. Looks great."

You: "I had this other idea. I thought it might be cool. Here it is."

Client: "Whoa! That's really weird, but I kinda like it."

You: "And then I thought maybe that's too far, so I split the difference."

Client: "Oh, that's awesome. Perfect. Great job. Done."

By providing them with a third option that borrows from their original idea but with your slant on it, you make them look good *and* improve the quality of the work. If you provide only one option, their version, it won't be as good. If you provide only your version, they'll feel like you steamrolled over their idea. If you provide just those two options, they're going to be torn because they know your version is better, but now you've made them feel bad about theirs and taken away some of their power. Clients like to have their thumbprint on a project. Remember, you're playing the role of psychologist in this interaction.

When you offer three versions, it allows your client to remain part of the process, and, frankly, they should be included. They know their brand better and should have some buy-in on the idea and the execution. Also, if you show them just one version, they have nothing to compare it to and can't say they prefer one version over another. The only feedback they can give you is to say they don't like it or point out what they don't like and ask you to change it. If you're dealing with an art director or

a creative director, in particular, they're trained to look for flaws.

If you show them three options and let them pick the one they like, you're not taking their power away because they still get to pick. They may want a slight change made, but generally speaking, they're going to pick one and be pretty happy with it. Their thumbprint is on it, and it's even better than what they expected. They can go to their boss and say, "I picked this one." Now they're your ally, too.

REMEMBER WHY YOU'RE PHASE FOUR

Remember, your reason for becoming phase four is so you can charge more money, which gives you more time and freedom to do the things you really want to do. If you seize opportunities like the ones we've discussed, you can give yourself a huge raise.

After the HBO job, I raised my rate with the studio. I still remember the conversation because I was so nervous. I walked into the executive producer's office and closed the door. I pulled out a $180 bottle of Scotch—Johnnie Walker Blue Label—and set it on his desk. I knew he liked Scotch, and I guarantee a freelancer had never given him such a nice gift. Another tip to remember: Gift your best clients. Anyway, I said to him, "You guys have been

such an amazing client, and I really appreciate the work you've been giving me. I wanted to give you this to say thank you and to let you know that I'm raising my rates starting January 1st." He gave me a stern look and said, "All right. Well, what is your rate going to be?" I was currently charging $500 a day. I said, "Six hundred dollars a day." I don't even think he took time to exhale. He just said, "Yeah, that's fine. You're worth it."

To go from $2,500 to $3,000 a week is not a small pay raise: it's massive. If you're on staff, you can't ask for a raise like that, but you can as a freelancer.

So now, you're a highly paid, highly sought-after freelancer. You've got clients who rave about you, your reel is improving all the time, and you're making enough to take some downtime *to do the work you want to do before you get paid to do it.* What now?

CHAPTER 8

PHASE FIVE: YOUR FREELANCE LIFE

The first four phases of *The Freelancer's Field Guide* were all about your client. Phase five is about you.

At this point, you have just about everything you need to control your work, your income, and your time. You're a phase four freelancer—look, we had to call it something!—with the tools to literally design your career and your life. Remember the Pains and Rainbows graph? Now is the time you get to decide how much time you want to spend on the Pain side and how much time you want to spend on the Rainbows side. From this point on, you're not focused on learning how to be a better freelancer for your client because you're there. Now you can leverage your status to get the balance you want between Pain, Rainbows, and everything else.

In *Part I: The Freelance Manifesto*, we talked about the "why," why you wanted to become a freelance Motion Designer. Now here you are, on the verge of freelance nirvana. Take a step back from the client. Let's talk about how you're going to get what *you* want. You have some choices to make.

How much money you make on each job will determine how much time you have for other things, so think about how much money you need to make. There are ways to make more money without working more hours, and

that's your goal. You can choose the jobs that give you the money you want *and* the free time you need.

MAKE MORE MONEY

The highest paid freelance Motion Designer I know personally made $260,000 in one year. He spent an entire year on the Pain side of the graph, double- and triple-booking himself to bring in an insane amount of money and an enormous amount of stress. It was a rough year, but at the end of it, he could pay off the mortgage on his house and live mortgage-free for the rest of his life. Do you think one year of agony is a fair price for never making a mortgage payment again? Maybe you do, or maybe you don't, but these are the kinds of decisions you get to make at this point in your freelance career.

Many MoGraphers might feel like they're sacrificing their artistic souls even thinking about making that kind of money. That's not why you got into this field, right? But you're not making money for the sake of making money. You're doing it for your *why*—your true purpose in life, the thing that makes you happy, and, in the bigger scheme of things, what you want your life to look like.

It's not so you can keep up with the Joneses. It's so you can pay off your mortgage or student loan and sleep better at

night. It's so you can travel and see the world. You may want to take your girlfriend to Spain or your grandma on a cruise. Those are great reasons to make more money. Money also buys you time, time you can spend with your family or doing anything else that makes you happy. The bottom line is, you should be making money for the right reasons.

Think about what those reasons are, write them down, and start planning your life. Figure out how much time you want to work and how much time you want to be doing something else. Then figure out how much money you need to make that happen. Once you have that figured out, you'll have a better idea of the type of jobs you should be taking and how much you need to charge for the work. You can also start thinking about the kind of Motion Designer you need to be to charge that rate. You can begin to design your career—and your life.

There are two traditional ways to make more money as a freelancer. One way is to increase your rate, the amount of money you charge per unit of time. The other way is to increase the number of hours that you work, double-booking. Those are the standard ways, and they both have limits. There's a limit to how much you can charge a client per hour or per day before you're too expensive to hire. You can only charge what you're worth—your value

to the client—and as your rate goes up, the expectations go up with it.

There's also a limit to how many hours you can work. Some Motion Designers take on a second client and do the work early in the morning and late at night, before and after the work they're doing for their first client. That's called double-booking, and it's actually frowned upon because your primary client doesn't want you burned out when you show up in the morning after you've been working all night. They want your A game. A producer from our survey had this to say:

WORKING DAYSIDE ELSEWHERE OR FOR ANOTHER CLIENT AND ACCEPTING WORK FROM US WITHOUT DISCLOSING THAT THEY ARE ALREADY ON A DAY JOB WILL PISS US OFF.
—ANONYMOUS PRODUCER FROM OUR SURVEY

So, if you're double-booking yourself, you need to be very tactful about how you handle it. Your primary client probably doesn't need to know, but the new client, the one you'll be doing work for late at night, they should know. If they trust you and don't need you on-site, they probably won't have any issue with you doing the work off-hours. But you have to take care of yourself, eat and get enough sleep, and not burn out. You still owe both

clients your best work. It's a bit of a risk, but if you choose to double-book to make more money, you can do it, and it's no one else's business. However, there's still a ceiling to how many hours you can work if you're double- or even triple-booking yourself. There are only twenty-four hours in a day.

You can make well over $100,000 using these traditional methods. But if you want to crack $200,000? Those options won't get you there.

MAKE MORE MONEY A SMARTER WAY—SCALE IT

You can make more money without raising your day rate or working more hours. You'll have to learn some new skills beyond being a great, reliable Motion Designer, but they're all within your abilities, and the payoff is huge.

There's a 1980s movie called *Over the Top* in which Sylvester Stallone plays an arm wrestling champion. When he's about to wrestle, he flips his baseball cap around. I want you to flip your baseball cap around. Now you're not just a freelancer; you are essentially a one-person studio.

What's the difference between a freelance Motion Designer and a Motion Design studio? We typically think,

Well, a studio has an office and more than one person working there. All that is just a construct that exists in our brains. There's no difference between one person who takes a job from start to finish and handles all the designing and animating—maybe hiring another Motion Designer if they need help—and a studio with fifty people, other than the scale of it.

Think of yourself as a studio. Instead of Joe Motion, you're now Joe Motion Studios, Joe Motion Design, Joe Motion Animation Assassins. It's mainly a construct in your mind. You're still a freelancer, but thinking about yourself as a studio allows you to scale. Scaling means doing more work without doing all the work yourself. That's all it means.

ESCAPE TIME FOR MONEY

As a one-person studio, you can charge for more hours. You can actually "work" more than twenty-four hours in a day. How do you achieve that miracle? You hire freelancers to do some of the work. You take care of the business end—getting clients to know, like, trust, need, book, and pay you. As a phase four freelancer, you're already a master at the business end of freelance Motion Design, while most other freelancers are not. They don't know how to do all those things. You take care of the business end and hire freelancers to do some of the design and animation. If

you have three people working eight hours, you're getting twenty-four hours of work done every day.

Being a one-person studio allows you to trade other people's time for money. You take care of the business end, pay your freelancers, and keep some of the money for yourself. Scaling your freelance career this way allows you to escape the limits of trading your time—and what you can produce in that time—for money. You can make more money *and* have more time.

Maybe you're thinking this is dishonest because if a client hires you based on your skills and you turn around and hire someone else, you're not going to be able to deliver on their expectations. Here's how this works in reality.

A client calls and says, "Hey, we've got this thing that we really need done. Please, please, sweet fancy Moses, tell me you're available." You say, "I'm actually booked on a pretty big job, but I've started working with another freelancer to handle my overflow work, and this freelancer is amazing. If you're cool with that, I can vouch for this person, direct him, and guarantee the work—which will be every bit as good as what you'd expect from me—and you can just book the job through me, and I'll work with him to get it done."

This only works if you're at phase four with the client, but

if you put it that way, you're putting your reputation on the line, and they will almost always say, "Sure, I trust you."

Now you're the creative director or art director. You're also the buffer between the freelancer and your client. Charge your client your day rate and pay the freelancer their day rate. You handled the business end of the deal and are ultimately responsible for ensuring the quality of the work, and you pocket the difference between your day rate and the freelancer's for managing that piece.

The client hires you because they like working with you and the work that you produce. If they hire you, and you have a freelancer doing animation and design, you're still doing the interacting part and making sure the work is high quality, in the end, they're not going to care who did it. As long as the work is good, and they still get it on time and the same service from you that they expect, it doesn't matter who made the key frames. Keep in mind this is going to add a little extra stress for you because now you have to worry about this other freelancer, check in on them, make sure they're doing things on time, and all of that stuff. You'll need to teach them how to hypercommunicate with *you* the same way you do with your clients.

If you're wondering why a freelancer would agree to do this work for you, think about the advantage to them.

They're going to be mentored by you, a phase four free-lancer who knows how to do great work but also knows how to work with clients. They'll be very happy to work with and learn from you. Now you're their client, and you're a vendor, too.

GO REMOTE

If you want to scale your freelance career, you're going to have to work remotely at some point. You can hire other freelancers to work for you—that's easy—but you can't manage them while you're sitting in someone else's studio eight hours a day.

Sometimes you can't work remotely with a brand-new client, but you can go remote with a client who already knows, likes, and trusts you. However, if you're working for a client in their studio and suddenly tell them you want to work remotely, they likely won't be open to it immediately. They're used to seeing what you're doing for them all day. If you're not sitting in their studio, how can they be sure you're working? You need to take some proactive steps before you broach the subject of working remotely with your client.

When you transition from working on-site in a studio to a remote off-site, there's a trial period where the bar is a lot

higher. The client will hold you to a very strict standard. Don't drop any balls during this time. Now, as a phase five freelancer, you shouldn't drop any balls *ever*, but you need to be especially vigilant during this time, when your client is still deciding if allowing you to work remotely will be a good fit for them.

For a freelance Motion Designer, working remotely basically comes down to three things: communication, communication, communication. If your producer sends you an e-mail, you have to acknowledge it as soon as possible. The faster you respond, the better—preferably within ten minutes, but do not make them wait more than an hour.

Carry your smartphone with you if you go to lunch, the gym, or for a bike ride. Let them know when you're going to be out of touch, even for short periods. Check your e-mail regularly. Even a short response like, *Got it, no problem*, reassures them, so they're not sitting there wondering if you got the e-mail—or if you're even working.

Proactively communicate with your client to let them know when you expect to be done with each step of a project. When you get revisions, always reply with some sort of time line. *Got it. I should have something new posted in three hours for you to look at.* At the beginning of each

day, write a quick message setting expectations: *Good morning! I'll have some new work for you around 11:00 a.m.* Hypercommunicate.

Show them your work frequently so they can check it and make sure you're all still in sync. Do this even before they ask. Give your client frequent opportunities to make adjustments, just as you would if you were sitting in their studio with them looking over your shoulder. If your work will be later than you initially thought, let them know immediately, so that they can adjust schedules and manage client expectations.

Got all that? Great! So how do you actually get a client to let you go remote?

You can't go from on-site to remote in the middle of a project. Wait until a project is complete and there's a break between bookings. The next time the client calls, that's when you talk to them about working remotely. But you have to have a reason for it. Even though *you* don't need a reason for working remotely, it's probably going to be a foreign concept to your client, so you need to justify it to them.

Explain your request in the context of how much more productive it will allow you to be. You can talk to your

client about how it would be easier to drop off the kids at school and pick them up if you were closer to home, which takes stress off you and avoids excessive travel time. You can get more sleep and start the day fresh because you won't have to commute to work in traffic. You can ride your bike on your lunch hour or go the gym, which helps your creativity in the afternoon. They're still getting you for the whole day. You're just going to be working remotely, where you'll have some autonomy, fewer distractions, and will be much more productive.

Set up a real-time messaging app, like Slack, for communicating with your producer and the studio staff. You can set up your own Slack channel and invite clients to join, so you can all upload videos and imagery, share links, chat, and be in constant communication with each other. It's also likely that your client may already have a Slack channel that you can join. There are many other tools for working remotely, and you should familiarize yourself with them before you go remote. I've included a list of e-mail tools and tools for working remotely in the appendix and online at freelance.how/tools.

For example, Frame.io is a video-review tool that is absolutely incredible. You can share video with your client, and they can go through it frame by frame, add comments at specific times, and even draw right on top of it. They can

show you what they want changed, added, or removed. You don't have to just imagine it on a phone call or write about it in an e-mail. Wipster is a similar tool.

You can share your screen in real time while chatting with Skype, Appear.in, or Screenhero. These tools let you show off RAM previews in real time—the quality isn't great, but it works well enough—so that you can show work in progress without having to render, upload a file, send a link, and so on. You can have a face-to-face conversation with your client while you show them your work. It's a huge time-saver and somewhat replaces the over-the-shoulder review sessions that happen on-site at the studio.

Dropbox is the tool everyone uses to share files when you're working on a project with multiple people, and you can also use it to deliver the final videos once you're done. Trello and Asana are both simple project management tools that can be very helpful if you're working for a client who doesn't have a staff producer or project manager making sure things are running smoothly.

These tools are easy to set up, and most of them have a free tier. Learn how they work before you have the conversation with your client about working remotely, so you can explain how the software is used intelligently, and it doesn't seem like you're winging it. Explain to

them how well it works with your other clients—even if you've never worked remotely with another client. Show your client these tools, and remind them it's a trial. If it doesn't work for them, you'll be back in the studio for the next job.

Have this conversation with your client: "I set up a Slack channel just for you so that you and I and anyone else on the team can communicate. Please let me know if you'd like me to invite anyone else. We can share things, and I can show you the work instantly. My philosophy when working remotely is hypercommunication. If you send me a message or an e-mail, I will respond within one hour, but generally, you can expect to hear from me within ten minutes. I'll be on Slack all day if we need to chat about anything, and I will share work in progress with you all day long. You will know what to expect from me every day." You need to say that and stick to it.

And here's the key to getting them to say yes to working remotely. Give them an escape hatch: "I know we haven't done this before, so why don't we just try it for this booking. After this booking is over, if it's not working for you, then next time you book me, I'll come back in, OK?" Make it very low risk for them, and answer all the questions they have in their head about what allowing you to work remotely is going to be like before they ask them.

Put them at ease, and remind them they have a way out if they're not happy with the setup.

If you have to pay for a tool, remind yourself that you're not just a freelancer anymore. You are a one-person Motion Design shop. Motion Design shops have expenses. You're investing in your studio to make a lot more money, and you'll easily recoup that investment when you're working remotely and scaling your freelance career.

Do your first remote job at your day rate. After you complete the job, talk to them to see if letting you work remotely was a success. If you did everything right, they will be happy and open to letting you work remotely from now on.

We've already talked about double-booking yourself and the risks involved. When you're fully remote, it's much easier to juggle multiple jobs, especially when those jobs have longer schedules with holes in them where you can fit in other work. However, remember that clients don't like to think that they aren't your number one priority. Even when working remotely, you *have* to keep the fact that you're working for other clients to yourself. But if you're doing good work, communicating regularly, and hitting the deadlines, clients don't really care how you're doing it.

SWITCH TO AN HOURLY RATE

Now that you're a freelancer working remotely, the next step is to get more flexibility with your time. You have to switch from a day rate to an hourly rate to get that flexibility. If your day rate is $500 a day for a ten-hour day, that's $50 an hour. When you go to an hourly rate, you can charge about 20 percent more per hour.

The benefit to the client is that not everything fits neatly into eight hours per day. They may have a small project that takes only four hours to animate. More often, they have a job that takes a week to complete, but it takes three full days of design and animation, a day off waiting for client feedback, four hours of revisions, another day off for client feedback, and one day for final work at the end. They have to pay you for seven days at your day rate, even though you worked only four and a half days.

To switch to an hourly rate, tell the client you want to be more flexible for them. They're getting a great deal because you're going to give them six hours of work, and they have to pay for only six hours instead of eight or ten. They'll be paying you only for actual work, not all the downtime you have working in their studio. At an hourly rate, they don't have to find something for you to do while everyone else is sitting around waiting for client feedback. Of course, they'll still need you for full days quite often,

and the 20 percent bump in your rate will translate into higher billing on those days, so you'll probably end up making about the same—just working less hours to do it.

So now you're on an hourly rate. Your rate is $60 an hour, and you're working remotely with a lot of flexibility in your schedule. You have to hit every deadline when you work hourly and remotely. The deadline is everything, and the quality has to be there, but the actual *time of day* you work is less important. For example, the client might give you a job that takes four hours to do. They need it by the end of the day tomorrow. Which four hours do you work? It doesn't matter, as long as you turn it in on time. You can get up at 5:00 a.m., have it done by 9:00 a.m., and then go snowboarding. Of course you've already posted the work on Frame.io, written an e-mail to the client with the link, and scheduled that e-mail to go out at 10:37 a.m. using Right Inbox. See how fun this gets?

You're slowly removing the conventions of work, the eight-hour workday that starts at 9:00 a.m. and ends at 5:00 p.m., with an hour for lunch. The more conventions you remove, the more control you will have over your work and your life. By the way, if this concept resonates with you, please read Tim Ferriss's *The 4-Hour Workweek*, which planted the seed for my thinking this way.

You have to do this step by step. You can't start working remotely, ask to be paid hourly, raise your rate, and tell the client you need mornings off to go surfing all in the same day or even during the same booking. That won't fly. Do it one step at a time. Prove to your client that each step works for them, and then you can take the next step.

BID 'EM

Your next goal is to start charging by the project. Warning: Motion Design studios typically won't pay you by the project. That's not the way they work, and if you want to bid at project rates, your clientele may have to change. You have to go after clients like big ad agencies and marketing companies or do direct-to-client work.

Remember, you want to escape the time-for-money construct because that limits how much money you make and keeps you locked into the normal rules of the modern workday. Your time is limited, so you need to do what studios do. When a studio has a job come in, they create a bid, a document detailing the amount of money they want to be paid to do the work that's being asked. That number is based on the amount of time it will take.

When you submit a bid, there are opportunities to get paid more. Clients are used to paying studios for items beyond

animation and design, so you can charge for those things, too. You have to break it all down for them in the bid, so they know what they're paying for. Here's the sample bid and deal memo provided earlier in this chapter:

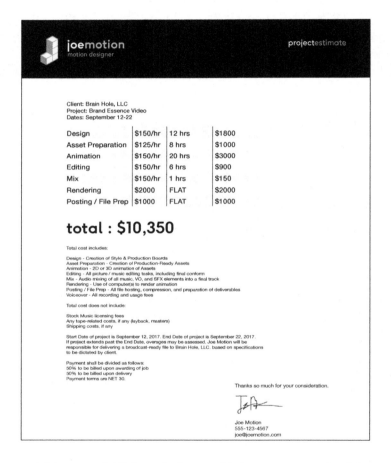

Within your bid, break down all the steps required in the production of a video: design, asset preparation,

animation, editing, audio mixing, rendering the anima-
tion, doing a voice-over, and posting it on the Internet so
the client can look at it.

As a freelancer working remotely for $500 a day or $60
an hour, you might do all the work of a studio—every-
thing listed in a bid—but the cost of each task is lumped
together in an amorphous jelly bean of time called a day
rate. When you provide a bid, you itemize each task and
charge individually for each. Charge for everything a
studio charges for. As a freelancer, you didn't charge ren-
dering, posting, or file-preparation fees, even though you
did all those things. You don't own a rendering farm, but
you're going to have to leave your computer on overnight
rendering, or you may have to rent time on a cloud-based
render farm. Charge a flat fee for rendering.

I generally charge $2,000 for rendering and $1,000 for
posting and filing-preparation fees. That may seem like
a crazy amount of money, but I assure you if you go to
a studio, they're charging that or more in one way or
another. Other tasks have their own hourly rates. Asset
preparation includes menial tasks necessary to produc-
tion and is charged at a lower hourly rate than animation,
editing, and mixing. Charging by the task, your hourly
rate goes up to $150 an hour. As a phase four freelancer
with clients like ad agencies, marketing firms, and direct

clients that call you first every time they have a job, you can charge that much.

You're not bidding the job as a freelancer. You're a one-person Motion Design shop, so you can charge what an actual Motion Design shop charges. The dollar amounts may start to get scary for you. A week and a half of work for $10,350? That's crazy! Remember this: Top Motion Design shops can charge a lot more than this, with rates that are twice as high. You might bid $150 an hour for a twelve-hour project. Eighteen-hundred dollars is a puny amount of money to an advertising agency looking at a studio bid. But for you, $1,800 for a day and a half of work is amazing. Think of it this way: At this level, you're being judged against other studios as well as freelancers. Your work better be damn good, and your client management skills must be stellar because studios have those advantages. But studios can't touch your pricing. You can bid half of what a studio can and still make a killing because your overhead is so small. You're literally saving your clients money.

ALWAYS PAD THE BUDGET

Be realistic with how long you think the work will take and then add 30 percent as a fudge factor. That will cover you if the work takes longer, or is more complicated, or there

are more revisions than you expect. The dollar amount on your bid is the *maximum* amount you can charge the client unless they change the parameters of the job in the middle.

If things get simpler and a lot of the work goes away, you will charge them less. If the client adds a massive new piece to the project, you have to talk to them about it and revise your bid. The number in your bid is not etched in stone, but there's a concept in sales called "price anchoring" where the first number you throw out is the number everything else will be judged by. Make your bid as high as you can initially, so you can lower it if you have to without eating into your profits. It's very hard to ask for more money once you've agreed to do a job at a certain price unless there's a big change in scope.

As I mentioned earlier, I like to bid in terms of a project Start and End Dates and include those dates in the bid. That way, revisions can be discussed in terms of their effect on the End Date and not in terms of "how many more rounds of revisions we agreed on." Put your payment terms on the bid in clear language. Fifty percent billed up front. Fifty percent billed on delivery. Net 30.

Bidding on a project lets you charge a lot more money for your work. You can, by bidding a job, charge $10,000

for one week of work. As a freelancer, it's pretty much impossible to charge a day rate high enough to make that much money in a week. An actual Motion Design studio that makes only $10,000 a week could go out of business because they have so much overhead, like staff, office space, and equipment. But for a one-person Motion Design studio, that's outstanding money, even if you're using some of it to pay freelancers who are helping you with that job. When you start making that kind of money, you'll understand why some of the services you have to pay for, like Frame.io and a premium Slack account, are investments worth the cost. You're starting to operate as a company without all the overhead and headaches.

The jobs you do for that big money are, quite possibly, not going to go on your reel. This is the work you do for banks and financial brands, the Pain jobs that pay you enough to take time off to travel, spend time with your family, and work on your reel.

How many jobs like that do you need to pay your bills? If you need $4,000 a month and you can make that in one week with a Pain job, isn't that a good use of your time?

Once you start bidding on projects, you'll most likely have to hire freelancers to help you. You might be able to do one project on your own, but as you take on more projects,

you are going to need help. You can pay them an hourly or a day rate, and you are still going to come out ahead. Eventually, you'll be doing one, two, maybe three jobs at a time, making a lot more money and working only slightly harder.

IT'S NOT THEIR MONEY

Here's a true story that drastically changed my mindset on pricing. I got a call from an ad agency client of mine: "Hey, we have an emergency." When a client says *emergency*, I hear *opportunity*. I could tell by the tone of the producer's voice that she was stressed out. It was Thursday night, and she needed a three-minute, fully animated video by the end of the day on Monday. This was a watershed moment for me with this client and would make me invaluable to her—if I could pull it off.

I said, "Hey, don't worry. I can definitely get this done for you. I'll move heaven and earth to make this happen, so don't worry about it. Now let's talk. Tell me what you need."

So far, this was phase four stuff, being a rock in the storm and coming to the client's rescue. We talked about the video, and I realized it would take me four days of working around the clock with no sleep to do it, but I wanted to do it. It was one of those opportunities you look for as a

freelancer, an opportunity to shine and to be able to raise your rate considerably for the next job.

She told me to send her a bid. This was phase five territory, and I was barely a phase four freelancer, but I did the math in my head and came up with a crazy number: $18,000. Eighteen thousand dollars for four days of work. Sure, I'd be working around the clock, but that's essentially a $4,500 day rate. I knew it was worth it to them. I sent her an e-mail with the bid form. Her response almost made me fall over and face-plant onto my desk. The e-mail simply said, "I got your bid. You need to ask for more."

Why would she say this to me? The answer is sort of mind-blowing: *Sometimes the money a client pays for a project isn't their money.* It's not the producer's money; your fee doesn't come out of their bank account. It's a budget they've been given by an ad agency, a Motion Design studio, or a marketing company. It's not their money, and they frankly don't care what you charge, as long as it's in the budget. All they care about is that it's done well, completed on time, and that they don't have to worry about things going wrong. For that reason, you should charge what the project is worth, and if they're under the gun to get some work done, it's worth a lot.

You might think they could get the job done cheaper

somewhere else, come in under budget, and then that would make them look good. But that's not how it works. It's nice to save money, but that's a much smaller consideration to them than knowing, *I have hired someone who I know 100 percent is going to get this job done on time and kill it, and I can relax now.* The advantage of feeling confident that they've hired the right person far overshadows the small benefit of getting a pat on the back for saving a few thousand bucks. Saving money is not the biggest consideration in these cases because it's not their money. Plus, when a company bills millions of dollars per year, saving a few thousand bucks on a job by hiring a cheaper freelancer just isn't worth the risk to most people.

That job ended up netting me over $20,000 for four—long, brutal—days of work. It's the highest rate I've ever been paid and proved to me that there's a way of operating as a freelancer that opens up a new universe of opportunity for you.

Phase five is about maximizing the efficiency with which you create income. You're still a Motion Designer. You're still a freelancer. But you're operating in ways that most freelancers don't operate, and you're overturning the conventions that society has put into all our brains about what constitutes a company and what constitutes a reasonable amount you can charge. You're ignoring all that

and just operating in a different way, and if you believe in the manifesto and follow this guide, you can actually make a lot of money quickly, which gives you amazing flexibility to choose how to spend your time.

Hopefully along the way, you've also started to feel more comfortable doing these things. Take a minute to reflect on the way your brain is thinking now versus the way your brain was thinking at the beginning of the book. Has anything shifted in your mindset? If you can feel your brain sort of vibrating with energy because you really want to try this out for yourself, that's a good sign that you're ready to make a change.

CONCLUSION

Congratulations, you made it. You got through all five phases of *The Freelancer's Field Guide* and know how to use freelancing as a tool to carve out your career and design your life. Hopefully, *The Freelance Manifesto* is starting to make a lot more sense, and you're beginning to enjoy some of the extraordinary benefits of being a freelancer.

You know how to get clients, how to raise your stock with them, and charge more money—to free up more time. What are you going to do with all that knowledge? Consider all the possibilities. Don't limit yourself. Decide what you actually want your life to look like. Design that life. Own it.

You probably have preconceived ideas about what your life is supposed to look like. Forget about those. We all get

one ride on the ol' merry-go-round of life, and you have every right to make yours exactly what you want it to be. If you want to work four months a year, and you can live on that, work four months a year. Don't feel ashamed by that. There is no rule that says you have to work fifty weeks a year. That rule doesn't apply to you—not anymore.

The important thing to remember is, there are no rules. You are designing the life that makes you happy. Give yourself permission to do that.

What you want your life to look like will change over the years as your situation and priorities change. What you want at twenty-five may not be what you want when you're forty-five. Sometimes it will change suddenly. You may decide to travel, move, get married, or have kids.

There are unlimited answers to the question, "What should I do with my freelancing skills?" The bigger question is, "Now that I have this freelancing tool, what should I do with my life?" Here are some people I know who used freelancing to design their lives, with completely different whys, goals, and outcomes.

KYLE, THE YOUNG ADVENTURER

Kyle Predki is a talented animator who now lives in Bend,

Oregon, with his girlfriend. Before that, he worked for me full time when I ran Toil in Boston. Kyle was a great team player. He showed up every day, did his job, and was great at it. Kyle had two weeks paid vacation every year. Working on staff, Kyle was beholden to whatever work he was given. He had no choice in the work he was doing. His salary wasn't based on anything in particular either. It was just what Toil was willing to pay him, not what he was willing to ask for. After I left Toil, I didn't see Kyle for a while.

When Kyle told me he wanted to go freelance, I gave him a lot of advice. He was nervous at first, terrified he would free fall into a death spiral of perpetual unemployment and never work again. He had fever dreams of ending up homeless, living in a van by the river, that his girlfriend would leave him... But he did it anyway.

Kyle is talented and extremely likable, so not surprisingly, he got booked fast and stayed booked constantly. His first twelve months freelancing, Kyle was booked fifty-one out of fifty-two weeks. He got a little burned out, but he kept going.

In the middle of his second year freelancing, Kyle took two months off and went snowboarding in Montana. Then he went to Vermont and snowboarded some more. Kyle

realized that as much as he loved Motion Design and animation, they were not the only things important to him. Being outside, snowboarding, hiking, mountain climbing, experiencing the world, and traveling—those things were important, too. That became a huge component of his life. When you're starting your career, you want to work with the best studios and do amazing work. You want to see your Motion Design work in the Super Bowl broadcast. As a freelancer, your goals shift.

Kyle's priorities changed quickly. Now, if his "dream" Motion Design studio offered him a job, he'd probably turn it down. What he wanted out of life changed. Kyle realized he could be a Motion Designer, but he could also have more control over his time to travel, snowboard, and hang out with his girlfriend. They left Boston and moved to Bend. He could do that because he's a freelancer, and it doesn't matter where he lives. Kyle's a modern-day digital nomad. He's loving life. And he knows that when he wants to get married, start a family, buy a house, and save for retirement, he can redesign his career to enable him to do all those things.

Kyle used to think of himself as a Motion Designer. Now he's many things. That's what happens when you freelance. You probably worked somewhere else before you became a Motion Designer. Maybe you worked at Smoothie King,

McDonald's, or the campus café. But if someone asked you, "Hey, tell me about yourself," you wouldn't say, "Oh, I'm a smoothie maker." But when you graduate from college with a degree in Motion Design, you say, "I'm a Motion Designer." It's the same if you go to school to be a lawyer, a doctor, or an engineer. You identify as that thing you studied, which is now your job.

When you're a freelancer, that association slowly goes away. You'll begin to understand that *what I do to pay my bills is Motion Design*. It's not that you won't love it anymore or that you won't wake up every day saying, "I am so lucky to be able to pay my bills doing something I enjoy," which a lot of people don't get to do. However, you will have other priorities, especially if you start a family.

ADAM AND DAVID, FAMILY GUYS

Nothing throws off your career ambitions like having a family. Children turn everything upside down. When you get married and have children, you will want to be around your family. It can be challenging in Motion Design to have that flexibility, especially if you're on staff.

I have friends in their thirties who are freelance Motion Designers. Like me, Adam Plouff and David Stanfield are also raising a family and trying to be good fathers. We all

went freelance for different reasons. Adam was laid off, and David quit his job to freelance. All three of us worked hard and watched our freelance careers take off. Then, all of a sudden, we had families.

We were phase three freelancers when we had our families, and our *whys* changed drastically. We were career-driven people with aggressive, artistic goals in the Motion Design industry, but once we had kids, our desire for world domination diminished greatly. In their place was the realization that we really loved playing with our kids. We loved having dinner with them every night, making them pancakes for breakfast, and taking a two-hour lunch to have pizza with them. Being able to spend time with your kids makes freelancing worth the work, the fear, and the risk. And doing big-paycheck jobs is less painful when the payoff is more family time.

I'LL TAKE AN EXTRALONG LUNCH BECAUSE I'LL PICK MY DAUGHTER UP FROM PRESCHOOL THAT DAY, AND WE'LL HAVE A LITTLE DATE OR SOMETHING. THAT STUFF HAPPENS ALL THE TIME NOW. OR I'LL RUN HOME AND HAVE LUNCH WITH MY WIFE AND END UP HANGING OUT FOR A LITTLE BIT LONGER, JUST BECAUSE I CAN.

—DAVID STANFIELD, DAVIDSTANFIELDIS.ME

All three of us—Adam, David, and I—have taken jobs that weren't perfect for a reel but gave us a paycheck that let us spend a lot more time with our kids. We still do a lot of creative work, too, and if you check out Dave's portfolio, you'll see he does beautiful, amazing work. David paid his dues, doing work he wanted to get paid for before he was actually getting paid for it. Now he gets paid to do amazing work for great clients like Google, Reddit, and Barack Obama, and also spends a lot of time with his kids. He has the exact work-life balance he wants.

Adam was also able to design a life he wanted. The funny thing is, his path took a few twists and turns. After enjoying a successful freelancing career, he actually went back to work full time for Google, an amazing company. It's a big company and one of the best, but he probably never would have had the opportunity if he hadn't freelanced first. Freelancing gave him the ability to work the big-paycheck jobs so he could take time off to get really good at Motion Design and put together an amazing portfolio. Working for a company like Google is probably as close to freelancing as you can get while still being full time, and that's what the best companies are doing now, building a culture and environment similar to what Motion Designers have as freelancers. After a year, Adam realized that freelancing still fit him better, and he left to, once again, go freelance.

Another freelancer—whom we'll call Jack—had a different *why* that required him to take money making to the extreme. Remember my $260,000-in-one-year buddy? That's Jack. Jack is a brilliant designer in his mid-forties. For most people in their forties, work is not their greatest source of pleasure. It wasn't for Jack anymore, and his *why* changed. He decided to pay off his mortgage. He realized if he paid off his mortgage, he could retire at fifty.

If you're working as a Motion Designer on staff, and you want to pay off your mortgage in one year and retire in five years, how do you do it? How do you make an extra $150,000 on top of your current salary? What options do you have to make that happen? There aren't many legal ones.

But remember, Jack is a freelancer. He doesn't work at a studio, so he can actually do that: he can make an extra $150,000. Jack, a true phase five freelancer, went after very high-paying clients. He scaled it and did direct-to-client work for the highest-paying clients he could find. He hired people as he needed them, double-booked—sometimes *triple*-booked—himself. His clients trusted him to get the work done because he had already proven himself to them.

Did Jack have fun that year? Nope, not even a little. Jack

probably had some heartburn, didn't get a lot of sleep, didn't travel, and didn't have much fun. But that was his choice. He chose to sacrifice one year to make a crapload of money. He made $260,000. The next year, he scaled way back and made only $110,000. (Yes, isn't it funny that we're saying *only* $110,000?) But he didn't have a mortgage anymore. You can live pretty well on $110,000 a year with no mortgage.

The point is, don't be repulsed by making a lot of money. You can still be an Artist. The money allows you to choose your *why* and design the life you want. You may not know what your *why* is yet, but always look for it. Be aware of those moments when you are really happy. Those are clues to your *why*, the universe telling you what you're supposed to be doing with your life.

Then there's me. For a while my *why* was, *I need a lot of money to pay for my wedding*, and later, *I need more time to spend with my family*. Toward the end of my freelance career, I found out I was having a third child—surprise!—and we were buying a house. I needed a bunch of money as quickly as possible, so I focused all my energy on high-paying, high-dollar clients.

When I was creative directing at Toil, my favorite part of the day was when someone had a question about how to

do something in After Effects or Cinema 4D, and I taught them how to do it. That was so rewarding. I became conscious of that over time. I loved seeing that light go on in people's faces when they learned something new and really got it. Later, teaching at Ringling made me realize how much I loved being a teacher, and that added another priority to my *why*—starting a Motion Design school. I focused on the money simply because I wanted to build my own company, School of Motion.

Teaching became my new *why*, and starting a school became my goal. It took me a while to actually come around to owning that goal. I put it aside for a while. Eventually, I owned it, and told people, "I'm going to build School of Motion. That is my goal. That's what I'm doing."

I started School of Motion while I had a full-time job. It was impossible to do both, and the school stagnated for two years. I had to quit my job, go back to freelancing, and do it right this time. That's when I codified everything in this book, and that's what allowed me to make the money I needed to have control over my time, so I could make School of Motion a success. Freelance Motion Design allowed me to focus all my energy on high-paying jobs, and that gave me everything I wanted, all my *whys*. It allowed me to start School of Motion, spend time with

my family, and have everything else I wanted in life. It allowed me to write this book.

Once you've got your *why*, go after it. Kyle's *why* is travel and snowboarding. Adam, David, and I want an amazing work-life balance, so we can spend a lot of time with our families and still make a good income. Jack wanted to pay off his mortgage, so he can retire at fifty.

Our *whys* and goals were different, but in order for them to work, we had to own them. Own your *why* and your goals.

Now that you've reached the end of this book, hopefully you see this is more than just an attempt to teach you the nuts and bolts of freelancing. I want to plant a seed in your brain that the life that society designs for us is not the only option we have. I told you in the first paragraph of this book that this is a Trojan horse to get you to take control of your career and your life. You should be getting that by now, and I want you to hang on to that.

There may be a lot of pressure on you to conform to a standard kind of life, especially from your friends stuck in day jobs and from your family who think you're crazy. Don't listen. Whatever it is you want to do, just own it, be proud of it, and go get it. Otherwise, it won't happen.

Still skeptical? I want you to try phase one. Even if you're on staff and you're not thinking of going freelance anytime soon, just pretend you are. Find a couple of clients and get through phase one. Follow my instructions and see how easy it is. You will be shocked by how quickly it works.

Prove to yourself right now that freelancing is a viable option. It's easy to get used to being on staff and limited in your career and your life. You don't have to settle for that. Don't put this off because it will never be easier than right now—right this minute—to prove to yourself that you can do this. You can become a freelancer.

Seth Godin, a brilliant author and entrepreneur, was interviewed by Tim Ferriss, who asked him, "If you were going to give a commencement speech, what would you say?"

Here is Godin's response: "You are more powerful than you think you are. Act accordingly."

I hope you do. Good luck.

APPENDIX

We talked about a lot of tools and services in this book. Here they are all collected in one spot. You can also find this list at freelance.how/tools. As I mentioned in the book, tools come and go all the time, so use this list as a starting point, but take it upon yourself to research the latest and greatest ways to stay on top of your freelancing career.

TOOLS FOR COMMUNICATING WITH CLIENTS

Slack: This messaging app has gotten so popular so fast that it's hard to remember a time before it existed. We use it at School of Motion, and it's mostly eliminated e-mail from our organization. It's free to use, although you can pay for some premium features if you need them.

→ **slack.com**

Skype, Google Hangouts, Screenhero, Appear.in: These four tools all enable you to have voice or video-chats with your client as well as share your screen in real time. Super handy for showing your client a quick work in progress. Appear.in integrates into Slack, which makes it frictionless to start a quick video chat. Screenhero has a great feature where your client's mouse can appear on your screen so that they can "point" to things for you to look at. Try them all; see what you like.

→ skype.com
→ hangouts.google.com
→ screenhero.com
→ appear.in

PROJECT MANAGEMENT TOOLS

Trello, Asana: Both of these apps let you manage projects in a team. Let's say you're working with another freelancer you've hired to complete ten videos. Keeping track of the various states of approval among ten videos can be tricky, but these project management apps make it really simple. We prefer Trello at School of Motion, as it's a simpler system that gives you plenty of visual cues as to what's going on in your project. If you've ever used a Kanban board, you'll immediately get how it works. Both apps have free tiers to get started.

→ asana.com

→ trello.com

Dropbox: C'mon, you know about Dropbox. It's invaluable. I don't know how I ever lived without it. Just in case you've been living in a cave for the past five years, Dropbox is an app that lets you sync a folder across multiple computers as well as the cloud. If you want to share a folder with a bunch of project files in it with a client, it takes about three clicks to do it with this indispensable tool.

→ dropbox.com

VIDEO/IMAGE REVIEW TOOLS

Frame.io, Wipster, Boords: These tools make it very easy for you to share work with your clients and get precise, actionable feedback. Gone are the days of getting an e-mail with lines like, "That part where that circle moves left, that needs to be 20 percent slower. And make that other thing blue." Frame and Wipster allow you and your clients to comment directly on specific video frames, draw and add notations right on the image, and track versions easily. Boords is a newer tool from the folks at Animade, streamlined not for video but for storyboards. It's another incredible tool to add to your arsenal.

→ wipster.io

→ frame.io

→ boords.com

ScreenMailer: This is one of my favorite tools. You click a button, and in seconds, you are recording your screen and your voice at the same time. As soon as you're done, you get a link to the video you just made to send to a client. It's a crazy-simple way to show a client something and talk them through it without having to schedule a meeting or write a big long message.

→ screenmailer.com

E-MAIL TOOLS

Voila Norbert: My go-to tool for finding e-mail addresses. Type in a first and last name and a domain, and the app searches for an address. I get about 60 percent success with this tool, so you'll need to use others as well.

→ voilanorbert.com

Hunter.io: This site will show you all known e-mail addresses for a domain. This is very useful if you can't find an e-mail address any other way. You can at least find out the domain's e-mail format, such as first.last@

domain.com, which gives you a much better chance of guessing the right address for a lead.

→ **hunter.io**

RocketReach.co: One of the newer tools that finds e-mails for you. It has a very high success rate, so definitely give this one a shot.

→ **rocketreach.co**

Rapportive: This is an extension for Gmail that automatically pulls up any associated LinkedIn information on people based on their e-mail addresses. It's not only a great way to verify if you've found a valid address, but it also pulls up info on anybody who e-mails you. This will let you reply with more knowledge about whom you're communicating with.

→ **rapportive.com**

WiseStamp: This is the tool I use to create beautiful, professional e-mail signatures in about ten seconds. Sure, you can just code your own for free, but this tool makes it so easy, plus it has advanced features that can update your signature constantly with your latest work and other things like that.

→ wisestamp.com

MailTrack.io: This tool is incredible. It's a Gmail extension that lets you know when somebody has received, opened, or clicked on any e-mails you send. It's not 100 percent accurate, but it's close enough and gives you the info you need to be a ninja-level freelancer.

→ MailTrack.io

Right Inbox, Boomerang: Both tools do pretty much the same things. You can write an e-mail and then schedule it to be sent later, handy for underpromising and over-delivering to your clients. It can also remind you about certain e-mails, which makes it really easy to remember to follow up if a client hasn't booked you yet.

→ rightinbox.com
→ boomeranggmail.com

PORTFOLIO PLATFORMS

Squarespace, Wix, Adobe Portfolio, Behance: There's no advantage anymore to going through the pain of setting up your own WordPress site. You don't need bells and whistles; you need a simple site that gives you a grid of your work. Squarespace seems to be the dominant choice

at the moment, and it's got a dead-simple interface to set up your site in minutes.

→ **squarespace.com**
→ **wix.com**
→ **myportfolio.com**
→ **behance.net**

INVOICING AND ACCOUNTING TOOLS

QuickBooks, FreshBooks: Most freelancers seem to prefer the simplicity of FreshBooks, but I always used QuickBooks because my accountant could access Quick-Books and do my taxes without my having to lift a finger. Both platforms are great and allow you to send and track invoices with ease. Both also let you add the "Pay Now" button I mentioned, which can help you get paid faster at the expense of about 3 percent of the bill.

→ **quickbooks.com**
→ **freshbooks.com**

FundBox: FundBox should be a tool of last resort for freelancers. It's essentially a line of credit based on your accounts receivable: what you're currently owed. You show them the invoices you've sent your clients, and they'll pay you immediately what you're owed, then put

you on a payment plan to pay them back. Once you get the check from your client, you can pay the balance of what you owe FundBox if you like or stay on the payment plan. Of course, you end up losing a little money through fees this way, but if you have a huge invoice out there that's going to take three months to get paid, and you need the cash now, this type of service might be invaluable.

→ **fundbox.com**

ACKNOWLEDGMENTS

It's a strange thing, writing acknowledgments to a book. It makes you realize just how many people you have to thank—and it's a lot! When you write a book, you're struck by the enormous volume of information that lives inside your head, and you wonder, *How did that knowledge get there?*

I didn't invent the tactics or ideas in this book. None of them. Zero. I learned them from mentors, through experience, and through a very healthy dose of trial and error. I learned them from interacting with clients, with students, and with other Motion Designers. I owe all of them a huge debt of gratitude.

Without the support of my wife, who is the best wife ever, this book would never have happened. She puts up with

every wild idea I come up with, and she's a saint for doing so. If this book helps you, thank my wife.

Alaena, Corey, and Amy, my School of Motion teammates: I don't know what I'd do without each of you. You add so much to the company and the community, and I know our students feel the same way. Shout-out to our Bootcamp TAs, too.

To Kyle Predki, Adam Plouff, David Stanfield, and all the other freelancers who replied to our survey or offered their thoughts: Your insights were invaluable. Thank you.

To all the producers, creative directors, studio owners, and others who gave us insights from the other side of the hiring process: I can't thank you enough. You are helping the Motion Design community in very powerful ways by sharing your wisdom.

Since starting School of Motion, I've had many mentors and people in my corner to help me grapple with the difficult task of running a business. Jaime Masters, Pat Flynn, Seth Godin, Tim Ferriss, Noah Kagan, Andrew Warner, Neville Medhora—some of you I know well, some of you I've only read, but you've all had a very deep influence on me, and many of the ideas in this book come from your teachings.

My parents, my sister, and my brother—also a published author—deserve most of the credit for the relatively normal head I have on my shoulders. I couldn't have done anything in life without you guys.

The folks at Book In A Box deserve a medal for getting this book out of limbo and into print. Tucker Max, Keating Coffey, Andrew Lynch, Dan Bernitt, and *especially* Susan Joy Paul for being supernaturally patient with me as the editor. Thank you all so much.

And finally, to the incredible Motion Design community, I say thank you from the bottom of my heart. I really hope this book helps as many artists as possible and that it might change a career or two. To my extended family, the amazing School of Motion community, to all of our students and alumni, this book is for you. Rock on.

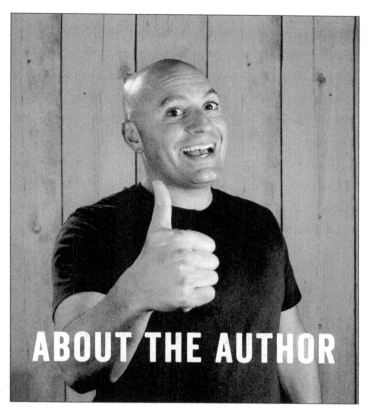

ABOUT THE AUTHOR

JOEY KORENMAN is the founder and head instructor for School of Motion, an online school for Motion Designers all over the world. Before finding his true calling as an educator, he was a working Motion Designer for over a decade, climbing the ranks from junior artist to freelancer to studio head and back to freelancer. Since founding School of Motion, he has dedicated his time to teaching aspiring and working Motion Designers how to be effective, high level, and in demand in their professional careers.

Joey has also presented and run workshops for Wacom, Shutterstock, Adobe, and the Ringling College of Art & Design, and acted as emcee at Blend, a Motion Design festival held in Vancouver, British Columbia. School of Motion content has been featured by Adobe, Maxon, and The Foundry.

When not teaching or animating, Joey is busy training for marathons in the sunny state of Florida. He lives there with his wife and three children. He is also a taco enthusiast.

Made in United States
North Haven, CT
13 October 2021

10311979R00197